beautiful news

beautiful news

positive trends, uplifting stats,
creative solutions

David McCandless

HARPER
DESIGN
An Imprint of HarperCollinsPublishers

HarperCollins books may be purchased for educational, business,
or sales promotional use. For information, please email the
Special Markets Department at SPsales@harpercollins.com.

First published in 2022 by
Harper Design
An Imprint of HarperCollins *Publishers*
195 Broadway
New York, NY 10007
Tel: (212) 207-7000
Fax: (855) 746-6023
harperdesign@harpercollins.com
www.hc.com

Distributed throughout the world by
HarperCollins *Publishers*
195 Broadway
New York, NY 10007

ISBN 978-0-06-218824-3

Library of Congress Control Number has been applied for.

Printed in Thailand

First Printing, 2022

dedicated to all those uncelebrated millions
who work quietly and steadily
to make the world a better place

Introduction

This is Beautiful News. Some of the amazing, beautiful, positive things happening in the world that we can't see because we're fixated on the negativity of the news.

If the news is your main window on the world – as it is for me – it's difficult not to see it as an infernal hellscape of conflict, murder, disagreement, tragedy and violence.

At best that's an unfair depiction of the world. At worse it's false, distorting and mentally harmful.

A function of charts and graphics has always been to show us what we can't naturally see. In this case, the slow developments, quiet trends that go unseen, uncelebrated. Decadal increases. Generational shifts. Historic reductions. Incremental change. Subtle upticks. The slow and steady symphony of progress.

Without these views, it's easy to succumb to doom, pessimism, powerlessness. The scale and complexity of the world's problems feels overwhelming. But often *understanding* can be the antidote.

That's why this book is not just beautiful trends, but also full of infographic primers – visual explainers of complex but important topics – so you can better understand them as they pop up in the news.

Working closely with these topics and all the surrounding data and information over the months, I've noticed a shift in myself and my outlook. I feel less heavy. A bit brighter. Maybe even ... a little hopeful?

The world is not perfect. It never will be. But nor is it as bad as it looks. That's clear.

I get this feeling that optimism is a muscle. One that can be supported by regular exercise and a diet of healthy information. So if the news is fast food – tasty and palatable but unhealthy – then take this book as a beautiful salad. Full of fresh ideas and nutritious perspectives to revitalize your mind, strengthen your heart and give you something delicious to chew on...

David McCandless, June 2021

health

cleaner energy

progress

nature

mixed

freedom & rights

climate

money

nice!

women & girls

what to do?

cool tech

Fewer Children Are Dying

% dying before the age of five worldwide

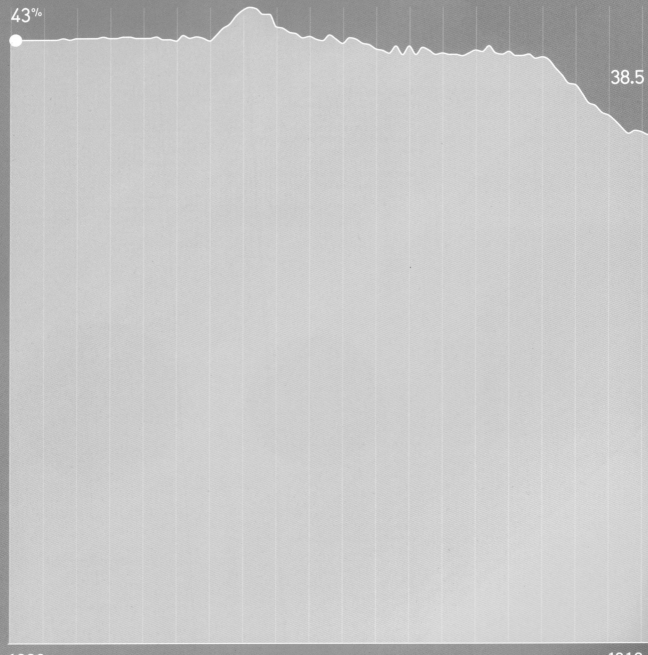

43%

38.5

1820

1918

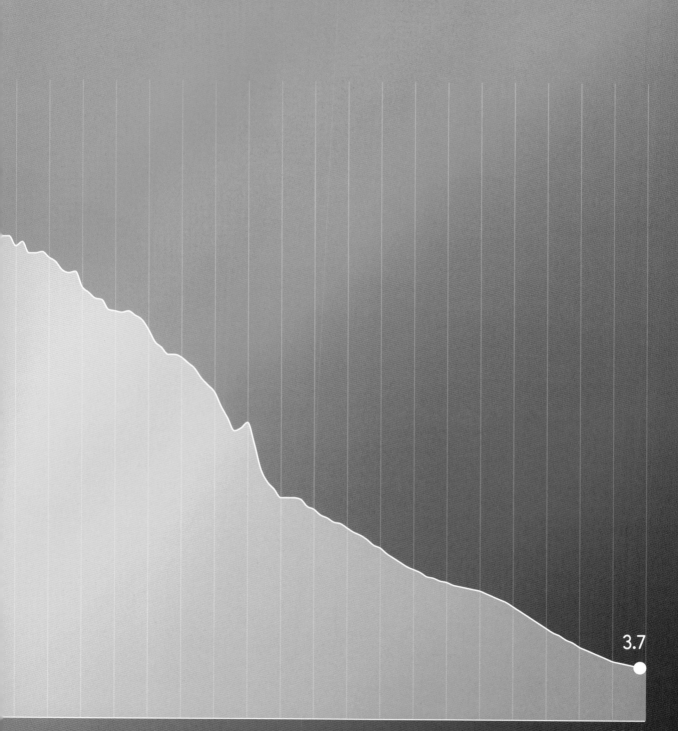

3.7

2020

source: Our World in Data

Foreign Aid Has Exploded
Money given to poorer nations

SOCIAL
ECONOMIC
PRODUCTION
MULTISECTOR

$4bn

DEBT RELIEF
COMMODITY
HUMANITARIAN
UNSPECIFIED

1960

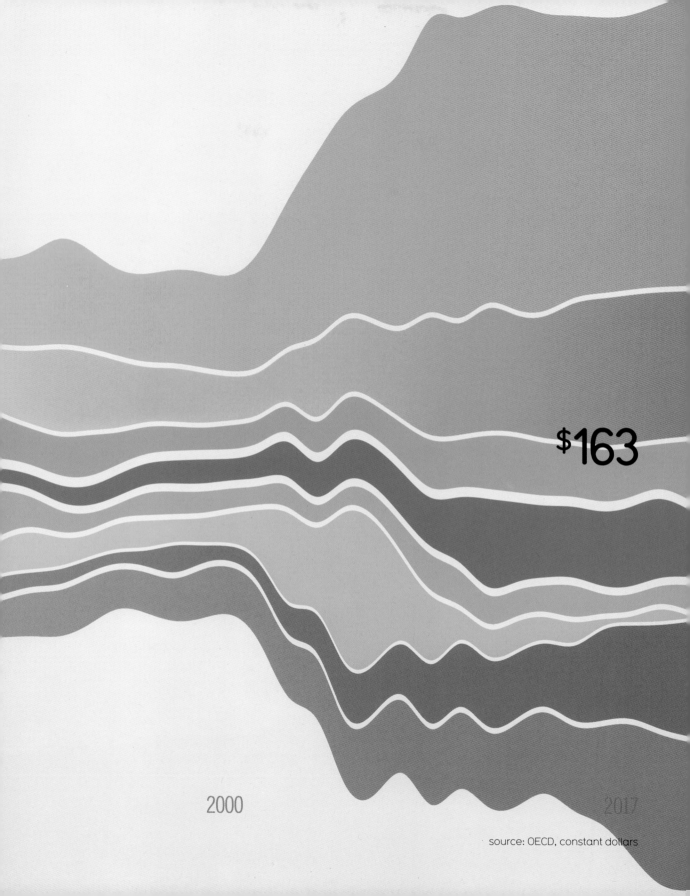

$163

2000 2017

source: OECD, constant dollars

Women Can Finally Vote Everywhere*
% of countries

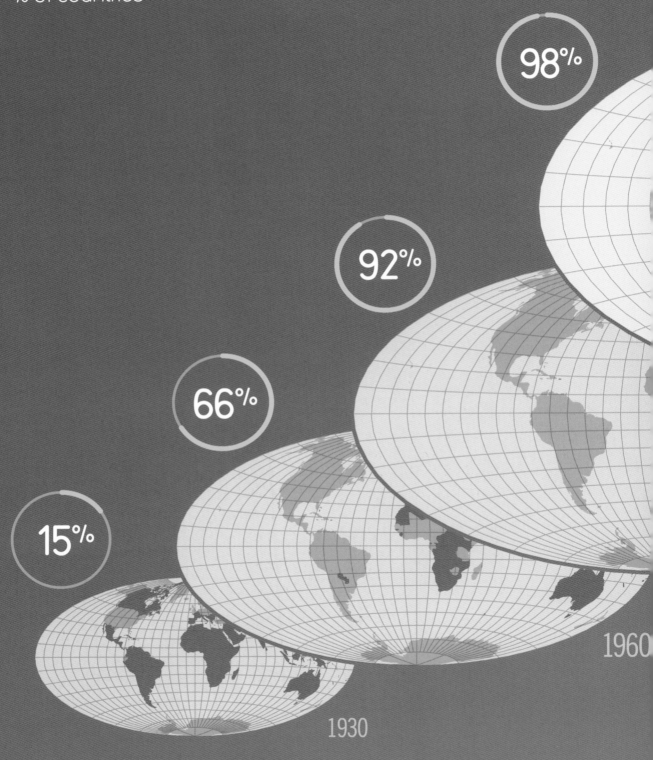

98%

92%

66%

15%

1930

1960

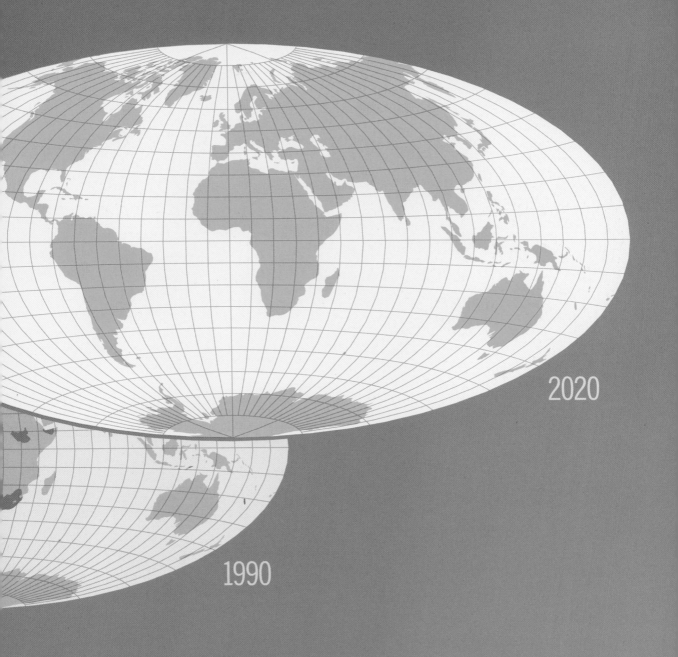

2020

1990

*except Vatican City and Brunei

source: Pew Research Center

World Hunger Has Reached Its Lowest Point in 20 Years

Angola

Sierra Leone

13%

population undernourished 60%

Haiti

40%

GLOBAL 9%

2019

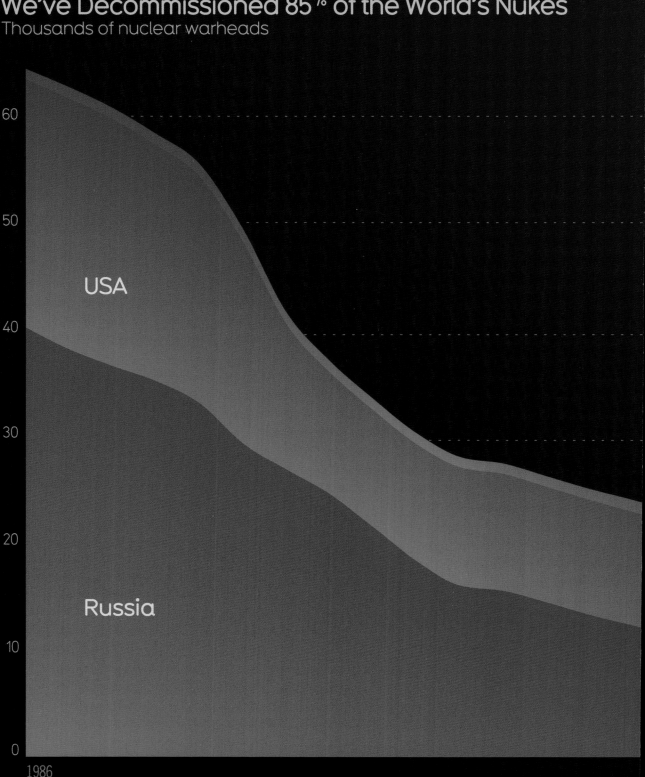

We've Decommissioned 85% of the World's Nukes
Thousands of nuclear warheads

60

50

USA

40

30

20

Russia

10

0

1986

other
China, France,
India, Israel,
N. Korea, Pakistan,
United Kingdom

Humpback Whales Are Recovering

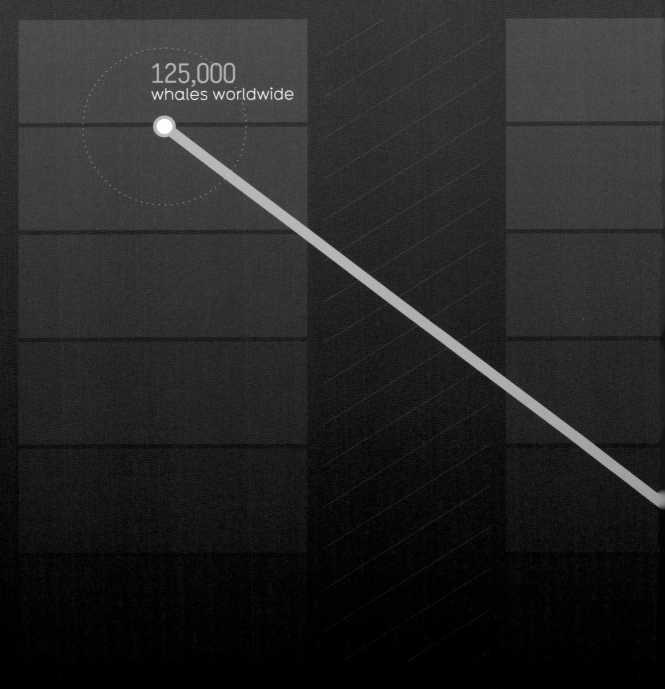

125,000
whales worldwide

1500

135,000

9 of 14 humpback populations
are no longer endangered

10,000

whaling ban imposed

1966

2019

sources: US National Park Service, Endangered Species Coalition

The world will solar panels EVERY HOUR over the next three years

add 70,000

Extreme Poverty Is Decreasing
% world population living on less than $1.90 per day

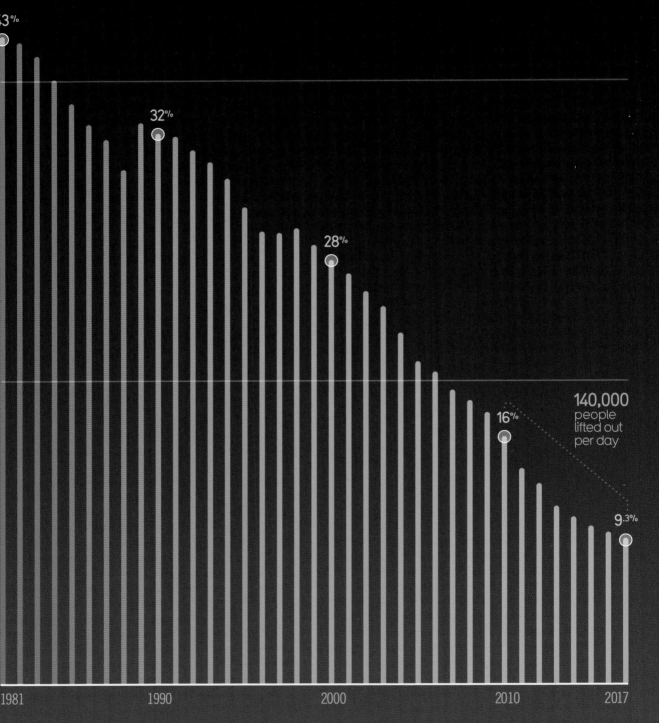

3%

32%

28%

16%

140,000 people lifted out per day

9.3%

1981 1990 2000 2010 2017

source: Our World in Data

More Than Half the World Now
Lives in a Democracy

100% of global population

50

52%
4 billion

37%
1.8 billion

1985

2018

source: Our World in Data

Billions More Can Now Drink Safely
world population with access to safe water

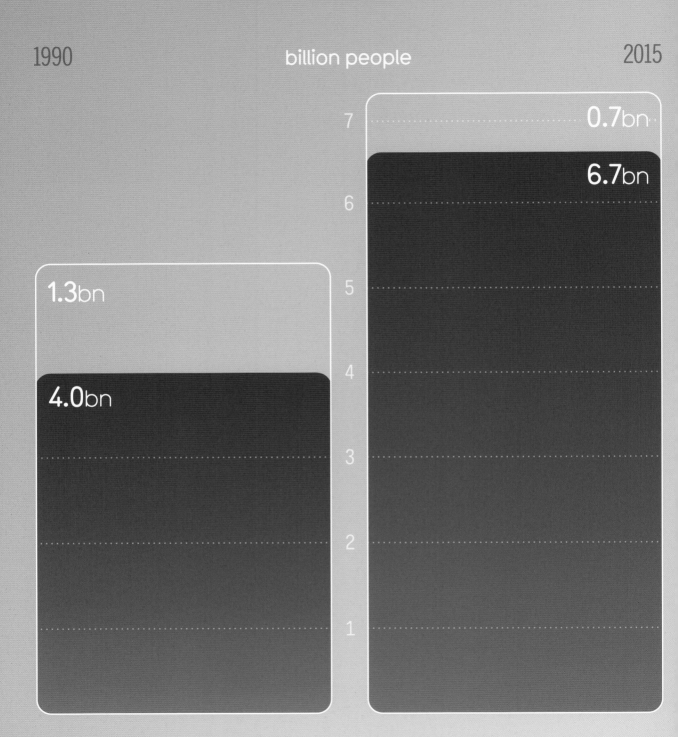

sources: Our World in Data, World Water

Natural Disasters Are Far Less Deadly
Floods, droughts, hurricanes & earthquakes

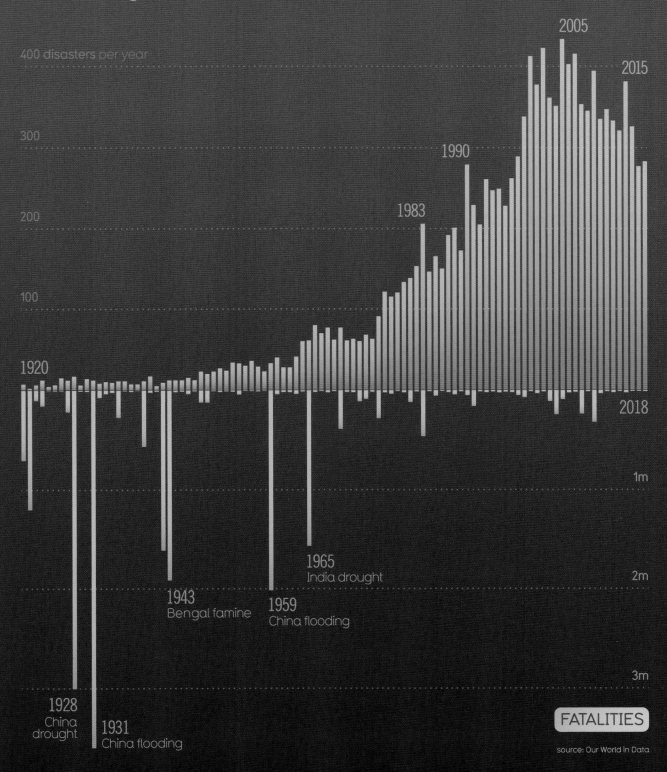

400 disasters per year

300

200

100

2005

2015

1990

1983

1920

2018

1m

1965
India drought

2m

1943
Bengal famine

1959
China flooding

3m

1928
China
drought

1931
China flooding

Fewer People Are Dying of Breast Cancer
Deaths per 100,000

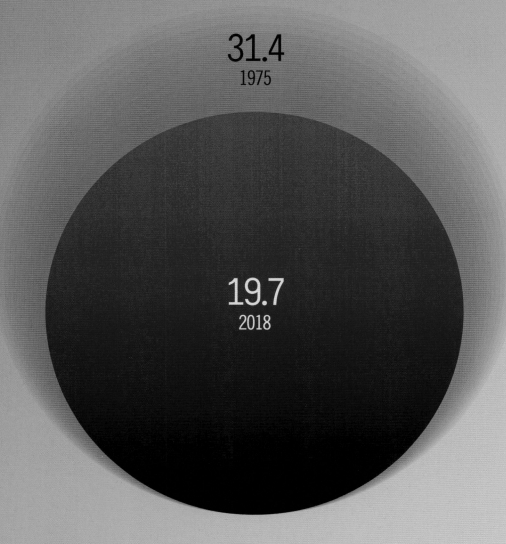

31.4
1975

19.7
2018

sources: Queen Mary University London, National Cancer Institute

Cancer Survival Rates Are Rising

% alive five years after diagnosis

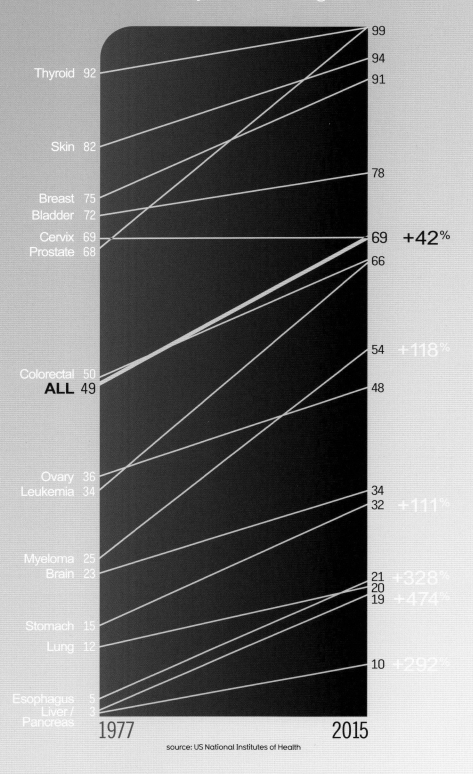

Thyroid 92
Skin 82
Breast 75
Bladder 72
Cervix 69
Prostate 68
Colorectal 50
ALL 49
Ovary 36
Leukemia 34
Myeloma 25
Brain 23
Stomach 15
Lung 12
Esophagus 5
Liver /
Pancreas 3

99
94
91
78
69 **+42%**
66
54 +118%
48
34
32 +111%
21 +328%
20
19 +474%
10 +292%

1977 2015

source: US National Institutes of Health

The Best Things in Life Really Are Free
What makes people most happy, according to data?

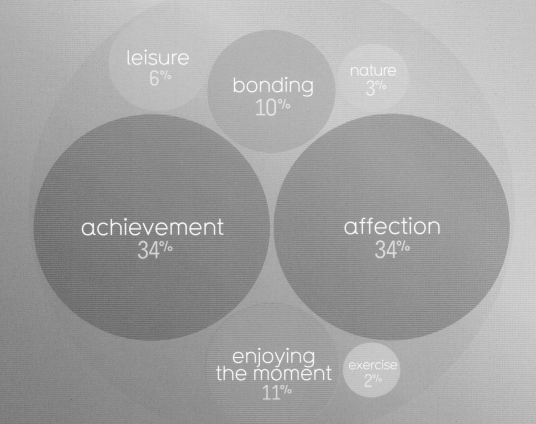

leisure
6%

bonding
10%

nature
3%

achievement
34%

affection
34%

enjoying
the moment
11%

exercise
2%

sources: Flowing Data, Happy DB

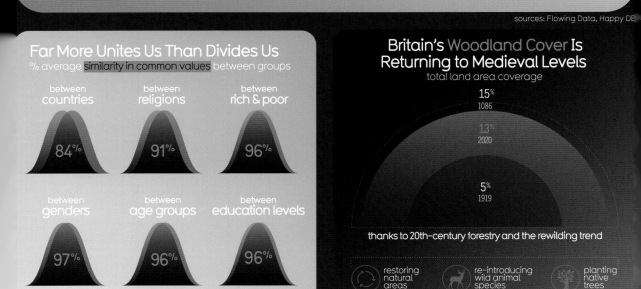

Far More Unites Us Than Divides Us
% average similarity in common values between groups

between
countries
84%

between
religions
91%

between
rich & poor
96%

between
genders
97%

between
age groups
96%

between
education levels
96%

Britain's Woodland Cover Is Returning to Medieval Levels
total land area coverage

15%
1086

13%
2020

5%
1919

thanks to 20th-century forestry and the rewilding trend

restoring
natural
areas

re-introducing
wild animal
species

planting
native
trees

Simple Oral Rehydration Therapy Has Saved Millions of Lives Around the World

Treating diarrhea is **easy, cheap** (0.20$/day) & **accessible**

GLUCOSE	31%
SODIUM	31%
CHLORIDE	27%
POTASSIUM	8%
CITRATE	4%

given to
millions
of kids under five
worldwide every year

And thanks to an improved formula with zinc,
deaths are still falling around the world

2.4 million under-five deaths from diarrhea worldwide

880,000

2000 — 2017

source: WHO, USAID

Over Two Billion More People Have Gained Access to Improved Sanitation

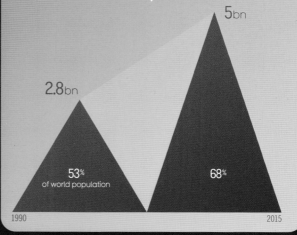

5bn

2.8bn

53% of world population

68%

1990 — 2015

source: Our World in Data

The EU has banned bee-harming pesticides

IMIDACLOPRID
CLOTHIANIDIN
THIAMETHOXAM

source: European Food Safety Authority

Pakistan has met its climate goals one decade before the United Nations deadline

 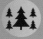

planted billions
of trees in
just two years!

ranked &
rewarded its
cleanest cities

protected up to
15% of its parks
& wildlife areas

source: Good News Network

Land Devoted to Producing Meat & Milk Is Beginning to Shrink Again

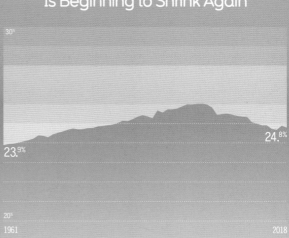

30%

23.9%

24.8%

20%

1961 — 2018

source: United Nations Food & Agriculture Organization

Healthy Life Expectancy Is Increasing in Almost Every Country

2000–2018

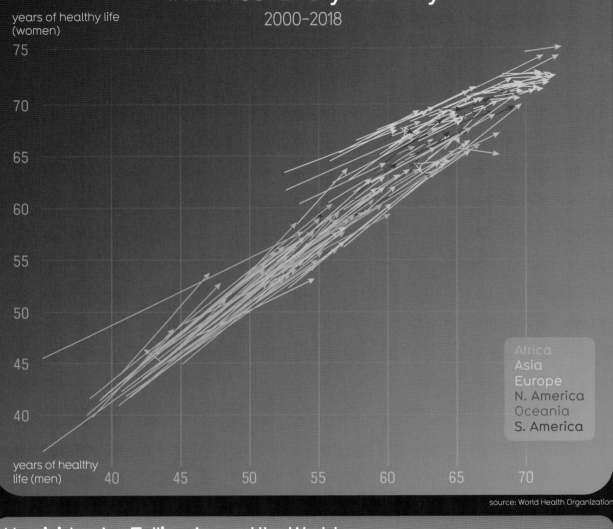

years of healthy life (women)

75

70

65

60

55

50

45

40

Africa
Asia
Europe
N. America
Oceania
S. America

years of healthy life (men)

40 45 50 55 60 65 70

source: World Health Organization

Homicides Are Falling Around the World %decrease 1998-2018

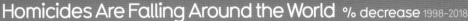

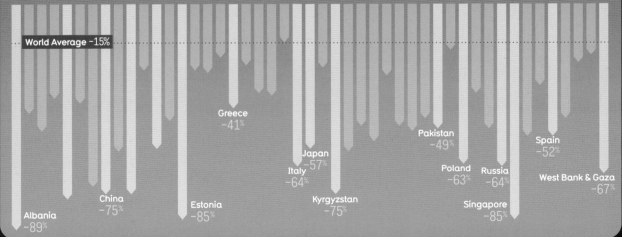

World Average –15%

Greece –41%

Japan –57%

Italy –64%

Pakistan –49%

Poland –63%

Russia –64%

Spain –52%

West Bank & Gaza –67%

Albania –89%

China –75%

Estonia –85%

Kyrgyzstan –75%

Singapore –85%

source: World Bank

The HPV Vaccine Has Slashed Infections
% prevalence among sexually active women aged 14-24

54% BEFORE VACCINE (2003–2006)

0.9% AFTER VACCINE (2011–2014)

source: Journal of Infectious Diseases, USA data

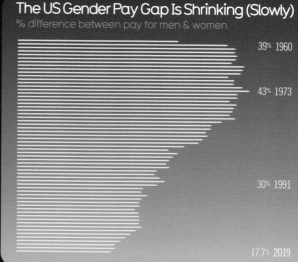

The US Gender Pay Gap Is Shrinking (Slowly)
% difference between pay for men & women

39% 1960

43% 1973

30% 1991

17.7% 2019

source: US Census Bureau, average pay

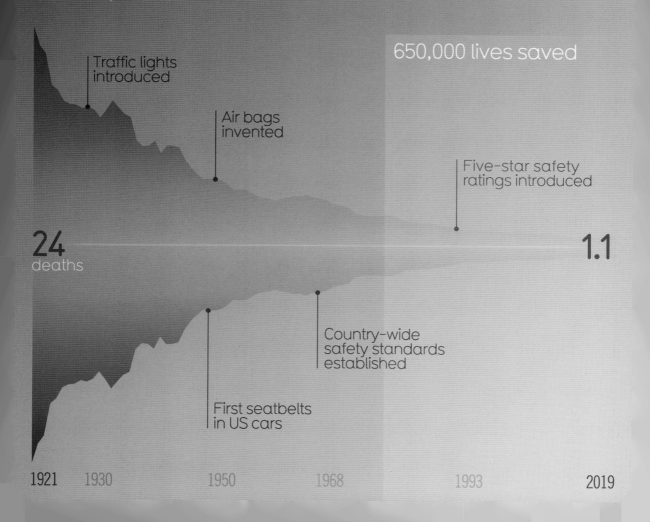

Road Travel in the US Is Safer than Ever
Fatalities per 100m vehicle miles traveled

Traffic lights introduced

Air bags invented

650,000 lives saved

Five-star safety ratings introduced

24 deaths

1.1

Country-wide safety standards established

First seatbelts in US cars

1921 1930 1950 1968 1993 2019

Eleven Diseases We've Nearly Controlled or Eradicated

on our way

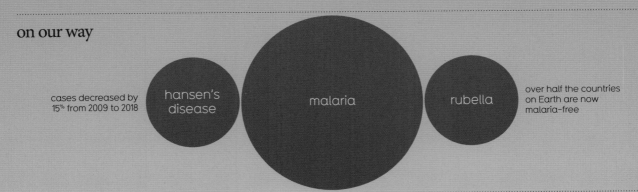

cases decreased by 15% from 2009 to 2018

hansen's disease

malaria

rubella

over half the countries on Earth are now malaria-free

progress!

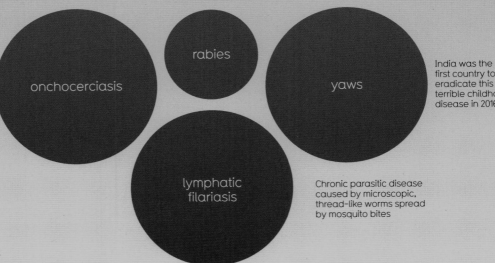

aka "elephantiasis," a lesser-known tropical disease spread by mosquitoes

onchocerciasis

rabies

yaws

India was the first country to eradicate this terrible childhood disease in 2016

lymphatic filariasis

Chronic parasitic disease caused by microscopic, thread-like worms spread by mosquito bites

nearly...

'sleeping sickness' spread by tsetse flies

African trypano-somiasis

polio

guinea-worm disease

terrible affliction spread by contaminated drinking water

eradicated

smallpox

 size = global impact of disease

sources: World Health Organisation, Our World in Data

Quick Quiz

What % of people in the world...

See next page
for answers

...live in extreme poverty ?

...can now read and write ?

...live in high- or middle-income nations ?

...have some access to electricity ?

Overall, compared to 25 years ago,
do you think the world today is

worse ?
the same ?
better ?
substantially better ?

Quick Quiz: Answers

How close were you?

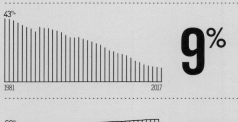

43% **9%**

1981 — 2017

69% **86%**

1978 — 2016

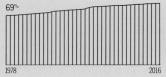

91%

71% **89%**

1990 — 2017

beautiful news

source: Our World in Data

These People Donate $1 Billion Every...

 61 DAYS
MacKenzie Scott

 126
Warren Buffet

 184
Bill & Melinda Gates

 227
Priscilla Chan & Mark Zuckerberg

 586
George Soros

 606
Michael Bloomberg

 7.5 YEARS
Jeff Bezos

 20 YEARS
Elon Musk

% of Net Worth Given Away

16%
Warren Buffet

10%
MacKenzie Scott

9%
Bill & Melinda Gates

5%
Michael Bloomberg

0.1
(before 2020)

5%
Jeff Bezos
(after 2020)

2%
Priscilla Chan &
Mark Zuckerberg

37%
George Soros

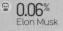 **0.06%**
Elon Musk

sources: World Economic Forum, EcoWatch, *New York Times*

Finland Is Teaching Kids to Identify Fake News

Professional methods are taught across all subjects

AWARENESS

CRITICAL THINKING

RESEARCH SKILLS

Finland Has Europe's highest media literacy

Index on how resilient a country's population is to fake news

Country	Value
Finland	76
Denmark	
Netherlands	70
Sweden	
Estonia	
Ireland	
Belgium	
Germany	
Iceland	
UK	60
Slovenia	
Austria	
Spain	
Luxembourg	
Portugal	
France	
Latvia	
Poland	
Czech Rep.	
Lithuania	
Italy	50
Slovakia	
Malta	
Croatia	
Cyprus	
Hungary	40
Greece	
Romania	
Serbia	
Bulgaria	30
Montenegro	
Bosnia	
Albania	
Turkey	
N. Macedonia	10

source: Open Society Institute (Bulgaria)

We Are Starting to Ban Fossil-Fuel Vehicles

● all cars ○ new cars

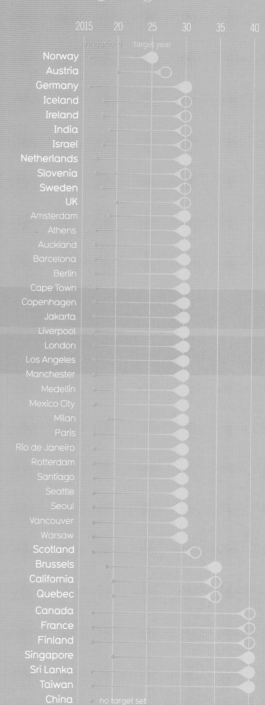

2015 20 25 30 35 40

announced target year

Norway
Austria
Germany
Iceland
Ireland
India
Israel
Netherlands
Slovenia
Sweden
UK
Amsterdam
Athens
Auckland
Barcelona
Berlin
Cape Town
Copenhagen
Jakarta
Liverpool
London
Los Angeles
Manchester
Medellín
Mexico City
Milan
Paris
Rio de Janeiro
Rotterdam
Santiago
Seattle
Seoul
Vancouver
Warsaw
Scotland
Brussels
California
Quebec
Canada
France
Finland
Singapore
Sri Lanka
Taiwan
China no target set

sources: *Guardian*, BBC, *Independent* and others

Millions of Children's Lives Have Been Saved

East Asia & Pacific Europe & Central Asia Latin America & Caribbean

Middle East & North Africa South Asia Sub-Saharan Africa

725
per day

265,000
per year

7.2m
over 25 years
source: Our World in Data

Millions of Children's Lives Are Being Saved

Preterm Infant Deaths Are Down
Deaths per 100,000 babies

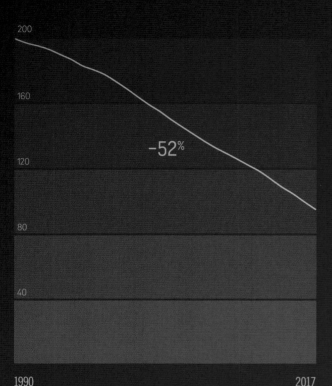

200

160

–52%

120

80

40

1990 2017

source: Our World in Data

Newborn Deaths Have Halved
Deaths per 1,000 live births

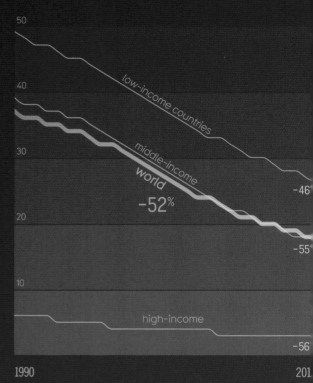

50

40 low-income countries

30 middle-income
 world
 –52% –46°

20 –55°

10

 high-income –56

1990 201

source: World Bar

Every Disease that Kills Children Is Declining
% reduction in the last decade

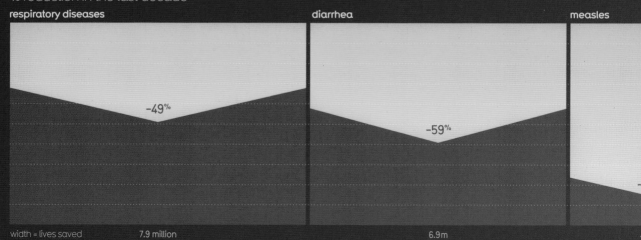

respiratory diseases

–49%

diarrhea

–59%

measles

width = lives saved 7.9 million 6.9m

Infant Deaths Have More than Halved
Deaths per 1,000 births wordwide

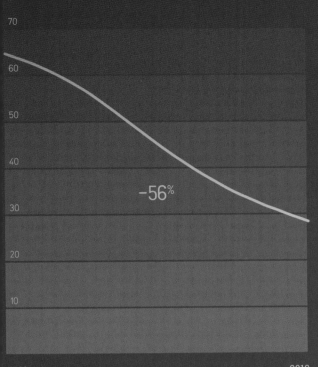

70

60

50

40

−56%

30

20

10

1990 2019

source: World Bank

Child Deaths Declined Worldwide
% of children dying before five years old

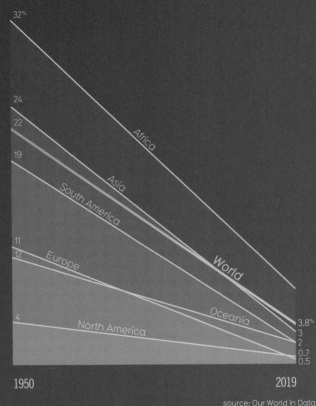

32%

24

22

19

Africa

Asia

South America

11

12

Europe

World

4

North America

Oceania

3.8%
3
2
0.7
0.5

1950 2019

source: Our World in Data

26 million lives saved

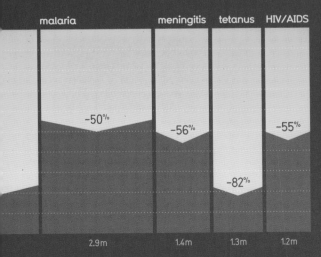

malaria meningitis tetanus HIV/AIDS

−50%

−56%

−55%

−82%

2.9m 1.4m 1.3m 1.2m

source: World Health Organization

What Children Die From
Thousand deaths per year

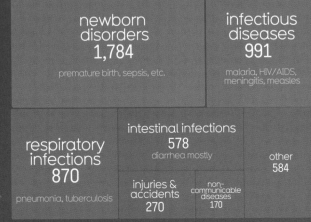

newborn disorders
1,784
premature birth, sepsis, etc.

infectious diseases
991
malaria, HIV/AIDS, meningitis, measles

respiratory infections
870
pneumonia, tuberculosis

intestinal infections
578
diarrhea mostly

injuries & accidents
270

non-communicable diseases
170

other
584

source: Our World in Data

How Have Child Deaths Been Reduced?

 better education of women

 increasing spending

 higher-quality healthcare

 improving health knowledge

Child Deaths & the Education of Mothers Are Interrelated

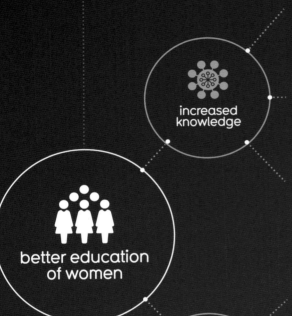 better education of women

increased knowledge

information exposure
mother better informed about issues through media & reading

health intelligence
grounding in the key understanding of health

less fatalistic
more understanding, less afraid of health outcomes

 more empowerment

more contro

better interactions
medical staff more likely to listen to educated mothers

more confident
handling bureacracy, decisions, choices, etc.

can also ignore outdated advice from family members

more choices

smaller families
educated mothers have fewer children

age of pregnancy
not too early, not too late decrease childbearing risk

birth spacing
fewer kids, more recovery time, fewer injuries, less risk of death during childbirth

may choose to become a health professional and help other mothers

increasing
education

rising
prosperity

declining
poverty

Educated mothers more
likely to receive:
• prenatal care
• immunizations
• trained personnel at
their deliveries

**better birth
outcomes**

MOTHER
SURVIVES

baby's health
thrives

proper feeding
educated mothers have
fewer children

immunization
not too early, not too late
decrease childbearing risk

diarrhea medicine
Educated mothers use
oral rehydration salts

incredibly affordable &
simple intervention that
saves children's lives

diarrhea kills

10%of kids
under five

but since 2000
deaths have declined

source: E. Gakidou et al., Lancet 2010

More Girls Are in School

Female & Male Literacy Rates Have Almost Equalized Worldwide

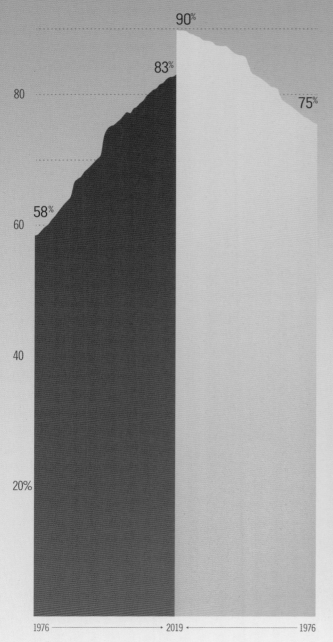

100

90%

83%

80

75%

60

58%

40

20%

1976 → 2019 ← 1976

Girls Not in Primary School Have Fallen to an All-Time Low

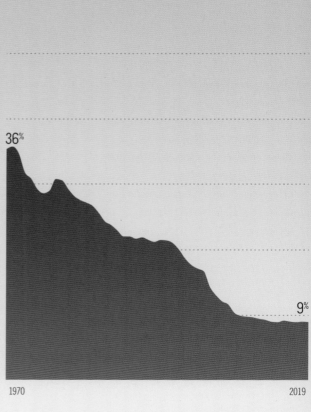

36%

9%

1970

2019

Even More Girls Are Enrolling in Secondary School

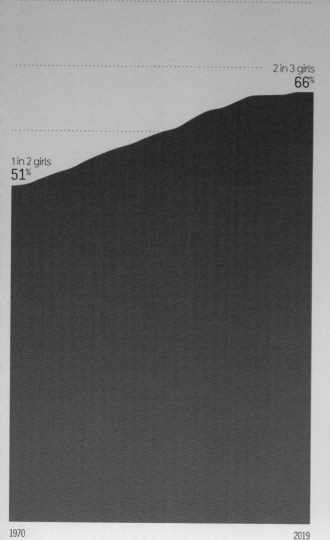

2 in 3 girls
66%

1 in 2 girls
51%

1970

2019

The Education Gender Gap between Girls & Boys Is Closing

% completing school

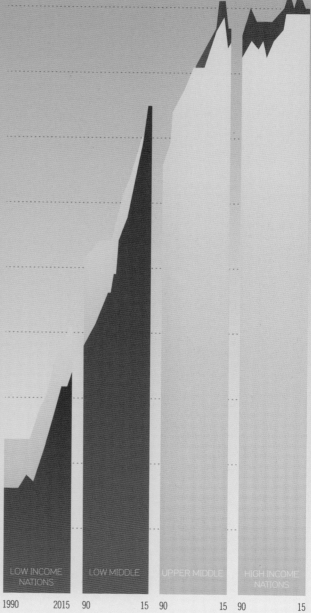

LOW INCOME
NATIONS

LOW MIDDLE

UPPER MIDDLE

HIGH INCOME
NATIONS

1990

2015

90

15

90

15

90

15

source: World Bank

Things Going Up! Up! Up!
improving substantially, globally

Life Expectancy
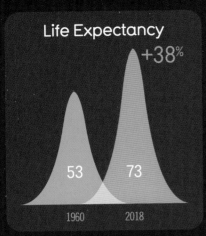
+38%
53 — 1960
73 — 2018

Domestic Violence Laws
% countries covered
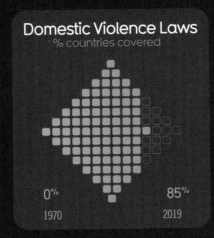
0% — 1970
85% — 2019

Leaf Area
% increase per decade
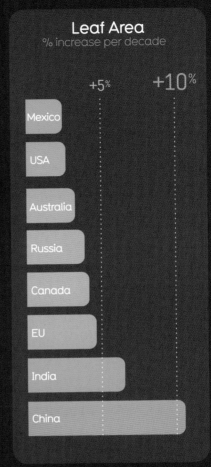
+5% +10%
Mexico
USA
Australia
Russia
Canada
EU
India
China

Global Health Spending
$ per person
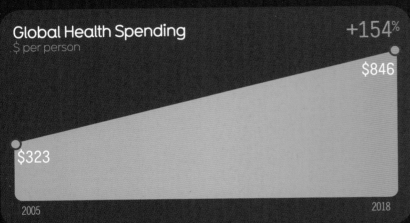
+154%
$846
$323
2005 — 2018

Meat Substitutes
yearly revenue $bn
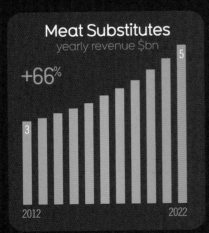
+66%
3
5
2012 — 2022

Same-Sex Union
countries where legal
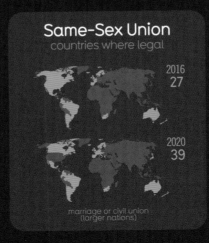
2016 — 27
2020 — 39
marriage or civil union
(larger nations)

Global Literacy
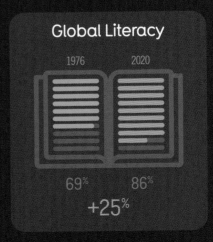
1976 2020
69% 86%
+25%

sources: NASA, Our World in Data, World Bank

The Happiest Countries in the World?

Senegal Mozambique Ethiopia
Nigeria Uruguay N.Macedonia Czech Republic
Chad
Myanmar **United Arab Emirates** Zambia
Panama Brazil Tajikistan **New Zealand** Indonesia
Uzbekistan Vietnam Algeria
Portugal Bosnia & Herzegovina **Canada** Kuwait Taiwan Malta
Dominican Republic Iraq Lebanon Mauritius
Niger Mauritania **Denmark** Liberia Serbia
Spain **Germany** El Salvador
Saudi Arabia Albania Mongolia Kenya Japan **Ireland** Georgia
Botswana Chile **Israel Iceland Costa Rica**
Libya China
Iran Kosovo Jamaica Slovenia Cyprus
Madagascar Uganda Peru Bangladesh Namibia Laos DR Congo South Korea
India Montenegro **Switzerland** Guatemala Cambodia
Gabon South Sudan Italy Romania Jordan Benin Colombia
France Sri Lanka **Netherlands** Belgium Ukraine
Croatia Russia Morocco
Azerbaijan United States Guinea Slovakia Yemen Pakistan
Mexico Haiti **Austria** Hungary
Belarus **Sweden Norway** Greece
Moldova Kyrgyzstan Latvia
Nicaragua Egypt Argentina Sierra Leone Togo Tunisia
Estonia Mali Nepal Palestine
Luxembourg Finland Cameroon Turkey
Philippines Afghanistan Armenia Lithuania
Turkmenistan Central African Republic Ghana
Bulgaria Malawi **Australia** Zimbabwe **Honduras**
Singapore **United Kingdom** Trinidad & Tobago
Ecuador South Africa
Bahrain Burkina Faso Thailand Kazakhstan
Hong Kong Congo Ivory Coast
Poland Tanzania **Bolivia**

source: The World Happiness Report 2020

But these ratings use a Western definition of 'happiness'

↑ Which centers more on 'vertical' feelings
of individualism & 'independence' ↑

known as independent **happiness**

FACTORS

freedom
autonomy to do what
I want, when I want,
how I want

thrilling experiences
pleasure-seeking,
novelty, intensity,
variety

positive emotions
intense high-arousal
feelings like excitement,
cheerfulness

achievement
success, recognition,
material gains, often linked
to hard work

individualism
my journey
my story
my life

positivity
preferably full or
overflowing with
no negative feelings

development
growth, self-improvement
in a linear fashion with an
individualized 'purpose'

self-esteem
an ongoing internal
feeling of
personal value

Different cultures have differing definitions of 'happiness'

← For instance, Eastern happiness is more 'horizontal',
focusing on relationships & connections →

known as interdependent **happiness**

FACTORS

social harmony
sychronizing with others,
not causing problems
or stress for others

relationships
meaning & purpose
through nurtured
social connections

low arousal
stability, absence
of major anxieties
or concerns

interpersonal goals
improving relationships,
focus on making
others happy

collectivism
feeling of being part
of a much larger
whole

ordinariness
similarity with others,
just catching up
with others

equity
equality of
accomplishment
with one's peers

'obedience'
being able to meet
others' expectations
of oneself

source: Hitokoto 2014, JICA Ogata Sadako Research Institute for Peace & Development

The Happiest Countries in the World
in terms of 'interdependent happiness'
countries highly ranked on both scales

Lithuania France
Germany Switzerland
Slovakia Netherlands Pakistan
Sweden Estonia Malaysia Palestine
Vietnam Chile Nigeria Portugal Bulgaria
Greece Turkey Serbia Thailand
Canada Romania USA South Africa
Jordan Italy Bolivia Peru UK Japan
Uganda Slovenia China Norway Czechia
Poland Israel Mexico Croatia Colombia
Ukraine Taiwan India Senegal Kenya
Hungary Denmark Brazil Russia Philippines
Latvia Spain S.Korea Georgia
Austria Indonesia
Argentina Belgium Hong Kong
New Zealand Singapore
Australia
N.Macedonia

note: not all nations have been rated for interdependent happiness, so may be missing

source: Cross-Cultural Happiness, Gardiner et al, 2020

Global Flavors of Happiness & Contentment

putuwa

Warming one's hands by the fire
while gently squeezing
someone else's hands

GADIGAL
(aboriginal)

عشرة

eshra

Connectedness and obligations
arising from people having
known each other a long time

ARABIC

정

jeong/jung

Deep affection, affinity,
connectedness
(not necessarily romantic)

KOREAN

Gjensynsglede

"goodbye happiness"
the joy of meeting someone you
haven't seen in a long time

NORWEGIAN

gemas

A feeling of love or affection, the
urge to squeeze someone because
they are so cute

INDONESIAN

gadugi

Cooperative labor,
working together for the
common good

CHEROKEE

Freudentaumel

"joy swash"
being giddy or delirious with
happiness

GERMAN

Arbejdsglaede

"work gladness"
Pleasure and satisfaction derived
from work

DANISH

vakasteglok

Taking care of one's parents, 'in return', in recognition and gratitude for the care they took of us in the past

MWOTLAP
(VANATU)

静寂
Seijaku

Quiet (*sei*) tranquility (*jaku*) Silence, calm & serenity, especially in the midst of chaos

JAPANESE

靠譜
Kào pǔ

Reliable, responsible; able to do things without causing problems

CHINESE

ᐃᓄᖃᑎᒌᑦᑎᐊᕐᓂᖅ
Inuuqatigiittiarniq

Being respectful of all people; healthy communities; neighborliness; living in peace and harmony with others

INUKITUT
(Canadian Inuit)

teash

A valued condition of being in balance with the community and the wider world

MONGOLIAN

shalev

Calm, peaceful, quiet, at ease

HEBREW

tarruru

Evening glow, dying down, peace of mind

NGARLUMA
(aboriginal)

น้ำใจ
nam jai

"water from the heart" selfless generosity and kindness

THAI

關係
Guān xì

Cultivating relationships & reciprocal connections, social karma, generosity or an act of mutual assistance.

CHINESE

source: The Positive Lexicography Project by Dr Tim Lomas

Transgender Rights Are Spreading

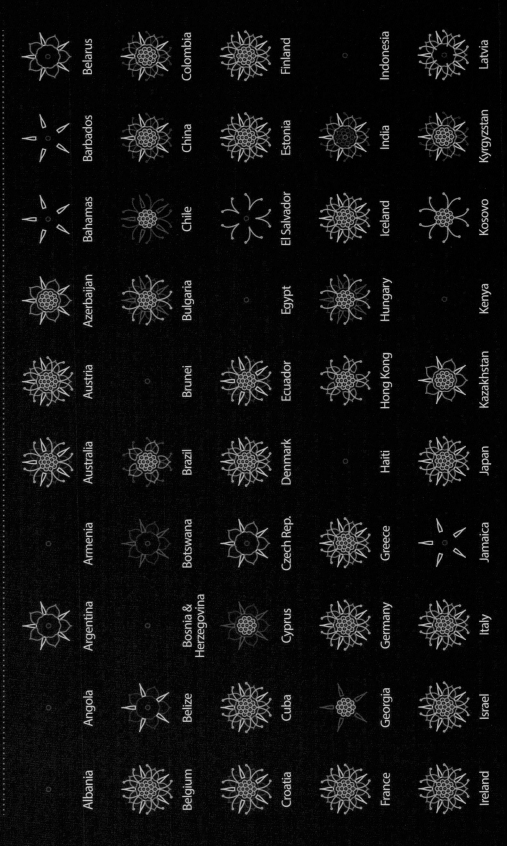

Legend

Legal change
of name possible

Legal change of gender
registration possible

Hormones taken with
medical supervision

Gender reassignment
surgery / treatment available

Faded shapes mean
some restrictions apply

Albania	Angola	Argentina	Armenia	Australia	Australia	Austria	Azerbaijan	Belarus
Belgium	Belize	Bosnia & Herzegovina	Botswana	Brazil	Brunei	Bulgaria	Bahamas	Barbados
Croatia	Cuba	Cyprus	Czech Rep.	Denmark	Ecuador	Egypt	Chile	China
France	Georgia	Germany	Greece	Haiti	Hong Kong	Hungary	El Salvador	Estonia
Ireland	Israel	Italy	Jamaica	Japan	Kazakhstan	Kenya	Iceland	Finland
							India	Indonesia
							Kosovo	Kyrgyzstan
								Latvia

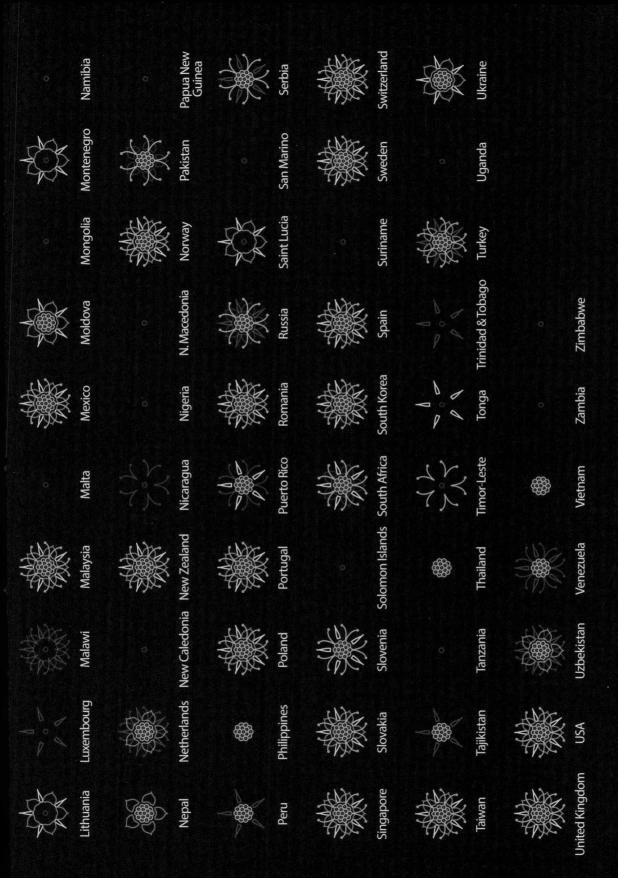

Lithuania

Luxembourg

Malawi

Malaysia

Malta

Mexico

Moldova

Mongolia

Montenegro

Namibia

Nepal

Netherlands

New Caledonia

New Zealand

Nicaragua

Nigeria

N. Macedonia

Norway

Pakistan

Papua New Guinea

Peru

Philippines

Poland

Portugal

Puerto Rico

Romania

Russia

Saint Lucia

San Marino

Serbia

Singapore

Slovakia

Slovenia

Solomon Islands

South Africa

South Korea

Spain

Suriname

Sweden

Switzerland

Taiwan

Tajikistan

Tanzania

Thailand

Timor-Leste

Tonga

Trinidad & Tobago

Turkey

Uganda

Ukraine

United Kingdom

USA

Uzbekistan

Venezuela

Vietnam

Zambia

Zimbabwe

Hundreds of New Vaccines Are in the Pipeline

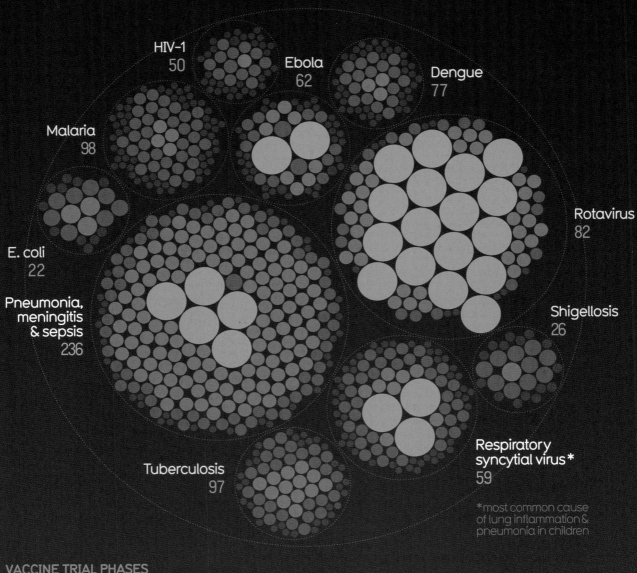

HIV-1
50

Ebola
62

Dengue
77

Malaria
98

Rotavirus
82

E. coli
22

Pneumonia,
meningitis
& sepsis
236

Shigellosis
26

Tuberculosis
97

Respiratory
syncytial virus *
59

*most common cause
of lung inflammation &
pneumonia in children

VACCINE TRIAL PHASES
average development time

stage

I Is it safe for humans?
2 yrs

II Are there any side effects?
2.5 yrs

III Does it work in the real world?
7.5 yrs

Approval
2 yrs

IV Released, monitored for adverse effects
lifelong

Vaccines Work!

Thousand cases per year before and after vaccine introduction

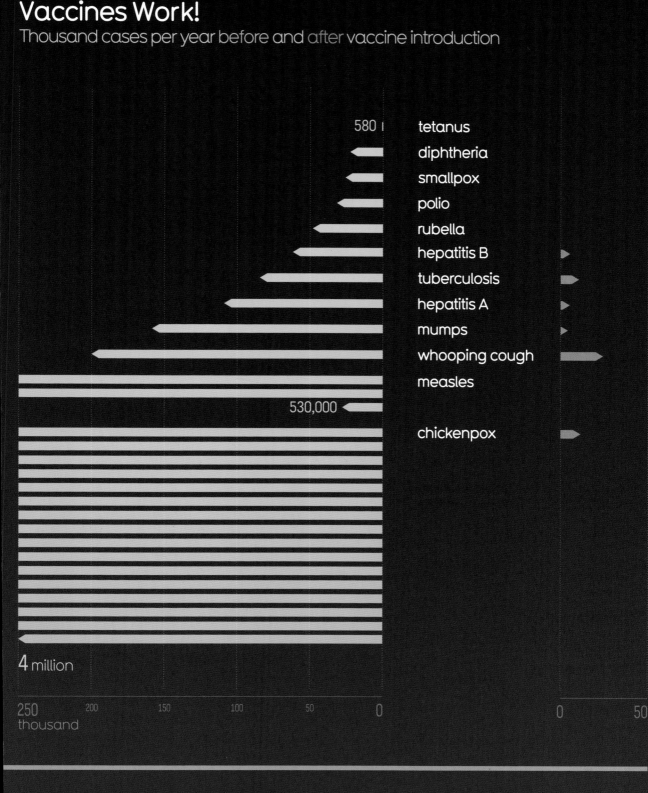

580

tetanus

diphtheria

smallpox

polio

rubella

hepatitis B

tuberculosis

hepatitis A

mumps

whooping cough

measles

530,000

chickenpox

4 million

250 thousand 200 150 100 50 0 0 50

sources: World Health Organization, EU Vaccine Initiative, Global Burden of Disease Collaborative Network, US Centers for Disease Control

Lives Saved by Vaccines in the Last 25+ Years
Global deaths from vaccine-preventable diseases

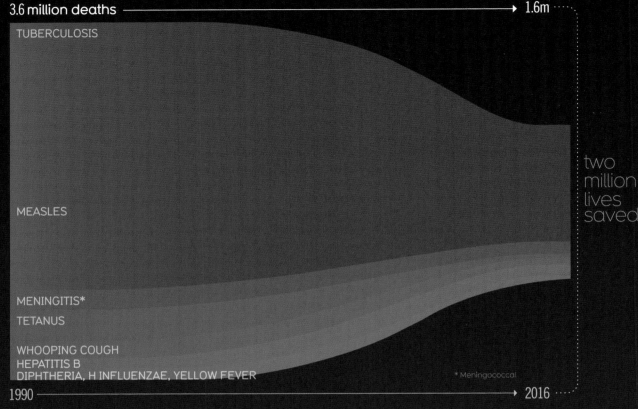

3.6 million deaths → 1.6m

TUBERCULOSIS

MEASLES

MENINGITIS*

TETANUS

WHOOPING COUGH
HEPATITIS B
DIPHTHERIA, H INFLUENZAE, YELLOW FEVER

* Meningococcal

two
million
lives
saved

1990 → 2016

They Are a Great Economic Investment
For every dollar invested in lower-income countries

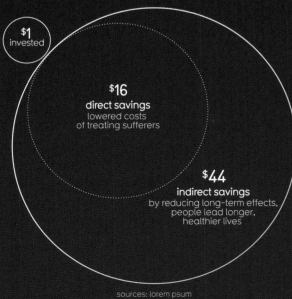

$1
invested

$16
direct savings
lowered costs
of treating sufferers

$44
indirect savings
by reducing long-term effects,
people lead longer,
healthier lives

sources: lorem psum

COVID Vaccines Save Millions of Lives
Estimated 75%-80% reduced death rate worldwide

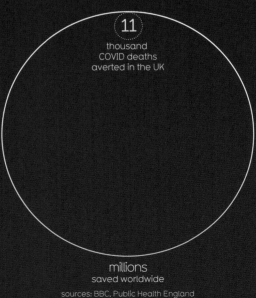

11
thousand
COVID deaths
averted in the UK

millions
saved worldwide

sources: BBC, Public Health England

Indigenous Communities Safeguard the Forests of the World

Forest owned by Indigenous communities has risen 40%

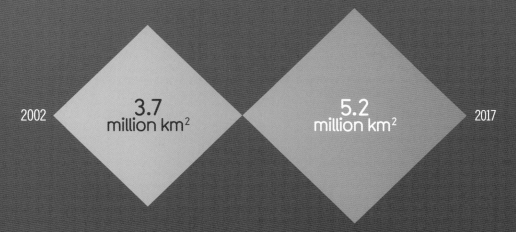

2002

3.7
million km$^2$

5.2
million km$^2$

2017

Good thing, because forests like these store
1,080 billion tonnes of CO2

Humanity's yearly CO2 emissions: 32bn

Deforestation emissions are much lower on these lands, meaning forests are now safer

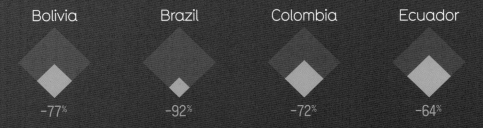

Bolivia	Brazil	Colombia	Ecuador
–77%	–92%	–72%	–64%

sources: RightsandResources.org, ForestLivelihoods.org

Creative Ways to Deal with Our Emissions

Iceland Is Injecting Carbon Emissions Deep Underground
Forming minerals that last millions of years

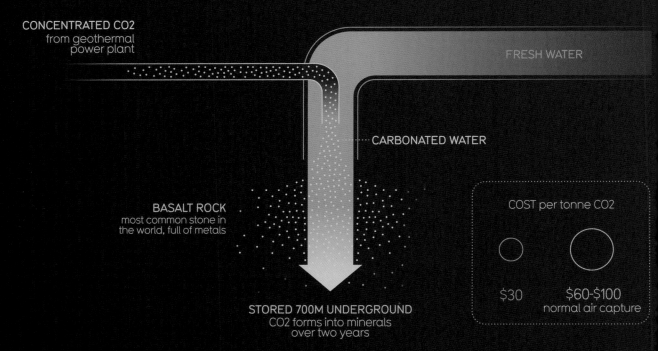

CONCENTRATED CO2
from geothermal
power plant

FRESH WATER

CARBONATED WATER

BASALT ROCK
most common stone in
the world, full of metals

STORED 700M UNDERGROUND
CO2 forms into minerals
over two years

COST per tonne CO2

$30

$60-$100
normal air capture

sources: BBC, RTE

Home Methane Digesters Can Replace Inefficient Cookstoves

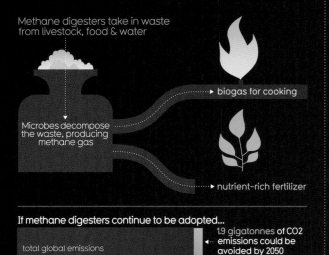

Methane digesters take in waste
from livestock, food & water

▶ biogas for cooking

Microbes decompose
the waste, producing
methane gas

▶ nutrient-rich fertilizer

If methane digesters continue to be adopted...

total global emissions

1.9 gigatonnes of CO2
emissions could be
avoided by 2050

source: Project Drawdown

Coral-Like Bioconcrete Generates Zero Emissions

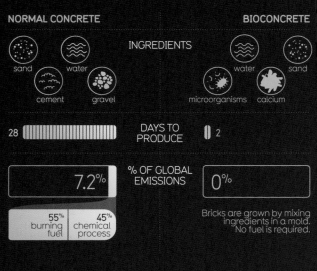

NORMAL CONCRETE BIOCONCRETE

INGREDIENTS

sand water water sand

cement gravel microorganisms calcium

28 ||||||||||||||||||||||||||||| DAYS TO ▌ 2
 PRODUCE

7.2% % OF GLOBAL 0%
 EMISSIONS

55% 45%
burning chemical
fuel process

Bricks are grown by mixing
ingredients in a mold.
No fuel is required.

sources: *Wired* UK, Biomason, WRI, Chatham House

'Bling without Sting'
Storing CO2 as Diamonds

carbon dioxide captured from the air

high-pressure chemical reaction

using wind & renewable energy

creates an
ECO-DIAMOND

each carat removes
20 tonnes
of CO2

EMISSIONS PER PERSON PER YEAR				
5	7		13	17
UK	CHINA & EU		CANADA	USA

The 'Whale Pump' Could Be the Ultimate Natural Carbon Sink

fecal plumes from whales
rich in nitrogen and iron

feed surface phytoplankton
microscopic algae

who capture 40% of our emissions
equivalent of 1.7 trillion trees

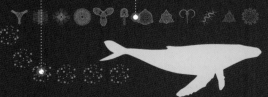

each whale
$2
MILLION
in carbon capture

whales also accumulate
33 tonnes
of carbon in their bodies

stored in the deep ocean when they die

all whales
$1
TRILLION
world wide

sources: *Scientific American*, International Monetary Fund

New Cookstoves Are Safer, Last Longer & Reduce Emissions

40%
of the world's population cook over open fires, using unhealthy fuels like...

wood animal dung charcoal crop residues coal

smoke from these fuels has negative effects

deaths		emissions
HEART DISEASE	9.4m	
INDOOR AIR POLLUTION	4.3m	2% to 5% global green-house gases
DIABETES	1.6m	
ROAD ACCIDENTS	1.4m	

1.5 million households already use a new improved stove that cuts emissions by

95%

reduced smoke & soot means fewer deaths from air pollution

secondary oxygen intake
forces gases & smoke back into flames, increasing efficiency

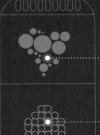

wood gas

solid fuel
wood pellets, not always easy to obtain

primary oxygen intake

sources: Project Drawdown, *Scientific American*, energypedia.info

Yay UK!

Biodiversity
Is Flourishing in the Thames

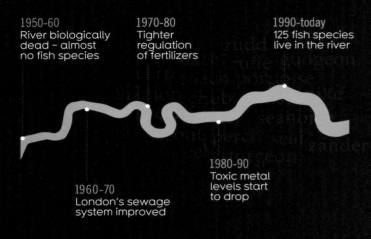

1950-60
River biologically dead - almost no fish species

1970-80
Tighter regulation of fertilizers

1990-today
125 fish species live in the river

1960-70
London's sewage system improved

1980-90
Toxic metal levels start to drop

sources: BBC, Zoological Society of London, Port of London Authority

UK Teen Pregnancies
Hit a Record Low

Births per 1,000 women aged 15-19

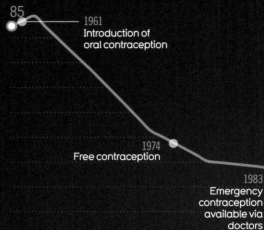

85

1961
Introduction of oral contraception

1974
Free contraception

1983
Emergency contraception available via doctors

1960

UK's Carbon Emissions Are Falling Fast
Thanks to cleaner electricity and declining energy use

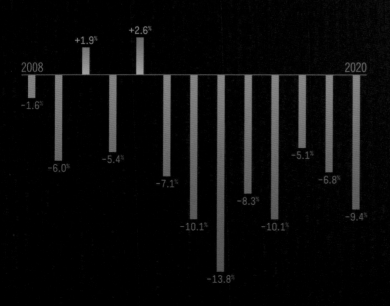

2008

+1.9%
+2.6%

-1.6%
-6.0%
-5.4%
-7.1%
-10.1%
-13.8%
-8.3%
-10.1%
-5.1%
-6.8%
-9.4%

2020

Coal Use Is Being Cut, Fast
% of energy mix

43

2012 2014

source: mygridGB

Smoking in Pregnancy Down

% smokers at time of delivery

15%

10%

2006-07 2016-17

source: BBC

−85%

13

2001
Available
over the counter

2018

source: World Bank

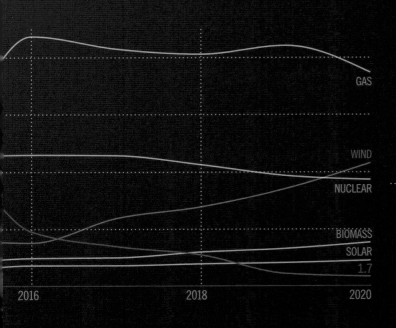

GAS

WIND

NUCLEAR

BIOMASS

SOLAR

1.7

2016 2018 2020

source: MyGridGB

Biggest Offshore Wind Farms

UK, Netherlands, Germany

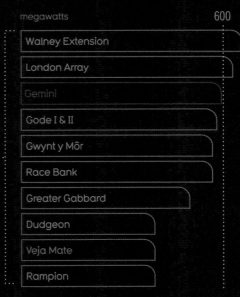

megawatts 600

| Walney Extension |
| London Array |
| Gemini |
| Gode I & II |
| Gwynt y Môr |
| Race Bank |
| Greater Gabbard |
| Dudgeon |
| Veja Mate |
| Rampion |

source: *The Guardian*

Women

More Women Are in Government Around the World

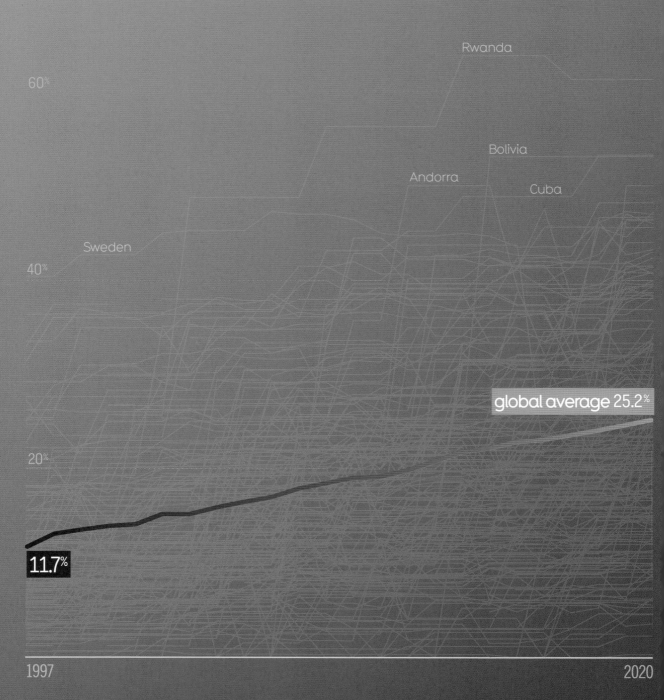

Rwanda

Bolivia

Andorra

Cuba

Sweden

60%

40%

global average 25.2%

20%

11.7%

1997

2020

source: World Bank

There Have Never Been More Female CEOs
In the Fortune 500

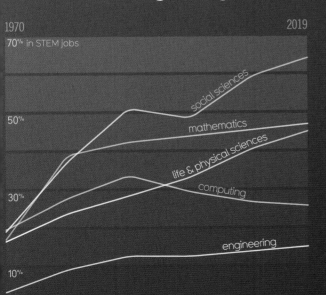

2020

37

1998

source: *Fortune*

Women's Economic Freedom Is Protected Almost Everywhere

Women, Business & the Law Index
assigns a score based on laws that affect women's economic opportunities across 8 key areas

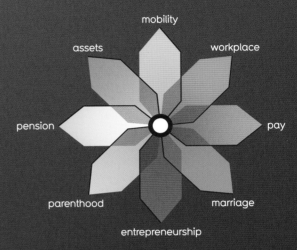

mobility

assets · workplace

pension · pay

parenthood · marriage

entrepreneurship

More US Women Are Moving into Science, Tech, Engineering & Math

1970 · 2019

70% in STEM jobs

social sciences

50%

mathematics

life & physical sciences

30%

computing

10%

engineering

source: United States Census Bureau

Overall Freedom Score by Country

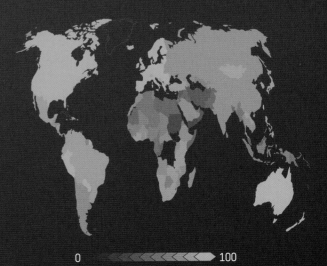

0 · 100

source: World Bank

Can Next-Gen Nuclear Energy Get Us to Carbon Zero?

PROS

 zero carbon
global-scale electricity with no greenhouse gas emissions

 consistent energy
backup when intermittent power like wind can't deliver

 established industry
already generates ~10% of the world's electricity

 small footprint
very little land required vs vast space for solar & wind

 quickest route
slash CO2, decarbonize in years not centuries

 need it now
difficult to imagine net carbon zero by 2050 without it

CONS

 radioactive waste
average plant creates 27 tonnes yearly, active for 24,000 years

 hugely expensive
More than $10bn to build. Can't compete with renewables on $$$

 old, aging tech
many reactors are 30-40 years old & beset with reliability issues

 big fear
the public is afraid of nuclear accidents, waste, weapons...

 reactors slow to build
takes 6-10 years – we'd need 100s now to replace fossil fuels

 regulatory holdups
approving, ensuring and testing new plants is a massive block

RESPONSES

 waste storage is possib
nations like Sweden have so established storage of pluto

some fear is irrational
 nuclear is much safer than c (kills 500K a year from polluti

Current State of Nuclear Energy Around the World

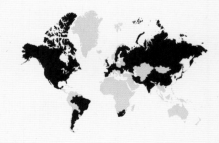

UK France
South Korea
China UAE
Finland Russia
India Turkey
Argentina

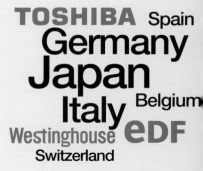
TOSHIBA Spain
Germany
Japan
Italy Belgium
Westinghouse eDF
Switzerland

436
reactors

31
countries

50
more being built

several
countries & companies phasing ou

Next-Gen Nuclear

ADVANCED REACTOR TYPES

dominant tech

PRESSURIZED WATER REACTOR

Super-heated water pumped into radioactive core. Resulting heat turns an electric turbine.

✕ CAN OVERHEAT & MELT DOWN, SO SAFETY A BIG OPERATIONAL COST

✕ INEFFICIENT – ONLY 1% OF POTENTIAL ENERGY HARVESTED

emerging tech

MOLTEN SALT REACTOR

Nuclear fuel dissolved in liquid salt at 600-700°C & circulated through the core

✔ VERY SAFE – REACTION SLOWS DOWN AUTOMATICALLY AS FUEL IS USED UP

✔ CAN RUN ON NUCLEAR WASTE OR SUPERABUNDANT THORIUM

experimental tech

TRAVELLING WAVE REACTOR

Simultaneously burns fuel & creates new fuel creating self-sustaining 'burn wave' of energy

✔ RUNAWAY REACTIONS IMPOSSIBLE

✔ NO REFUELLING NEEDED EVERY 2 YEARS

✔ RECYCLING! USES ITS OWN WASTE AS FUEL

problematic tech

FAST BREEDER REACTOR

Recycles the fuel repeatedly at very fast rates extracting more and more energy

✔ CAN RUN OFF PLUTONIUM NUCLEAR WASTE

✕ REQUIRES WASTE TO BE CONVERTED INTO AN EXPENSIVE METAL ALLOY

✕ THIS METAL COULD BE STOLEN OR DIVERTED

prototype tech

PEBBLE-BED HIGH-TEMP REACTOR

Fuel is packed into tennis-ball-sized spheres (pebbles) instead of fuel rods

✔ SAFE – PEBBLES BLOCK RADIOACTIVITY

✔ CAN BE CONTINUALLY FUELLED

✔ HIGH TEMPERATURE GENERATES EVEN MORE ELECTRICITY

SIZE VARIATIONS

SMALL MODULAR REACTORS

Compact, factory-produced nuclear modules that can be combined to increase output

50-300 megawatts
(mid-sized town)

✔ LESS UPFRONT $$$ NEEDED

✔ STANDARDIZED DESIGN, SO CHEAPER & QUICKER TO BUILD & MASS PRODUCE

✔ SMALL CORES LESS HOT, UNLIKELY TO OVERHEAT

Canada, China, Russia, UK, USA
all building SMRs

MICROREACTORS

Even smaller, super-portable power sources that can be transported by truck, ship or plane

1-20 megawatts
(small town)

✔ CAN RUN FOR 10 YEARS WITHOUT REFUELLING

✔ IDEAL FOR REMOTE LOCATION OR LOWER-INCOME NATIONS

✕ REQUIRE HIGHER-CONCENTRATION URANIUM FUEL SO NEEDS SPECIAL SUPPLY

sources: Yale School of Environment, *New York Times*, *Asia Times*, UIS Office of Nuclear Energy

Nuclear Fusion Could Supply Clean, Limitless Power
The Holy Grail of energy – if only we can make it happen

HOW IT WORKS

existing nuclear reactors create energy by splitting atoms apart (**fission**)

fusion smashes atoms together to reproduce the energy of the stars

creating a 'miniature sun' that generates more energy than it consumes

the hydrogen in a glass of water is enough energy for one person's lifetime

zero emissions, no carbon, no green-house gases, no global heating

much less **radioactive waste** vs traditional fission reactors (100s of years vs 1,000s)

very safe – there's no chance of meltdown plasma just cools if disrupted

IT'S NOT EASY

the fuel must be heated up to unbelievably high temperatures

MILLION DEGREES CENTIGRADE

- **15** temperature at the center of the sun
- 20
- 40
- 60
- 80
- **100** minimum temperature required for deuterium-tritium* fusion
- 120
- 140
- **150** operating temperature at ITER

* alternate forms of hydrogen (isotopes) required for fusion

the heat turns the fuel into a plasma

an energized mix of charged particles

a violently unstable state

must somehow be contained & controlled

WHEN IS IT COMING?

new ultra-powerful superconducting magnets

CREATE VASTLY STRONGER CONTAINMENT FIELDS

innovative liquid nitrogen cooling processes

MUCH CHEAPER THAN CURRENT LIQUID HELIUM

5-10

years is finally a credible ETA

AFTER 50 YEARS OF FALSE STARTS

novel materials able to withstand the plasma

REDUCED-ACTIVATION STEEL & TUNGSTEN

next-gen fusion techniques already emerging

STELLARATORS & LATTICE-CONFINEMENT

International Thermonuclear Experimental Reactor
ITER is the world's largest fusion megaproject

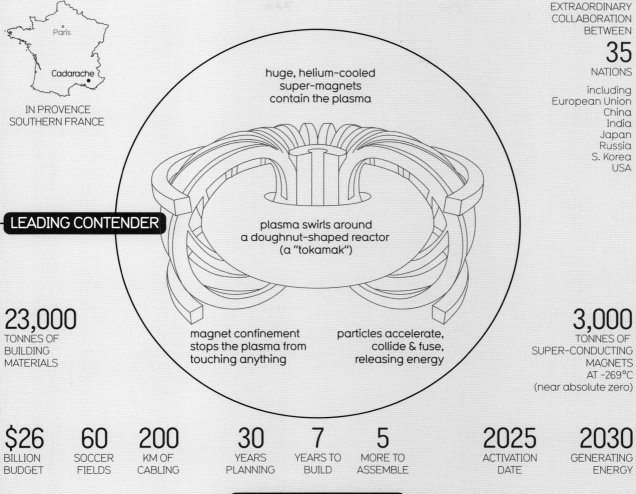

Paris

Cadarache

IN PROVENCE
SOUTHERN FRANCE

EXTRAORDINARY
COLLABORATION
BETWEEN

35
NATIONS

including
European Union
China
India
Japan
Russia
S. Korea
USA

huge, helium-cooled
super-magnets
contain the plasma

LEADING CONTENDER

plasma swirls around
a doughnut-shaped reactor
(a "tokamak")

23,000
TONNES OF
BUILDING
MATERIALS

magnet confinement
stops the plasma from
touching anything

particles accelerate,
collide & fuse,
releasing energy

3,000
TONNES OF
SUPER-CONDUCTING
MAGNETS
AT -269°C
(near absolute zero)

$26	**60**	**200**	**30**	**7**	**5**	**2025**	**2030**
BILLION BUDGET	SOCCER FIELDS	KM OF CABLING	YEARS PLANNING	YEARS TO BUILD	MORE TO ASSEMBLE	ACTIVATION DATE	GENERATING ENERGY

CREDIBLE ALTERNATIVE

Field Reverse Configuration (FRC) using hydrogen-boron as a fuel

hydrogen-boron
produces 3–4x
more energy

with virtually
zero waste

but requires
extraordinary
temperatures

5.4 BILLION DEGREES **!**
but actually feasible

in FRC, the hotter
the plasma,
the more stable

complete
opposite of a
tokamak

sources: World Economic Forum, EcoWatch, *New York Times*, BBC, Wikipedia, Bill Gates "How to Avoid a Climate Disaster"

At Least 100 Towns & Cities Now Get Most of Their Energy from Renewables

Reporting more than 70% green energy

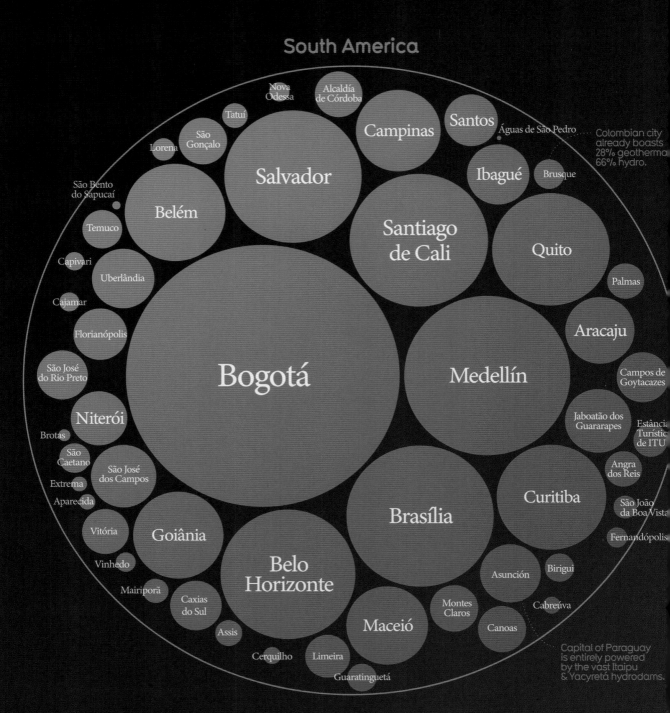

South America

Bogotá

Salvador

Santiago de Cali

Medellín

Belém

Belo Horizonte

Brasília

Goiânia

Curitiba

Quito

Campinas

Santos

Ibagué

Aracaju

Maceió

Niterói

Nova Odessa

Alcaldía de Córdoba

Tatuí

São Gonçalo

Lorena

Águas de São Pedro

Brusque

São Bento do Sapucaí

Temuco

Capivari

Uberlândia

Cajamar

Florianópolis

São José do Rio Preto

Brotas

São Caetano

Extrema

Aparecida

São José dos Campos

Vitória

Vinhedo

Mairiporã

Caxias do Sul

Assis

Cerquilho

Limeira

Guaratinguetá

Montes Claros

Asunción

Birigui

Cabreúva

Canoas

Palmas

Campos de Goytacazes

Jaboatão dos Guararapes

Estância Turística de ITU

Angra dos Reis

São João da Boa Vista

Fernandópolis

Colombian city already boasts 28% geothermal 66% hydro.

Capital of Paraguay is entirely powered by the vast Itaipu & Yacyretá hydrodams.

68|69

population

Asia

Inje

This South Korea city has pledged to 100% renewable energy by 2045.

North America

Vancouver

N. Vancouver

Seattle

Burlington

Prince George, BC

Montreal

León de los Aldamas

Chorrera Aspen Winnipeg Eugene

Became first city in the USA to run entirely on renewables in 2015.

This Colorado town is 100% renewable, including 53% wind!

Oceania

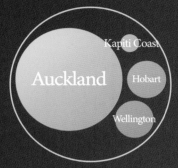

Auckland

Kapiti Coast

Hobart

Wellington

Africa

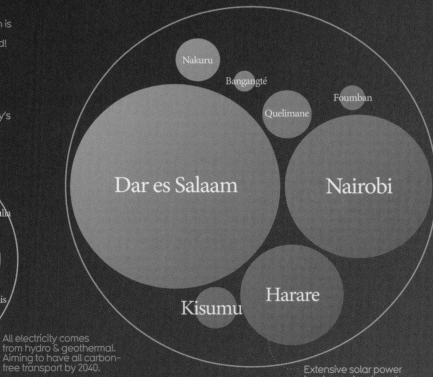

Nakuru

Bangangté

Quelimane

Foumban

Dar es Salaam

Nairobi

Kisumu

Harare

Extensive solar power has been developed to counter Zimbabwe's frequent power cuts.

Europe

Powered by the city's renewable energy company.

Gladsaxe Fafe

Arendal

Bærum Basel Zürich Braga

Moita Alba-Iulia

Porto Stockholm

Akureyri Cascais

Bolzano Reykjavík

Lausanne Oslo Nyon

Oristano

All electricity comes from hydro & geothermal. Aiming to have all carbon-free transport by 2040.

source: Carbon Disclosure Project

Every single country in the world has seen

Chad -56%
Burundi -60%
Central African Rep. -60%
DRC -63%
Nigeria -67%
Sierra Leone -71%
Turkmenistan -73%
Togo -76%
Uzbekistan -79%
Afghanistan -82%
Cambodia -87%
Morocco -89%

Guinea-Bissau -60%
Guyana -60%
Somalia -64%
Zimbabwe -69%
Tonga -72%
Kiribati -73%
Swaziland -76%
Haiti -79%
Ethiopia -82%
Saint Vincent and the Grenadines -86%
Fiji -89%

Niger -66%
Paraguay -67%
Cameroon -67%
Uganda -69%
Zambia -72%
Mali -74%
Melanesia -77%
Laos -80%
United States -82%
Jamaica -86%
Ecuador -89%

Mauritania -70%
Equatorial Guinea -70%
Djibouti -70%
Sudan -70%
Benin -72%
Mozambique -74%
Congo -77%
Channel Islands -80%
Argentina -83%
Moldova -86%
Denmark -89%

São Tomé and Príncipe -72%
Micronesia -73%
Lesotho -73%
South Sudan -73%
Guinea -74%
Burkina Faso -77%
Rwanda -80%
Gabon -83%
Honduras -87%
Curaçao -89%

Angola -75%
Trinidad and Tobago -75%
Comoros -75%
Papua New Guinea -75%
Ghana -76%
Malawi -78%
Tajikistan -80%
India -83%
Panama -86%
Western Sahara -89%

Cote d'Ivoire -78%
Tanzania -78%
Pakistan -78%
Bolivia -78%
Uruguay -78%
Liberia -79%
South Africa -80%
Madagascar -84%
Australia -87%
Netherlands -89%

World -80%
Kenya -80%
Philippines -81%
Azerbaijan -81%
Botswana -82%
Gambia -82%
Suriname -82%
Myanmar -84%
Vietnam -87%
Kyrgyzstan -89%

Yemen -84%
Aruba -85%
Namibia -85%
Eritrea -85%
New Zealand -85%
Armenia -85%
Senegal -86%
Solomon Islands -86%
United Kingdom -87%

Samoa -88%
Timor -88%
Polynesia -88%
Bahamas -88%
Guatemala -88%
Colombia -89%
United States Virgin Islands -88%
Georgia -88%
Cape Verde -87%
Canada -89%

Kazakhstan -90%
Mexico -90%
Belize -90%
Switzerland -90%
Sweden -90%
Bangladesh -90%
Palestine -90%
Vanuatu -90%
Algeria -90%
Nepal -90%

drops in infant and child mortality since 1950

Iraq -90%	Mongolia -91%	Jordan -93%	Ukraine -93%	France -94%	Finland -95%	Saudi Arabia -96%	Japan -97%	Réunion -98%
Bhutan -91%	Brazil -92%	Bulgaria -93%	French Guiana -93%	Turkey -94%	Russia -95%	Montenegro -95%	Estonia -97%	Mayotte -98%
Indonesia -91%	Romania -92%	Israel -93%	Tunisia -94%	Ireland -94%	Egypt -95%	Qatar -95%	Italy -96%	Portugal -98%
Dominican Republic -90%	Malta -92%	El Salvador -92%	Saint Lucia -93%	Thailand -94%	Martinique -95%	Iran -95%	Bosnia and Herzegovina -96%	Belarus -97%
Syria -91%	Guam -92%	Puerto Rico -92%	Brunei -94%	Hungary -94%	Cyprus -95%	Poland -95%	Taiwan -96%	Hong Kong -98%
Peru -90%	Norway -92%	Barbados -92%	Mauritius -93%	Sri Lanka -94%	Malaysia -95%	Czech Republic -95%	Bahrain -97%	Maldives -98%
Venezuela -91%	North Korea -92%	Libya -92%	Iceland -93%	N. Macedonia -94%	Cuba -95%	Austria -95%	Croatia -96%	South Korea -98%
Slovenia -91%	Grenada -92%	Albania -92%	Belgium -93%	Greece -94%	Chile -95%	Guadeloupe -96%	Spain -97%	Oman -97%
Lebanon -90%	Antigua and Barbuda -92%	New Caledonia -92%	Costa Rica -93%	China -94%	Germany -94%	Kuwait -95%	Macao -96%	Singapore -97%
Seychelles -90%	Nicaragua -92%	Serbia -93%	Luxembourg -94%	Slovakia -94%	Latvia -95%	French Polynesia -96%	Lithuania -97%	United Arab Emirates -98%

source: Our World in Data

How to get the world to NET CARBON ZERO * by 2050

***net carbon zero**

Doesn't necessarily mean zero emissions. There will still be some emissions — though massively reduced. But CO2 capture, offsetting and other methods will mean the overall emissions in the global or national system will be zero.

DEEP DECARBONIZATION
80–100% reduction
in global emissions

TWO ROUTES

100% renewables
wind & solar
supported by energy
storage, new grids
& transmission
systems

mix
wind & solar +
nuclear, geothermal
& limited fossil fuels

reduce
emissions

increase
efficiency

decarbonize
. energy

boost
carbon sinks

MAYBE

carbon
capture

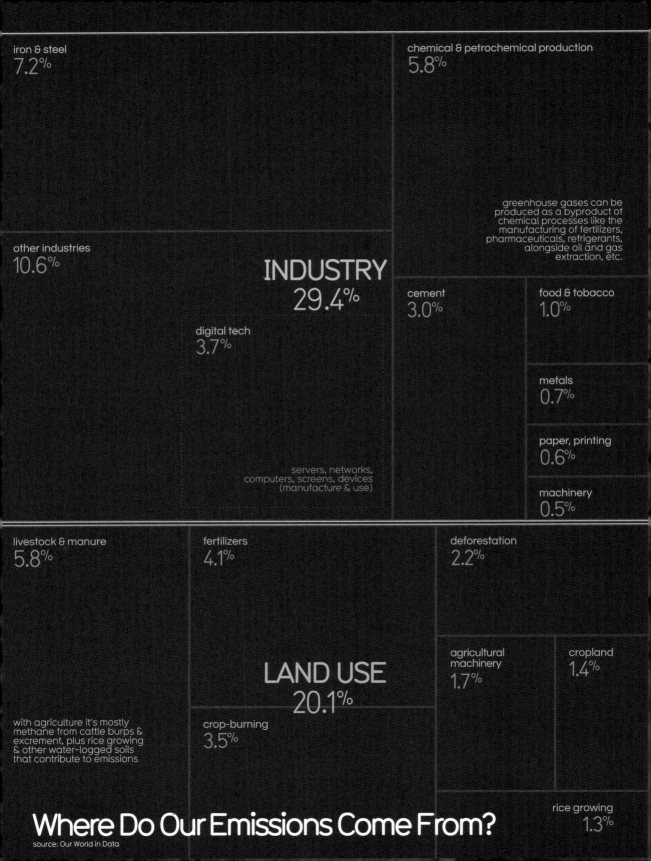

iron & steel
7.2%

chemical & petrochemical production
5.8%

greenhouse gases can be produced as a byproduct of chemical processes like the manufacturing of fertilizers, pharmaceuticals, refrigerants, alongside oil and gas extraction, etc.

other industries
10.6%

INDUSTRY
29.4%

digital tech
3.7%

cement
3.0%

food & tobacco
1.0%

metals
0.7%

paper, printing
0.6%

servers, networks, computers, screens, devices (manufacture & use)

machinery
0.5%

livestock & manure
5.8%

fertilizers
4.1%

deforestation
2.2%

LAND USE
20.1%

agricultural machinery
1.7%

cropland
1.4%

with agriculture it's mostly methane from cattle burps & excrement, plus rice growing & other water-logged soils that contribute to emissions

crop-burning
3.5%

rice growing
1.3%

Where Do Our Emissions Come From?

source: Our World in Data

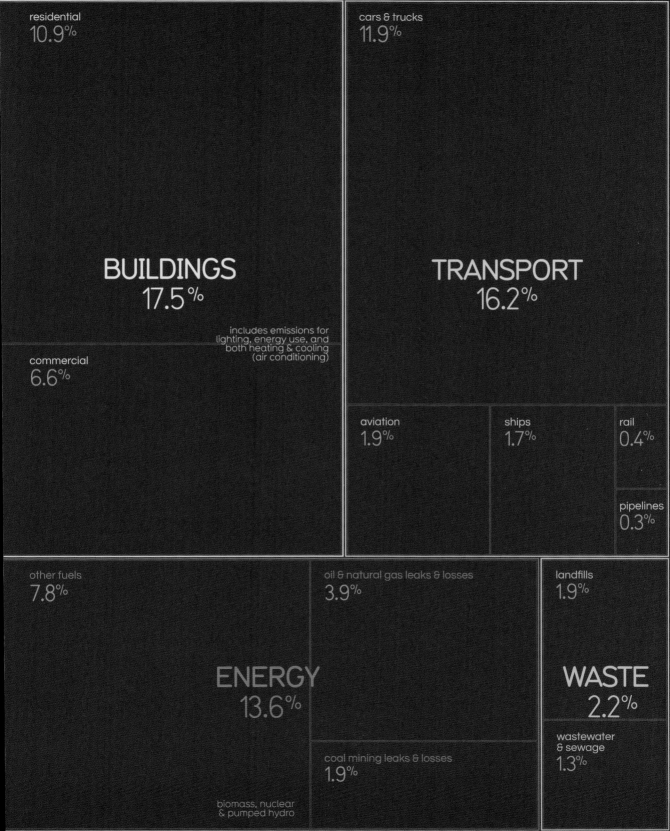

residential
10.9%

cars & trucks
11.9%

BUILDINGS
17.5%

includes emissions for
lighting, energy use, and
both heating & cooling
(air conditioning)

commercial
6.6%

TRANSPORT
16.2%

aviation
1.9%

ships
1.7%

rail
0.4%

pipelines
0.3%

other fuels
7.8%

oil & natural gas leaks & losses
3.9%

landfills
1.9%

ENERGY
13.6%

WASTE
2.2%

coal mining leaks & losses
1.9%

wastewater
& sewage
1.3%

biomass, nuclear
& pumped hydro

How to Halve Emissions by 2030

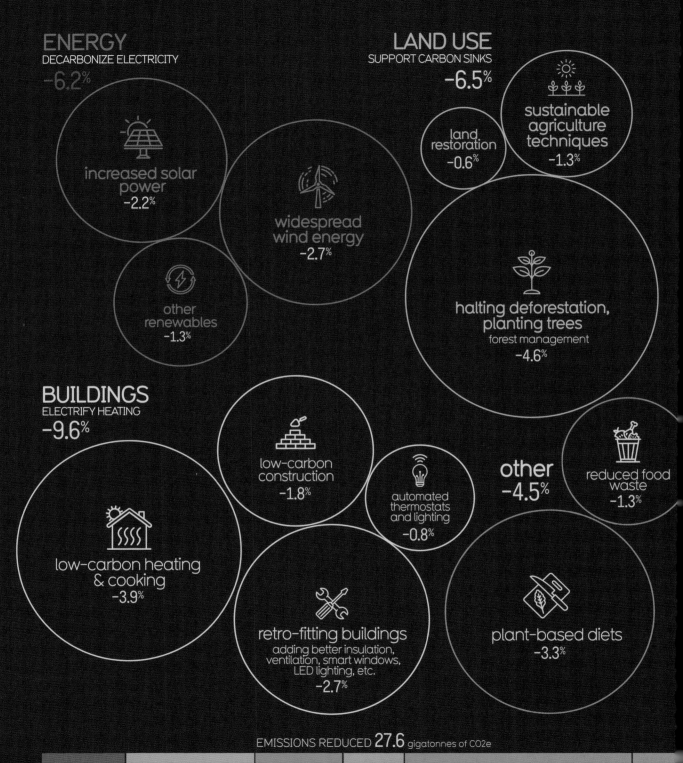

ENERGY
DECARBONIZE ELECTRICITY
-6.2%

increased solar power
-2.2%

widespread wind energy
-2.7%

other renewables
-1.3%

LAND USE
SUPPORT CARBON SINKS
-6.5%

land restoration
-0.6%

sustainable agriculture techniques
-1.3%

halting deforestation, planting trees
forest management
-4.6%

BUILDINGS
ELECTRIFY HEATING
-9.6%

low-carbon heating & cooking
-3.9%

low-carbon construction
-1.8%

automated thermostats and lighting
-0.8%

retro-fitting buildings
adding better insulation, ventilation, smart windows, LED lighting, etc.
-2.7%

other
-4.5%

reduced food waste
-1.3%

plant-based diets
-3.3%

EMISSIONS REDUCED **27.6** gigatonnes of CO2e

CO2e = carbon dioxide equivalent = a way of combining all greenhouse gas emissions in one measure

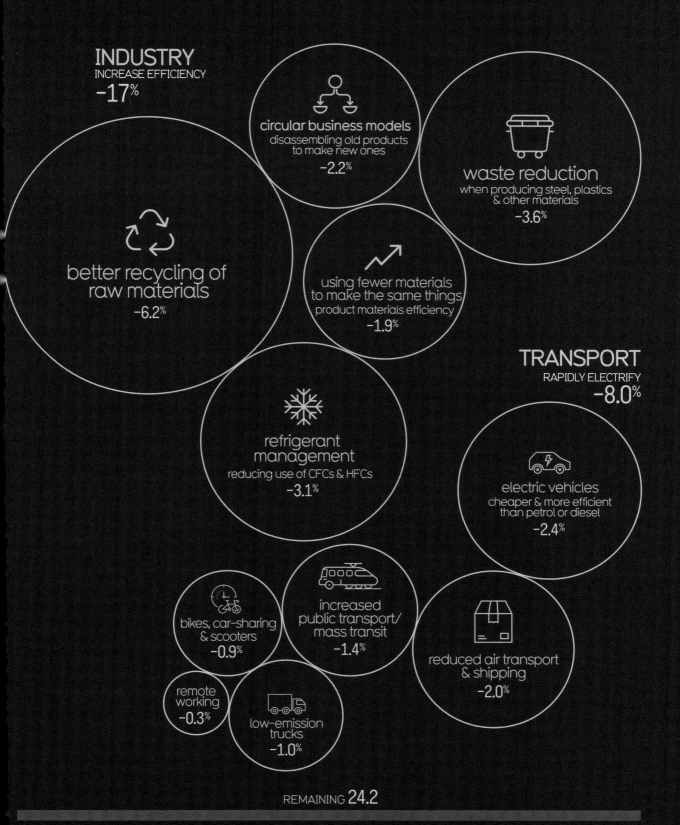

INDUSTRY
INCREASE EFFICIENCY
−17%

circular business models
disassembling old products
to make new ones
−2.2%

waste reduction
when producing steel, plastics
& other materials
−3.6%

**better recycling of
raw materials**
−6.2%

**using fewer materials
to make the same things**
product materials efficiency
−1.9%

TRANSPORT
RAPIDLY ELECTRIFY
−8.0%

**refrigerant
management**
reducing use of CFCs & HFCs
−3.1%

electric vehicles
cheaper & more efficient
than petrol or diesel
−2.4%

**bikes, car-sharing
& scooters**
−0.9%

**increased
public transport/
mass transit**
−1.4%

**reduced air transport
& shipping**
−2.0%

**remote
working
−0.3%**

**low-emission
trucks
−1.0%**

REMAINING **24.2**

sources: Our World in Data, Project Drawdown, ECOFYS, Exponential Climate Action Roadmap, IEA

Carbon Zero by 2050 Project Plan

ENERGY

renewables!
rapid upscale of renewable carbon-free electricity
(solar, wind, wave, geothermal)

▸174

install advanced smart- & micro-grids
so we can use the variable power of renewables

develop grid-scale electrical storage
huge batteries, basically

improve efficiency
so much energy is lost through inefficiency

extend electricity transmission networks
especially high voltage both above- and underground

expand clean 'firm' power
nuclear, hydro, geothermal

increase biofuel & hydrogen use
adding carbon capture

retire fossil-fuel power plants early

burn waste & convert it to power, capturing emissions
waste-to-energy

reduce individual consumption in richer nations

TRANSPORT

electric vehicles dominate the roads
+ widespread charging grids

- 🚗 passenger cars
- 🚚 light/med. trucks
- 🚌 buses

phase out fossil-fuel vehicles

reduce vehicle use, adding diverse alternatives
public transport, scooters, bikes, car & taxi pooling, walkable cities, high-speed rail, pooled ride-hailing

taxes on inefficient fuel & vehicles

higher fuel economy & emissions standards

more efficient aviation

switch to advanced biofuels
to power 'electrification-resistant' trucks, ships, and airplanes

- 🚚 long haul trucks
- ✈ aircraft
- 🚢 container ships

BUILDINGS

electrification
heating, stoves & furnaces

zero-carbon buildings go mainstream

aggressive electrical appliance standards
to increase efficiency & lighten demand on the grid

establish & police higher energy-efficiency standards

supply carbon-neutral fuels for older buildings
that cannot be retro-fitted

increase air-conditioning efficiency
could reduce overall building energy demand by 45% global

LAND USE

methane (natural gas) capture and destruction
landfill-captured methane used to produce electricity

▸228

reforestation
even more tree planting and land restoration

▸126

enhance sustainable land sinks in agriculture
sinks absorb CO2 naturally

improve rice production
flooded rice paddies produce large quantities of methane

agriculture sector globally on track to store more carbon than it emits
agroforestry & precision agriculture widely adopted

enhance land protection
increases natural carbon storehouses in soils

- 🏞 land
- 🌾 grasslands
- 🌿 wetlands
- ⛰ peatlands

plant-rich diets
widespread adoption of low-carbon diets

height =
impact
v. order = priority
shaded =
special
difficulty

INDUSTRY

new efficiency standards
help heavy industries to reach
max efficiency

**switch from coal & natural
gas to electricity, biofuels**
& other sustainable alternatives

**(re) design industrial facilities
to reduce waste**

reduce non-CO2 emissions
nitrous oxides, methane, etc.

**all construction carbon
neutral**
or even stores CO2

**industrial carbon capture,
transport & storage (CCS)**

**decarbonise & electrify
cement, steel & chemical
processes**

**all companies adopt
circular business models**

fix refrigerants
fluorinated 'F-gases'
from air-conditioners are
potent GHGs

develop, promote & use
alternatives

INVESTMENT

**fund new carbon-free tech
to ensure cheap, scaleable
& widespread rollout in the
years ahead**

 next-gen nuclear ▸066

 geothermal

 hydrogen & ammonia
combustion turbines

 cheap long-duration
energy storage ▸144

 biomass & natural gas
power plants with
CO2 capture

carbon capture
storing industrial CO2 and/
or sucking CO2 from the
atmosphere to store it
underground
or using it to resynthesize fuels

▸214

circular economy
where products &
materials are
sustainably
designed & made
to be reused or
recycled, rather
than dumped

▸140

POLICY

global 'carbon pricing'
catch-all term for taxes &
credits to
• make carbon-emitting
things more expensive
• disencourage fossil fuel
production & use
• incentivize renewable
tech & infrastructure
so new tech can compete
against subsidised fossil tech

**govt-backed financing,
investment & regulatory
support**

**international cooperation
secures strong global
climate agreement &
roadmap**
The Paris Agreement shows
that it is possible

▸114

**implement & support
green new deals
in every country**

**enact subsidies on
renewable energy, green
industries & climate tech**

**dramatically increase
clean-energy R&D funding**
+ incentives for innovation
adoption & export of new tech

EQUITY

**ensure climate finance
flows to the Global South**
alternative term for 'third'
or 'developing' world

created just 8% of global GHGs

**new jobs & training for
displaced workers**

**government support for
those affected**

**bring indigenous peoples
into decision-making**
their knowledge already
protects forests & ecosystems

▸059

sources: *New York Times*, Zero Carbon Action Plan 2020,
Net Zero America (Princeton), How to Avoid a Climate Disaster (Bill Gates, 2020),
Project Drawdown, Our World in Data, Sitra, XCAR, ECOFYS, Exponential Climate Action Roadmap, IEA

What can we do personally?

We need to get average yearly global emissions per person down
to 2.1 tonnes CO2e

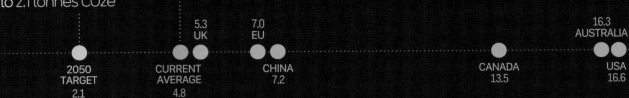

| | 2050 TARGET 2.1 | | CURRENT AVERAGE 4.8 | 5.3 UK | 7.0 EU | CHINA 7.2 | | CANADA 13.5 | USA 16.6 | 16.3 AUSTRALIA |

Genuinely Impactful Actions

TONNES OF CO2e
SAVED PER YEAR

| 0.5 | 1.0 | 1.5 | 2.0 |

🚗 drop the car — bus, train, bike, walk — **-2.4**

✈ take fewer flights — per one roundtrip transatlantic trip — **-1.6**

☀ purchase green energy — **-1.4**

🚗 buy a more efficient car — with better fuel economy & maintenance — **-1.2**

🚗 get an electric car — still emits emissions via manufacture & energy usage — **-1.2**

🍎 switch to a plant-based diet — vegan ideal, vegetarian helps too — **-0.8**

🚗 hybrid car — **-0.4**

🛍 reduce food waste — **-0.37**

🌳 plant a tree — **-0.3**

washing machine wash clothes in cold water — **-0.25**

🐄 reduce meat — **-0.23**

hang clothes to dry — **-0.21**

♻ recycling — **-0.21**

🏠 more efficient home heating — smart thermostats are the way to go — **-0.18**

💡 change lightbulbs to LEDs — **-0.1**

💬 talk to teens — establishing lifelong habits are crucial — teens can catalyze other family members to act — plus they get it! — **∞**

source: 'The climate mitigation gap' (Wynes and Nicholas), Environmental Research Letters 2017

Getting the USA to Carbon Zero by 2050

affordable

less than 1% of GDP required
per year to transition

feasible

the technology already exists
– and is getting better

starting now

needs to happen now to lay
groundwork & infrastructure

working together

everyone participating – individuals,
corporations, government, institutions

The USA Is Ripe for Solar & Wind Power

Potential utility-scale solar energy capacity per state (terawatt hours)

Receives more sunshine than Germany

1,104 Maine	

| **8,283** Alaska | Despite shorter days, Alaska is a suprisingly sunny state | | | **5,097** Wisconsin | | | | | **56** Vermont | **61** N. Hampshire |

1,772 Washington	**3,960** Idaho	**8,199** Montana	**9,739** N. Dakota	**10,826** Minnesota	**8,195** Illinois	**5,266** Michigan		**1,545** New York	**100** Mass.	
3,766 Oregon	**8,639** Nevada	**5,734** Wyoming	**10,013** S. Dakota	**7,021** Iowa	**4,975** Indiana	**3,713** Ohio	**610** Pennsylvania	**484** New Jersey	**27** Connecticut	**15** Rhode Island
9,102 California	**5,215** Utah	**10,282** Colorado	**9,280** Nebraska	**5,366** Missouri	**1,850** Kentucky	**56** W. Virginia	**1,910** Virginia	**615** Maryland	**287** Delaware	
	11,939 Arizona	**16,390** New Mexico	**14,532** Kansas	**5,105** Arkansas	**2,276** Tennessee	**4,301** N. Carolina	**2,789** S. Carolina			

Southern sun-belt states are drenched in potential solar power

9,392 Oklahoma	**4,170** Louisiana	**5,008** Mississippi	**3,743** Alabama	**5,535** Georgia	

| **42** Hawaii | | **39,288** Texas | Texas land space & sun could make it a solar powerhouse | | **5,210** Florida |

Potential onshore wind energy capacity per state (terawatt hours)

29 Maine	

The Great Plains states have the fastest wind speeds so lots of energy to harvest

| **1,373** Alaska | | | | **255** Wisconsin | | | | **9** Vermont | **8** N. Hampshire |

47 Washington	**44** Idaho	**2,746** Montana	**2,534** N. Dakota	**1,429** Minnesota	**649** Illinois	**144** Michigan		**64** New York	**3** Mass.	
69 Oregon	**21** Nevada	**1,654** Wyoming	**2,902** S. Dakota	**1,724** Iowa	**378** Indiana	**129** Ohio	**10** Pennsylvania	**0** New Jersey	**0** Connecticut	**0** Rhode Island
90 California	**32** Utah	**1,096** Colorado	**3,011** Nebraska	**690** Missouri	**0** Kentucky	**6** W. Virginia	**5** Virginia	**4** Maryland	**0** Delaware	
	31 Arizona	**1,399** New Mexico	**3,102** Kansas	**27** Arkansas	**1** Tennessee	**2** N. Carolina	**1** S. Carolina			

Ringed states have massive offshore wind potential

1,522 Oklahoma	**1** Louisiana	**0** Mississippi	**0** Alabama	**0** Georgia

In more tropical states, air rises upward so there's little energy for turbines.

| **12** Hawaii | Texas's vast land area means lots of space for turbines | **5,552** Texas | | **0** Florida |

source: US Renewable Energy Technical Potentials, Lopez et al. (2012)

Total Potential Solar Energy
282,845
terawatt hours

Potential Onshore Wind Energy
32,780

US yearly
electricity
use
4,127

Netzero Timeline

sector	what	today	2030	2050	
electric vehicles INCREASE	personal electric cars	1.6m	50m	300m	with all cars electric, US energy consumption drops by 13%
	% of new sales	2%	30–50%	100%	battery costs expected to decrease 1,000% by 2030
	% of total cars	0.4%	6–17%	61–96%	*fast charger = 240-mile range for 30m charge
	public charging points	90,000 +17,000 fast chargers*	3–5m +120,000 fast chargers	18m +720,000 fast chargers	all electric or hydrogen-cell power
	electric trucks & buses	63,000	1,000,000	2,500,000+	
	% of new sales	not clear	15%	80%	
homes SWITCH	heated by electric pumps	10–12m	25–30m	130m	100% electric induction hobs
	% of total homes	5%	10–23%	80–100%	
carbon-free electricity INCREASE	share of energy	37%	70%–85%	98%+	for 100% renewables
	solar power	65GW	300GW	1.5TW	1m km²
	wind power	100GW	300GW	4.2TW	+64,000 km² offshore
	investment	$140bn	$810bn	$3.4tr	
power lines INCREASE	new transmission lines	not yet	195,000 GW/km	unclear, but many	extra demand will require new power lines
	power capacity	not yet	+60%	+350%	about 75GW per year added
INCREASE	investment	not yet	$530bn	$2.5tr	

	Current	Mid-term	Target	Notes
power grids				
🔋 grid battery capacity	23GW	100GW	(battery)	
electric grid flexibility	n/a	+5–10%	+40%–60%	because solar & wind is intermittent, not constant
batteries	0.9GW	5–15GW	50–180GW	6-hour batteries to support the grid
alternative energies				
BUILD hydrogen	not yet	3 EXAJOULES	8–19 EXAJOULES	
BUILD biomass	38m ton/year	80m ton/year	620m ton/year	
MAINTAIN existing nuclear	keep nuclear plants going	keep nuclear plants going	50% retired	
BUILD new advanced nuclear	n/a	10–260GW	500GW+	250 x 1GW reactors (or 3,800 small reactors)
fossil fuels				
decrease as energy source	n/a	–75%	–90%	
ELIMINATE coal	700 mines	200 mines	all mines shut	
DECREASE natural gas	n/a	2–30%	–65%+	will lower emissions by 1GT/year
carbon capture				
BUILD nationwide pipeline & storage network	not yet	begin construction	21,000–25,000 km²	
gigatons per year captured	not yet	0.25	1.7–4.2	
reforestation	1 million hectares/year	1.3 million hectares/year	20–40 m hectares/year	
jobs INCREASE				
% of workforce in energy industry	1.5%	+30%	+300%	4.5% of workforce in energy industry
extra jobs	not yet	+3 million	+5 million	

sources: International Energy Agency, Bloomberg, Zero Carbon Action Plan 2020, Net Zero America (Princeton), *New York Times*

Netzero Costs to 2030
$billions

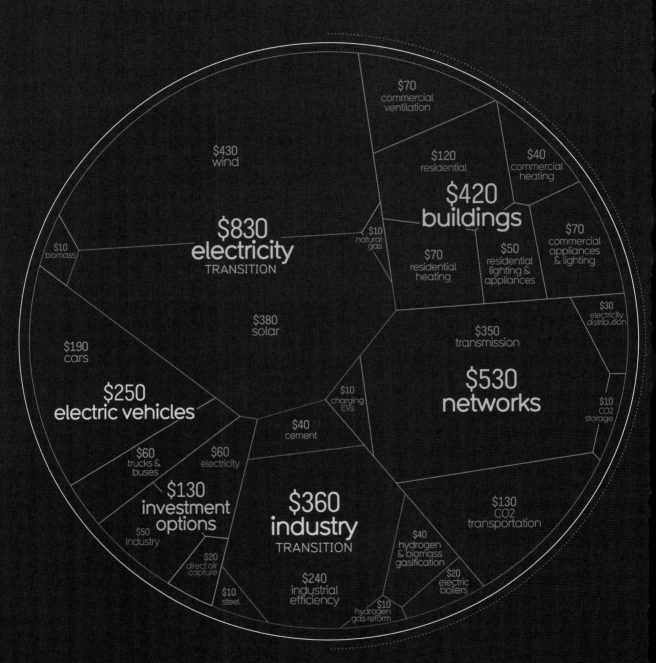

$70
commercial
ventilation

$430
wind

$120
residential

$40
commercial
heating

$830
electricity
TRANSITION

$420
buildings

$10
biomass

$10
natural
gas

$70
commercial
appliances
& lighting

$70
residential
heating

$50
residential
lighting &
appliances

$380
solar

$350
transmission

$30
electricity
distribution

$190
cars

$250
electric vehicles

$10
charging
EVs

$530
networks

$40
cement

$10
CO2
storage

$60
trucks &
buses

$60
electricity

$130
CO2
transportation

$130
investment
options

$360
industry
TRANSITION

$50
industry

$40
hydrogen
& biomass
gasification

$20
direct air
capture

$20
electric
boilers

$10
steel

$240
industrial
efficiency

$10
hydrogen
gas reform

source: Net Zero America (Princeton)

Comparison Costs
$trillions

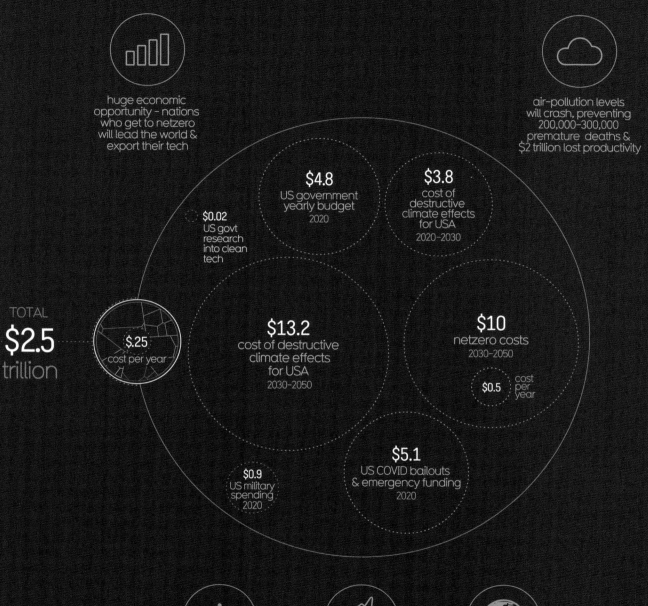

huge economic opportunity - nations who get to netzero will lead the world & export their tech

air-pollution levels will crash, preventing 200,000-300,000 premature deaths & $2 trillion lost productivity

$4.8
US government yearly budget
2020

$3.8
cost of destructive climate effects for USA
2020-2030

$0.02
US govt research into clean tech

$13.2
cost of destructive climate effects for USA
2030-2050

$10
netzero costs
2030-2050

$0.5 cost per year

TOTAL
$2.5 trillion

$.25
cost per year

$0.9
US military spending
2020

$5.1
US COVID bailouts & emergency funding
2020

most zero carbon solutions are more expensive than fossil-fuel equivalents - that could change

carbon-free electricity, for example, would likely be about 15-20% more for public consumers

but fossil fuels only seem cheaper because the eco damage is not included in their price

Netzero Problems, Challenges, Responses, Solutions

Raise lots of money to transition
Markets, industry & government together

Mix public & private funding
10% taxpayer, 90% market capital

Start spending now
The amount needed is less than coronavirus spend

Invest early in critical infrastructure
One of the biggest in history

Demo prototypes & de-risk new tech
Funded initially by government to reduce risk

Factor costs of mitigating climate effects
Floods, heatwaves, crop failure, migration

Understand this is a huge project
Perhaps the biggest in history

Come together to do this as a society
Public, markets, government & companies together

Support communities impacted by transition
Lower-income areas will likely suffer more

Create public acceptance of the possibilities
Public demand for clean energy will help

Generate new jobs
Netzero will actually create more opportunities

Support transitioning workers

Who's going to pay for all this stuff?
Tax payers? Government? Corporates?

What about investment risk?
Lot of unknowns here

We need to start spending now, right?
The next ten years are essential

Where will the upfront cash come from?
A LOT is needed for infrastructure, etc.

**Climate crisis is already happening –
who will pay for the fallout?**

How are we going to build all this stuff?
Turbines, solar panels, transmission lines...

Grid expansion is a massive undertaking
Easier said than done!

What about lost and displaced jobs?
Dramatic decrease in oil & gas = unemployment

**How to ensure individuals & communities
aren't disproportionately affected?**
Ensure material well-being for all

What about local opposition to disruptive

Have a clear goal of netzero
Then we all align to achieve it

Envision multiple pathways & scenarios
No one single route to Netzero—keep options open

Sustain political will to see it through
Public demand for clean energy will help

Enhance & streamline policies & processes
Many weren't designed with climate change in mind

Test & prototype policies & standards locally
Before implementing them nationwide

Prioritize improving efficiency
For immediate easy wins

Research & develop new tech innovations
Offer tax breaks for companies to fund breakthroughs

Implement direct subsidies for netzero tech
As we currently do for fossil fuels

Consider carbon capture across the board
Direct carbon capture at source to trap emissions

Gradually phase out old fossil-fuel tech
And adapt and modify the rest

Develop & support bio- & electrofuels
We'll still need to use some liquid fuels

Use less stuff
Reduce demand, reuse & recycle

WILL

How do we create and sustain public enthusiasm?
Unclear how the public will receive all this change

Regulatory barriers—state & federal—are massive impediment to swift transition
Outdated policies created before climate crisis

Won't fossil fuel companies resist this massive change?
They are going to be the losers, right?

TECH

What about planes & ships that are not easy to switch to batteries?
There are never going to be electric 747's

And essential but fossil-fuel-dependent industries like steel?
Ingrained processes use a lot of CO2

Or cement?
You literally can't make it without CO2

What will happen to all the redundant fossil-fuel technology and machinery?
Vehicles, power plants, pipelines

Especially the massive & extensive petroleum & natural gas networks?
Including 4,000,0000 km of pipelines

HEY

Shouldn't we be reducing consumption?
Bring down our emissions and dispel the myth of continuous growth?

sources: Net Zero America (Princeton), New York Times, Rewiring America, Science magazine

Smoking Is Declining in Nearly Every Country

% population smoking

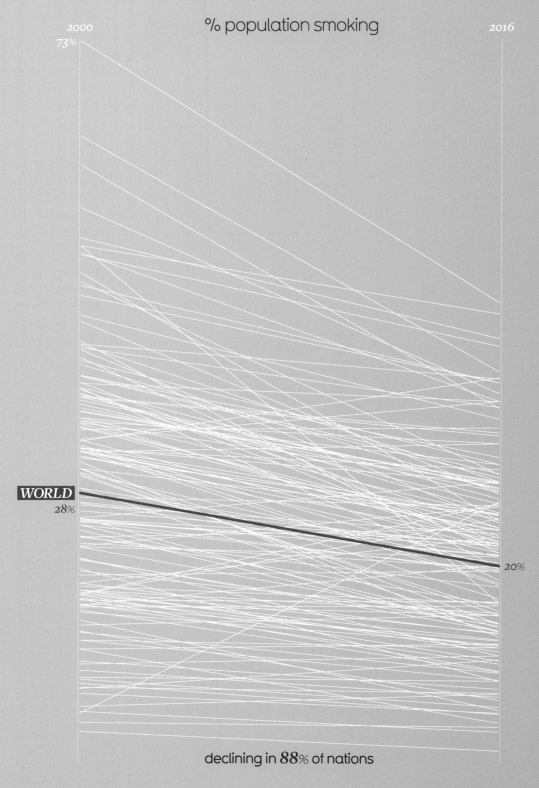

73%

WORLD
28%

20%

declining in **88**% of nations

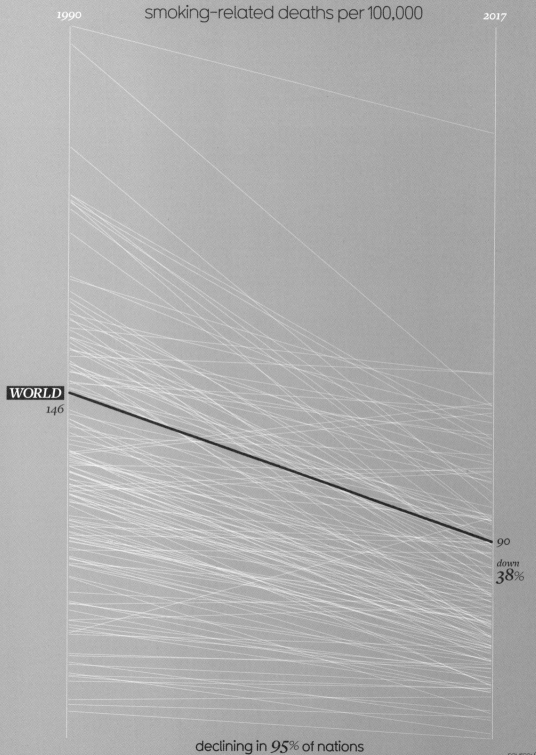

smoking-related deaths per 100,000

1990 2017

WORLD
146

90

down
38%

declining in *95%* of nations

source: Our World in Data

Some of the World's Poorest Nations Are Also The Most Generous

POOR & GENEROUS COUNTRIES

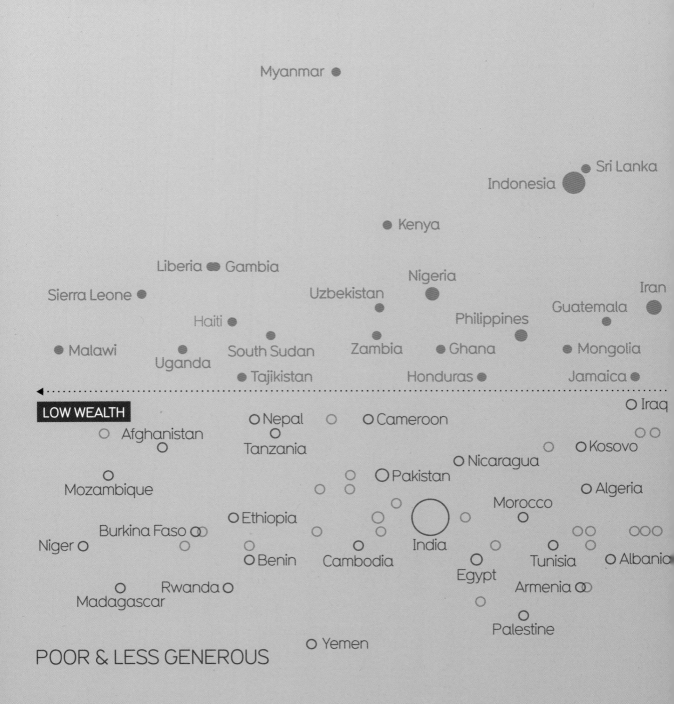

Myanmar ●

Sri Lanka ●
Indonesia ●

● Kenya

Liberia ●● Gambia Nigeria
Sierra Leone ● Uzbekistan ● ● Iran ●
 Guatemala
Haiti ● Philippines ●
● Malawi South Sudan ● Zambia ● ● Ghana ● Mongolia
 Uganda ●
 ● Tajikistan Honduras ● Jamaica ○

LOW WEALTH

 ○ Iraq
 ○ Afghanistan ○ Nepal ○ ○ Cameroon ○○
 ○ ○ Kosovo
 ○ ○ Tanzania ○ Pakistan
 ○ Mozambique ○ ○ ○ Nicaragua ○ Algeria
 Morocco
 ○ Ethiopia ○ ○ ○ ○ ○○○
Burkina Faso ○○ ○ India ○ ○
Niger ○ ○ ○ ○ ○ ○ ○○○
 ○ Benin Cambodia Tunisia ○ Albania
 ○ Rwanda ○ Egypt Armenia ○○
Madagascar ○ ○
 ○
 Palestine

 ○ Yemen

POOR & LESS GENEROUS

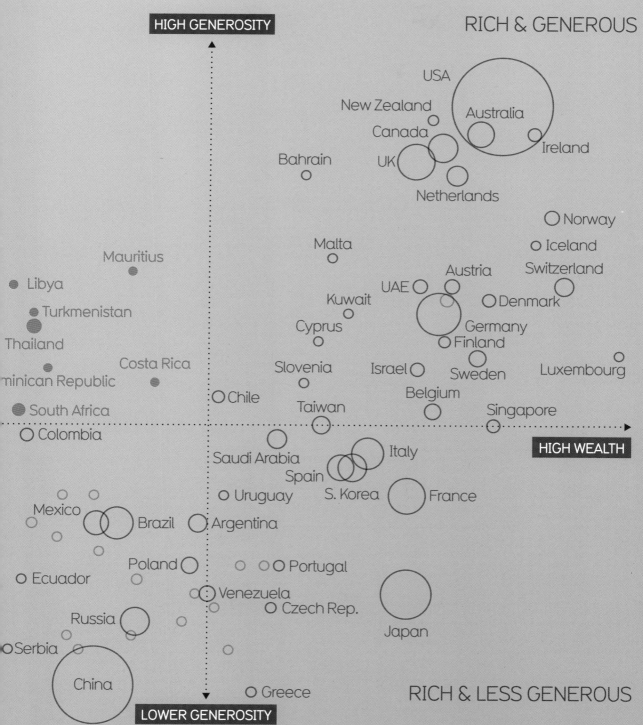

size of economy

HIGH GENEROSITY

RICH & GENEROUS

USA
New Zealand
Canada Australia
Bahrain UK Ireland
Netherlands

Norway
Iceland
Mauritius Switzerland
Libya Malta Austria
UAE Denmark
Turkmenistan Kuwait Germany
Thailand Cyprus Finland
Costa Rica Slovenia Israel Sweden Luxembourg
minican Republic Belgium
South Africa Chile
Colombia Taiwan Singapore

HIGH WEALTH

Saudi Arabia Italy
Spain
Uruguay S. Korea France
Mexico Brazil Argentina
Poland Portugal
Ecuador Venezuela
Russia Czech Rep.
Serbia Japan

China
Greece RICH & LESS GENEROUS

LOWER GENEROSITY

source: Charities Aid Foundation, wealth per person
generosity measurd by helping strangers, donating money & volunteering time

We're Hacking Photosynthesis to Feed Our Growing Population

Improving the molecular efficiency of plants

UNMODIFIED

MODIFIED

up to
40%
larger

technology is being used on:

| soybean | rice | potato | tomato | eggplant |

and distributed free to small farms

source: Illinois University

A Natural Substance Could Replace Controversial Herbicide Roundup

Newly discovered sugar stops weed growth

7-deoxy-sedoheptulose

early tests show it's harmless to humans & animals

 Roundup (Glyphosate) is the most commonly used herbicide in the USA

 Discovered & brought to market by **Monsanto** (taken over by **Bayer** in 2018)

 Controversial due to evidence of **possible toxicity** in humans and animals

source: Nature Journal

Food Tech

Biofortified Cassava Is Set to Transform the Health of Millions

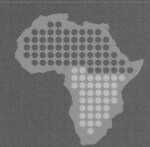

nearly
HALF A BILLION
Africans rely on cassava for
50%
of their calories

but cassava is

NUTRIENT
POOR
which contributes to → anemia diarrhea deaths cognitive problems

Hacking the genes

Biologists inserted two genes from thale cress... ...into cassava

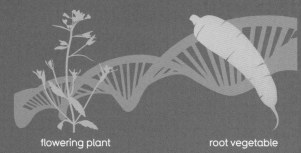

flowering plant root vegetable

Transforming the nutrient profile

% of requirements of zinc and iron for women and young children

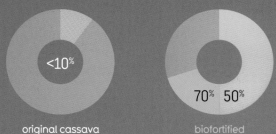

<10% 70% 50%

original cassava biofortified

sources: American Council on Science and Health, Nature

Biofortified Golden Rice Could Reduce Lethal Vitamin A Deficiency

250m children worldwide suffer deficiency

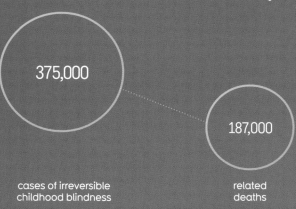

375,000

187,000

cases of irreversible childhood blindness

related deaths

Golden rice can counter this

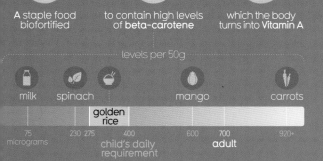

A staple food biofortified

β to contain high levels of **beta-carotene**

which the body turns into **Vitamin A**

levels per 50g

| milk | spinach | golden rice | mango | carrots |

| 75 | 230 | 275 | 400 | 600 | 700 | 920+ |
| micrograms | | child's daily requirement | | | adult | |

Golden rice is being approved for consumption

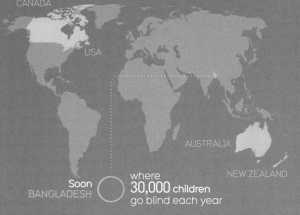

CANADA

USA

AUSTRALIA

NEW ZEALAND

Soon
BANGLADESH

where **30,000 children** go blind each year

sources: World Health Organization, US National Institute of Health

Rice Production Is Improving, Boosting Food Security & World Health

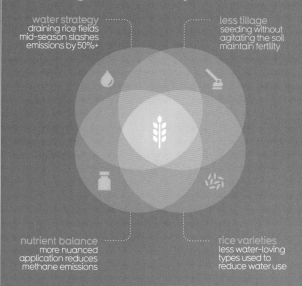

water strategy
draining rice fields mid-season slashes emissions by 50%+

less tillage
seeding without agitating the soil maintain fertility

nutrient balance
more nuanced application reduces methane emissions

rice varieties
less water-loving types used to reduce water use

Wider adoption could save 13.8 gigatonnes of CO2

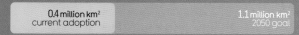

0.4 million km² current adoption

1.1 million km² 2050 goal

source: Project Drawdown

Rice Can Now Be Grown in Salty Water
Tonnes yielded per hectare

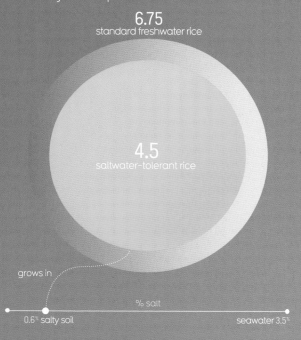

6.75
standard freshwater rice

4.5
saltwater-tolerant rice

grows in

% salt

0.6% salty soil

seawater 3.5%

source: South China Morning Post

Canada has the largest protected boreal forest on the planet

boreal = high-latitude forests consisting mainly of conifers

created

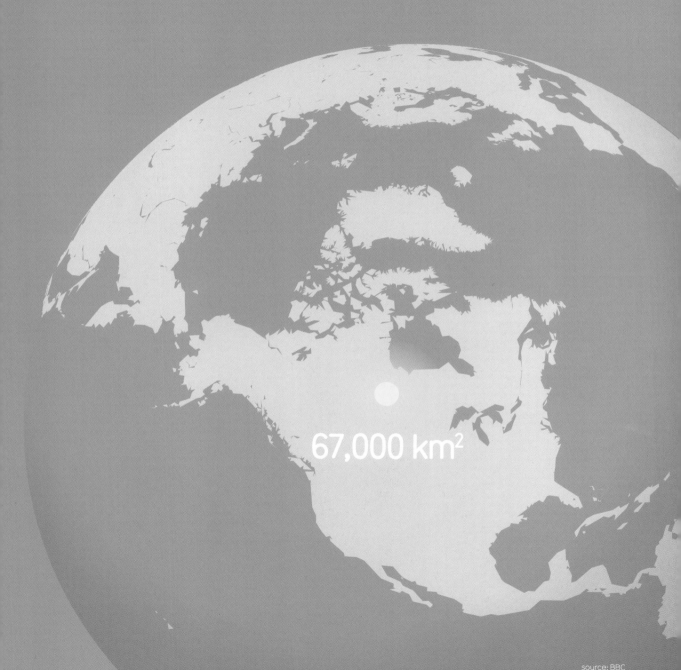

67,000 km²

source: BBC

The World Economy Has Ballooned
Trillion dollars

1968

2

$700
per person

2019

88

$11,400
per person

The Potential of Geothermal Power Is Amazing

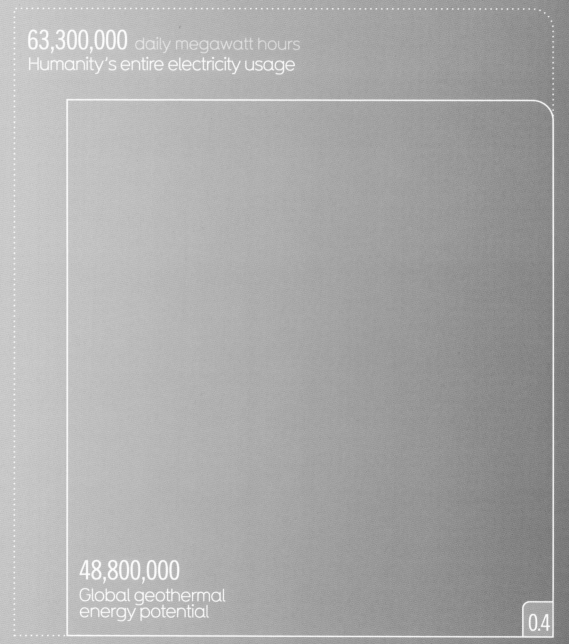

63,300,000 daily megawatt hours
Humanity's entire electricity usage

48,800,000
Global geothermal
energy potential

0.4

% we're currently using

30 Countries Could be 100% Powered by
Renewable Geothermal Energy
Yearly potential vs current electricity use

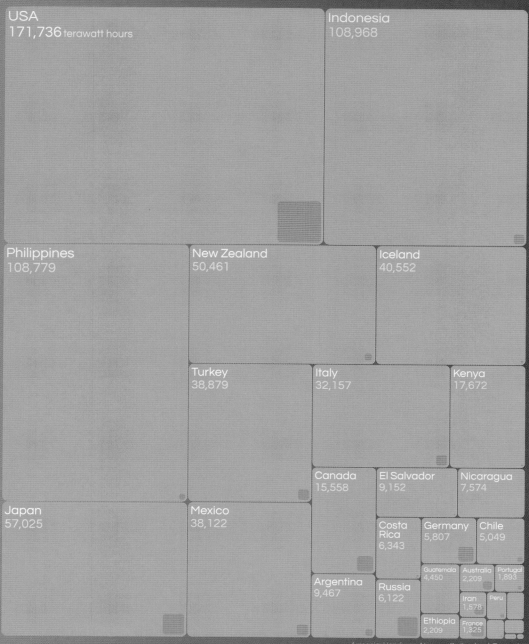

USA
171,736 terawatt hours

Indonesia
108,968

Philippines
108,779

New Zealand
50,461

Iceland
40,552

Turkey
38,879

Italy
32,157

Kenya
17,672

Canada
15,558

El Salvador
9,152

Nicaragua
7,574

Japan
57,025

Mexico
38,122

Costa Rica
6,343

Germany
5,807

Chile
5,049

Guatemala
4,450

Australia
2,209

Portugal
1,893

Argentina
9,467

Russia
6,122

Iran
1,578

Peru

Ethiopia
2,209

France
1,325

Armenia, Honduras, Norway, Switzerland, Tanzania

source: International Renewable Energy Agency

Yay Africa!

The new
African Union
passport allows
visa-free travel
between
55 countries

source: Washington Post

When Submarine Internet Cables Arrived in Africa...

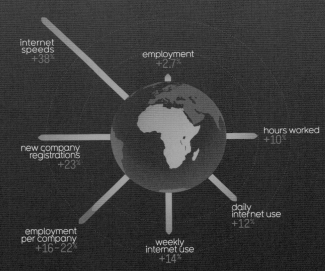

internet
speeds
+38%

employment
+2.7%

hours worked
+10%

new company
registrations
+23%

daily
internet use
+12%

employment
per company
+16-22%

weekly
internet use
+14%

source: American Economic Review

Female Genital Mutilation Is Declining Across Most of the Continent
Prevalence by region %

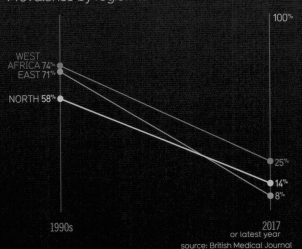

100%

WEST
AFRICA 74%
EAST 71%

NORTH 58%

25%

14%

8%

1990s

2017
or latest year

source: British Medical Journal

South Africa Is Cutting HIV Infections
Despite suffering the world's biggest epidemic

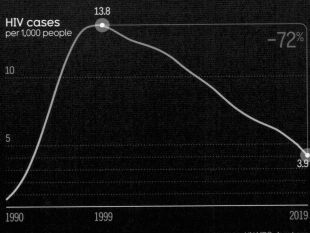

HIV cases
per 1,000 people

13.8

-72%

10

5

3.9

1990

1999

2019

sources: UNAIDS, Avert.org

Drones Have Revolutionized Medical Deliveries in Rwanda

DELIVERY TIME

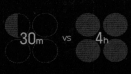

30m vs 4h

with drone pre-drone

CURRENT USAGE

35%

of blood supply delivered

MAX LOAD

1.75KG

3 units of blood

CRUISE SPEED

100km/h

in ideal conditions

African Countries Have Agreed to a New Free-Trade Bloc

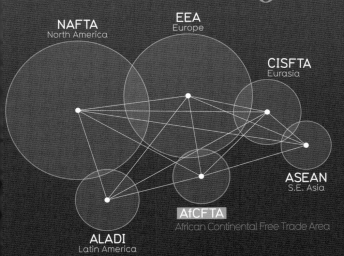

= total GDP

NAFTA
North America

EEA
Europe

CISFTA
Eurasia

ASEAN
S.E. Asia

AfCFTA
African Continental Free Trade Area

ALADI
Latin America

source: United Nations

Africa Leads the World in Mobile Money Transactions

Africa
396 million
Registered accounts

Rest of the World
470 million

source: Our World in Data, Africa = Sub-Saharan Africa

United Africa Is an Economic Powerhouse
Yearly GDP $US Tillions

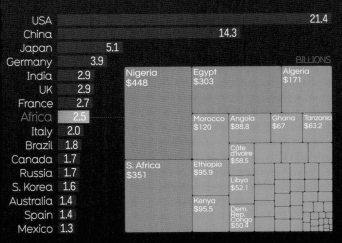

BILLIONS

USA	21.4
China	14.3
Japan	5.1
Germany	3.9
India	2.9
UK	2.9
France	2.7
Africa	2.5
Italy	2.0
Brazil	1.8
Canada	1.7
Russia	1.7
S. Korea	1.6
Australia	1.4
Spain	1.4
Mexico	1.3

Nigeria $448
Egypt $303
Algeria $171
Morocco $120
Angola $88.8
Ghana $67
Tanzania $63.2
Côte d'Ivoire $58.5
S. Africa $351
Ethiopia $95.9
Libya $52.1
Kenya $95.5
Dem. Rep. Congo $50.4

source: World Bank

Access to Electricity Is Rising Across The Continent

% with power 1% 100%

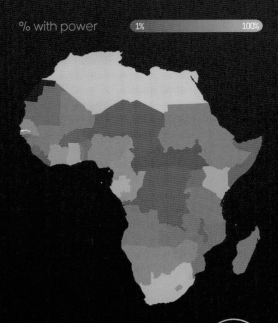

COVERED AREA

Kigali
85km
from distribution center

EFFECTIVE RANGE

22,500 km²
covered area

source: *The Guardian*

millions gaining electricity per year

9
2013

20
2019

source: International Energy Agency

The EU Is Leading on Recycling & Emissions

Its Economy Is Growing While Emissions Are Falling

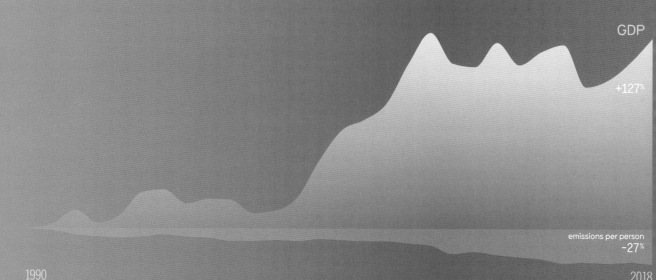

GDP

+127%

emissions per person
-27%

1990

2018

It Could Power the Entire World with Wind

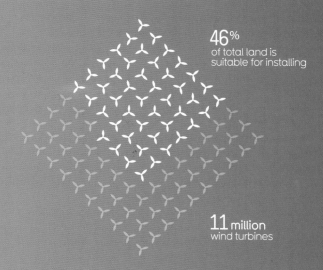

46%
of total land is
suitable for installing

11 million
wind turbines

Will Increase Its Offshore Wind Capacity by 250%

2020

2050

expected global demand 2050

EU wind energy generating potential

Paper Recycling Has Doubled over the Last 25 Years

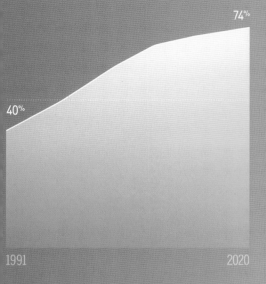

74%

40%

1991 2020

The EU has required all key electronic appliances to be easier to repair

dishwashers

washing machines fridges

lights

televisions

Some European States Are Recovering Almost All Plastic Packaging
Making it into new industrial products*

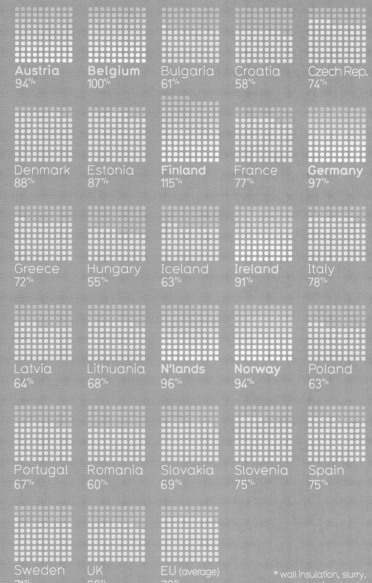

Austria 94%	Belgium 100%	Bulgaria 61%	Croatia 58%	Czech Rep. 74%
Denmark 88%	Estonia 87%	Finland 115%	France 77%	Germany 97%
Greece 72%	Hungary 55%	Iceland 63%	Ireland 91%	Italy 78%
Latvia 64%	Lithuania 68%	N'lands 96%	Norway 94%	Poland 63%
Portugal 67%	Romania 60%	Slovakia 69%	Slovenia 75%	Spain 75%
Sweden 71%	UK 68%	EU (average) 79%		

* wall insulation, slurry, lubricants, etc.

430 exajoules

497

sources: *Independent, Energy Policy,* European Paper Recycling Council, Eurostat

62 Nations Have Completely Banned Corporal Punishment
In all settings: home, schools & prisons

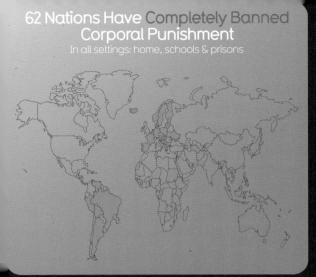

Corporal punishment = intended to cause physical pain source: World Bank

Air Travel Has Never Been Safer
Millions of flights **vs** no. of fatal crashes

39

35

25

23

16

12

18

10

24

3

0

7

1993 zero fatal crashes! >>> 2017 2020

sources: Aviation-Safety.net, World Bank, commercial passenger crashes only

Atmospheric Acidity Is Back to Normal

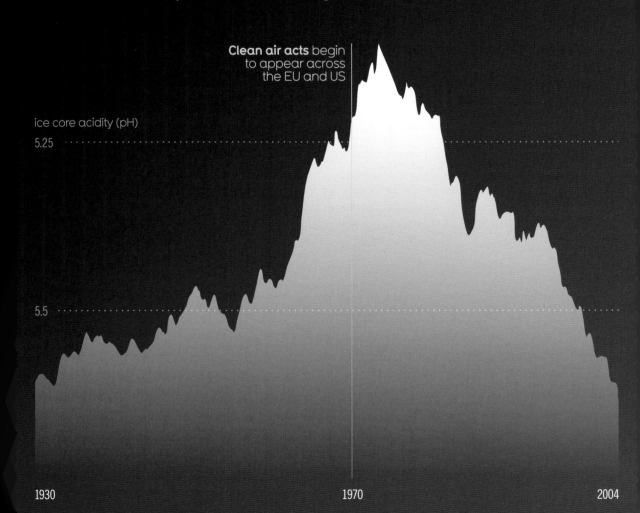

Clean air acts begin
to appear across
the EU and US

ice core acidity (pH)

5.25

5.5

1930 1970 2004

A New Device Uses Ocean Forces To Clean Plastic From Our Seas
From giant objects to microplastics

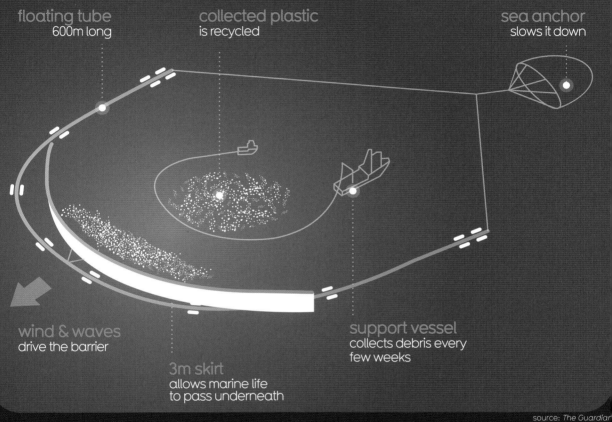

floating tube
600m long

collected plastic
is recycled

sea anchor
slows it down

wind & waves
drive the barrier

3m skirt
allows marine life
to pass underneath

support vessel
collects debris every
few weeks

source: *The Guardian*

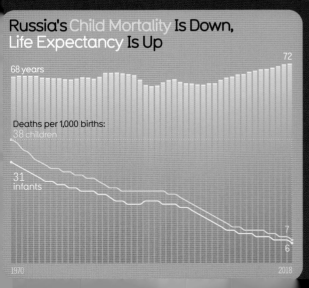

Russia's Child Mortality Is Down, Life Expectancy Is Up

72

68 years

Deaths per 1,000 births:
38 children

31 infants

7

6

1970

2018

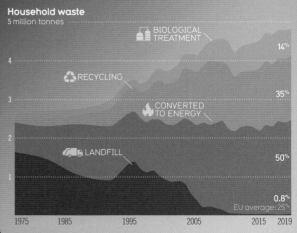

Sweden Sends Almost No Trash to Landfill

Household waste
5 million tonnes

BIOLOGICAL TREATMENT — 14%

RECYCLING — 35%

CONVERTED TO ENERGY — 50%

LANDFILL — 0.8%
EU average: 25%

4

3

2

1

1975 1985 1995 2005 2015 2019

Money Spent on Disadvantaged Kids Is a Great Long-Term Investment

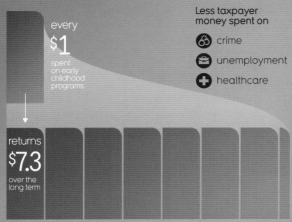

every
$1
spent on early childhood programs

Less taxpayer money spent on
- crime
- unemployment
- healthcare

returns
$7.3
over the long term

source: University of Chicago

75% of All the Aluminum Ever Used in the USA Has Been Recycled

60 days
for a can to be recycled & back in use

98% BR **73%** JP
Brazil & Japan are top recyclers of drink cans

only 9% of all plastics are recycled

sources: Aluminium.org, The Verge, Reute

45,000+ Microgrids Are Out There
Small, affordable, hyper-efficient power grids essential bridge to a fossil-fuel future

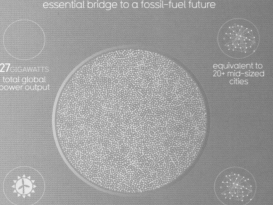

27 GIGAWATTS total global power output

equivalent to 20+ mid-sized cities

mix intermittent renewable sources

stand alone or plugin to 'macrogrid'

source: Navigant Research, Project Drawdown

Most of the World Can Now Afford Mobile Internet
152 countries meet the affordability threshold*

better access to
- banking & microfinance
- education & books
- health services
- public services

92% OF GLOBAL POPULATION

* 1 gigabyte of data for no more than 2% of average monthly income

source: World Bar

Finland Has Almost Eradicated Vaping

The government introduced pioneering e-cigarette regulations

 bans on flavors

 18+ age limits for buyers

 prohibition of marketing

 import restrictions

banned in non-smoking areas

As a result, the country enjoyed drops in traditional smoking, without an accompanying rise in vaping

Finns smoking daily
25% 1998
14% 2018

Finns vaping daily
1%
Sweden* 4.4%
UK* 5.7%

Smoking Bans Improve Health

Declines after introduction of public smoking laws

child admissions for nose/throat/chest infections	−3.5%
premature births	−3.8%
asthma-related hospital visits	−9.8%
hospitalizations for acute coronary events	−12.0%
heart attack related health costs	−14.8%
hospitalization of children with lower respiratory tract infections	−18.5%

...tch Prisons Are Closing
...d being turned into housing for refugees

...rceration rates are down

Prison closures 2009–2016

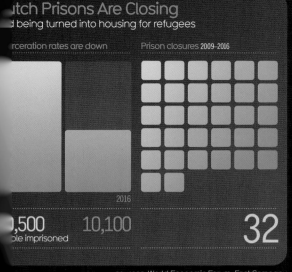

2016

...,500 10,100 **32**
...le imprisoned

sources: World Economic Forum, Fast Company

Most One-Year-Olds Are Vaccinated Against Three Lethal Diseases
Diphtheria, tetanus & whooping cough

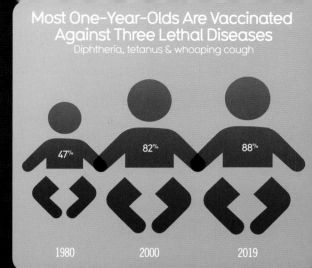

47% 82% 88%

1980 2000 2019

source: World Health Organization, global figure

...orld Vegetable Intake Almost Doubled
...ncrease in consumption per person

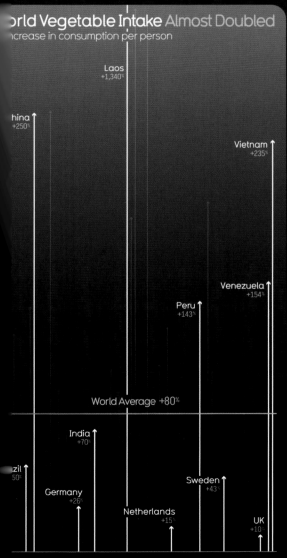

Laos +1,340%

...hina +250%

Vietnam +235%

Venezuela +154%

Peru +143%

World Average +80%

India +70%

...azil ...50%

Germany +26%

Netherlands +15%

Sweden +43%

UK +10%

Cycling to Work Is on the Up
Cities with most bicycle commuters

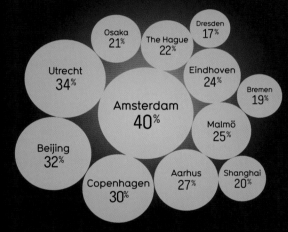

Osaka 21%

The Hague 22%

Dresden 17%

Utrecht 34%

Eindhoven 24%

Bremen 19%

Amsterdam 40%

Malmö 25%

Beijing 32%

Copenhagen 30%

Aarhus 27%

Shanghai 20%

sources: Urban Audit, LTA Academy, Jane Jacobs Japa

More Afghan Girls Are Being Educated
Primary school enrollment rates

4%

1999

82%

20 years ago, the country had the lowest rate worldwide

2018

Major Fashion Brands Are Going Fur-Free

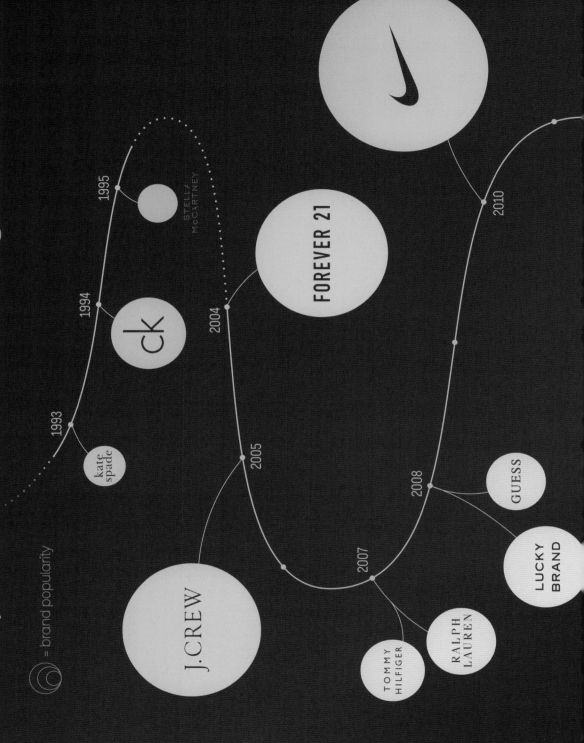

= brand popularity

1993

kate
spade

1994

ck

1995

STELLA
McCARTNEY

2004

FOREVER 21

2005

NIKE

2010

J.CREW

2007

2008

TOMMY
HILFIGER

RALPH
LAUREN

LUCKY
BRAND

GUESS

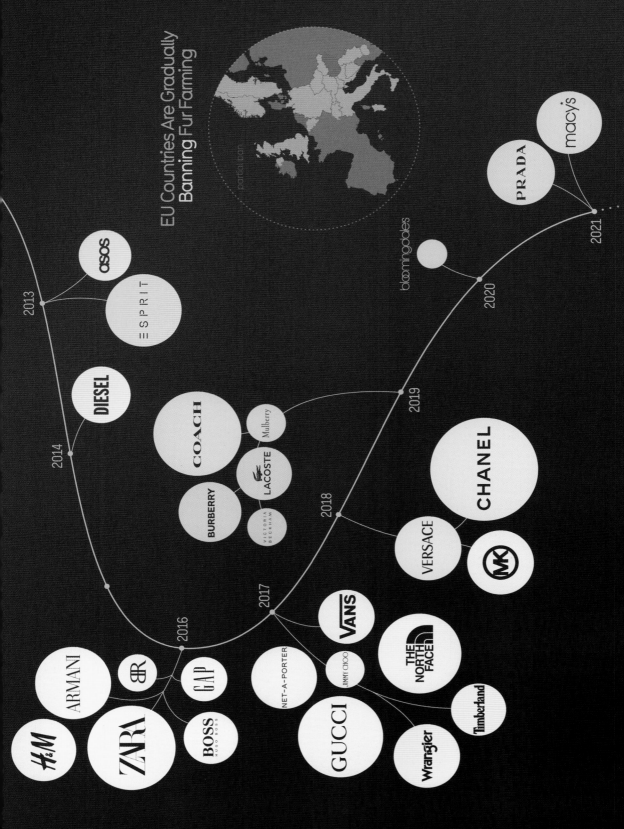

EU Countries Are Gradually Banning Fur Farming

2013 · ASOS · ESPRIT · DIESEL · 2014

2016 · ARMANI · H&M · ZARA · BR · BOSS HUGO BOSS · GAP

2017 · VANS · NET-A-PORTER · JIMMY CHOO · GUCCI · THE NORTH FACE · Wrangler · Timberland

2018 · VERSACE · CHANEL · MK

COACH · BURBERRY · Mulberry · LACOSTE · VICTORIA BECKHAM

2019

2020 · bloomingdales

2021 · PRADA · macy's*

sources: The Guardian, Independent, Harper's Bazaar

190 Nations Have Signed the Paris Climate Agreement
With only a few holdouts

size = level of emissions	Afghanistan	Albania	Algeria	Andorra	Angola	Antigua and Barbuda	Argentina
Belarus	Belgium	Belize	Benin	Bhutan	Bolivia	Bosnia and Herzegovina	Botswana
Cameroon	Canada	China			Central African Republic	Chad	Chile
Cote d'Ivoire	Croatia				Cuba	Cyprus	Czech Republic
Eritrea	Estonia				Eswatini	Ethiopia	Fiji
Grenada	Guatemala	Guinea	Guinea-Bissau	Guyana	Haiti	Honduras	Hungary
Italy	Jamaica	Japan	Jordan	Kazakhstan	Kenya	Kiribati	Kosovo
Liberia	Libya	Liechtenstein	Lithuania	Luxembourg	Macedonia	Madagascar	Malawi
Micronesia	Moldova	Monaco	Mongolia	Montenegro	Morocco	Mozambique	Myanmar
Niue	North Korea	Norway	Oman	Pakistan	Palau	Palestine	Panama
Russia		Rwanda	Saint Kitts and Nevis	Saint Lucia	St Vincent and the Grenadines	Samoa	San Marino
		Slovenia	Solomon Islands	Somalia	South Africa	South Korea	South Sudan
Switzerland	Syria	Tanzania	Tajikistan	Thailand	Timor-Leste	Togo	Tonga
Uganda	UK	Uruguay	Uzbekistan	Vanuatu	Vatican City	Venezuela	Vietnam

Armenia | Australia | Austria | Azerbaijan | Bahamas | Bahrain | Bangladesh | Barbados

Brazil | Brunei Darussalam | Bulgaria | Burkina Faso | Burundi | Cabo Verde | Cambodia

Colombia | Comoros | Congo | Congo (Dem. Rep.) | Cook Islands | Costa Rica

Denmark | Djibouti | Dominica | Dominican Republic | Ecuador | Egypt | El Salvador | Equatorial Guinea

Finland | France | Gabon | Gambia | Georgia | Germany | Ghana | Greece

Iceland | India | Indonesia | Iran | Iraq | Ireland | Israel

Kuwait | Kyrgyzstan | Laos | Latvia | Lebanon | Lesotho

Malaysia | Maldives | Mali | Malta | Marshall Islands | Mauritania | Mauritius | Mexico

Namibia | Nauru | Nepal | Netherlands | New Zealand | Nicaragua | Niger | Nigeria

Papua New Guinea | Paraguay | Peru | Philippines | Poland | Portugal | Qatar | Romania

São Tomé and Príncipe | Saudi Arabia | Senegal | Serbia | Seychelles | Sierra Leone | Singapore | Slovakia

Spain | USA | Sri Lanka | Sudan | Suriname | Sweden

Trinidad and Tobago | Tunisia | Turkey | Turkmenistan | Tuvalu

Yemen | Ukraine | United Arab Emirates | Zambia | Zimbabwe

source: United Nations

LEVEL 4
13%

LEVEL 3
45%

Global Health Expenditure per Person Has Never Been Higher

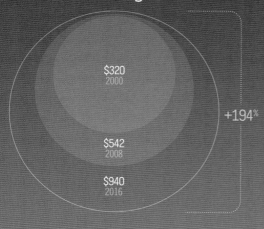

$320
2000

$542
2008

$940
2016

+194%

LEVEL 2
38%

The % of Global Population Covered by Essential Health Services Is Growing

LEVEL 1 **4%**

Australia	**Iceland**	**New Zealand**	**Switzerland**
Belgium	**Israel**	**Norway**	**Thailand**
Brunei	**Italy**	**Portugal**	**UK**
Canada	**Japan**	Singapore	Uruguay
Cuba	Luxembourg	**South Korea**	USA
Denmark	**Malta**	**Spain**	
Germany	**Netherlands**	**Sweden**	

Algeria	**Cze. Republic**	**Latvia**	**Romania**
Argentina	Dom. Republic	Lebanon	**Russia**
Armenia	**Ecuador**	Libya	**Saudi Arabia**
Austria	Egypt	**Lithuania**	**Serbia**
Azerbaijan	El Salvador	**Malaysia**	Seychelles
Bahamas	Estonia	**Maldives**	Slovakia
Bahrain	Eswatini	**Mauritius**	Slovenia
Barbados	Fiji	**Mexico**	South Africa
Belarus	Finland	Moldova	**Sri Lanka**
Belize	**France**	**Mongolia**	St Lucia
Bhutan	**Georgia**	Montenegro	Suriname
Bolivia	Greece	Morocco	Syria
Bosnia	Grenada	Myanmar	Tajikistan
Botswana	**Guyana**	N. Macedonia	Tunisia
Brazil	Honduras	N. Korea	**Turkey**
Bulgaria	**Hungary**	Namibia	Turkmenistan
Cabo Verde	Iran	**Nicaragua**	UAE
Cambodia	Iraq	**Oman**	Ukraine
Chile	Ireland	**Panama**	Uzbekistan
China	Jamaica	Paraguay	Venezuela
Colombia	Jordan	Peru	Vietnam
Costa Rica	Kazakhstan	**Philippines**	
Croatia	Kuwait	**Poland**	
Cyprus	Kyrgyzstan	Qatar	

Albania	Gambia	Mauritania	Timor-Leste
Angola	Ghana	Micronesia	Togo
Bangladesh	Guatemala	Mozambique	Tonga
Benin	Guinea-Bissau	Nepal	Uganda
Burkina Faso	Haiti	Nigeria	Vanuatu
Burundi	India	Pakistan	Yemen
Cameroon	**Indonesia**	Papua NG	Zambia
Côte d'Ivoire	Kenya	Rwanda	Zimbabwe
Djibouti	Kiribati	**Samoa**	
DR Congo	Laos	Senegal	
Equ. Guinea	**Lesotho**	Sudan	
Gabon	Malawi	Tanzania	

based on indicators like level of
antenatal care, immunization,
TB & HIV treatments, cancer
screening, hospital access,
access to essential medicines

bold countries = free healthcare

source: World Health Organization

Unendangered Animals

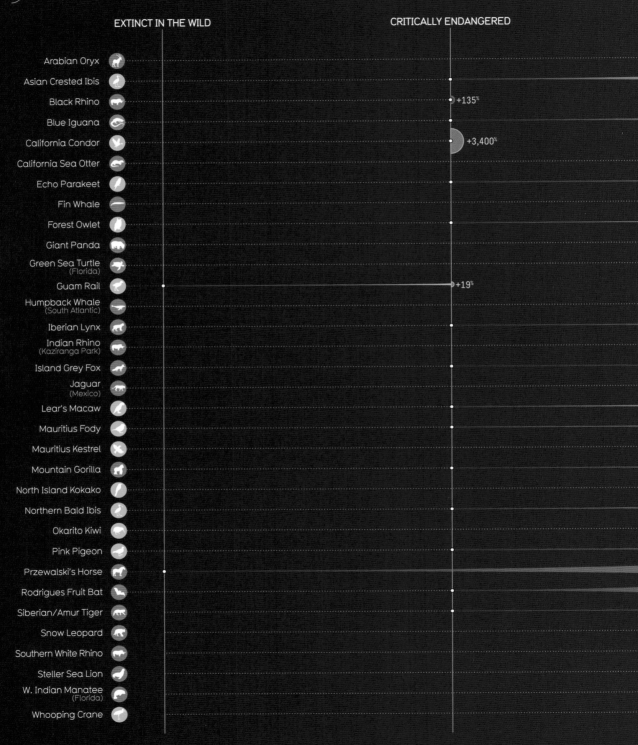

☽ = % change in population

EXTINCT IN THE WILD CRITICALLY ENDANGERED

Arabian Oryx
Asian Crested Ibis
Black Rhino ☽ +135%
Blue Iguana
California Condor ☽ +3,400%
California Sea Otter
Echo Parakeet
Fin Whale
Forest Owlet
Giant Panda
Green Sea Turtle
(Florida)
Guam Rail ☽————————————————☽ +19%
Humpback Whale
(South Atlantic)
Iberian Lynx
Indian Rhino
(Kaziranga Park)
Island Grey Fox
Jaguar
(Mexico)
Lear's Macaw
Mauritius Fody
Mauritius Kestrel
Mountain Gorilla
North Island Kokako
Northern Bald Ibis
Okarito Kiwi
Pink Pigeon
Przewalski's Horse ☽
Rodrigues Fruit Bat
Siberian/Amur Tiger
Snow Leopard
Southern White Rhino
Steller Sea Lion
W. Indian Manatee
(Florida)
Whooping Crane

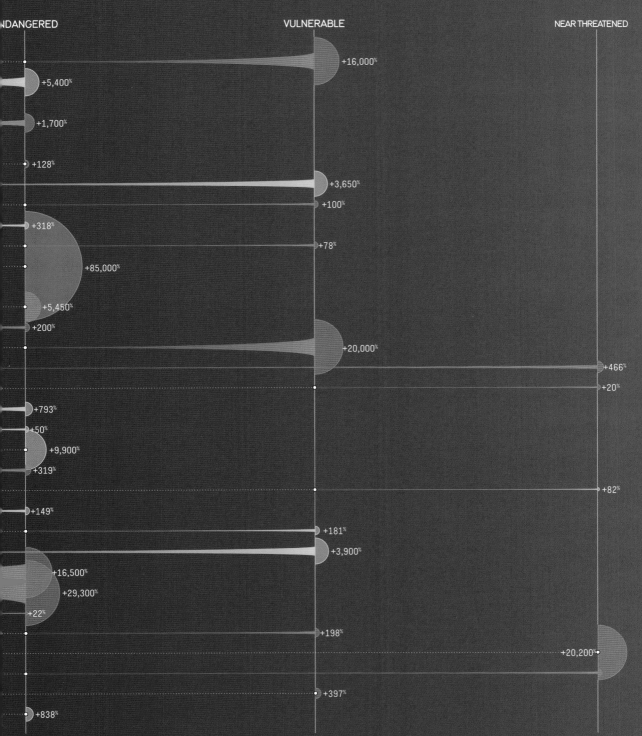

ENDANGERED VULNERABLE NEAR THREATENED

mammal reptile bird

+16,000%

+5,400%

+1,700%

+128%

+3,650%

+100%

+318%

+78%

+85,000%

+5,450%

+200%

+20,000%

+466%

+20%

+793%

+50%

+9,900%

+319%

+82%

+149%

+181%

+3,900%

+16,500%

+29,300%

+22%

+198%

+20,200%

+397%

+838%

sources: IUCN Red List of Threatened Species, World Wildlife Fund, Smithsonian, Guardian, Birdlife International, Insider.com

The Potential of Solar Is Amazing

63,300,000
daily megawatt hours
humanity's entire
electricity use

401,850,000
global solar energy potential

amount we're
currently using

0.5%

source: Sandia National Laboratories

Every Single Year We're Adding More and More
Worldwide solar capacity (gigawatts)

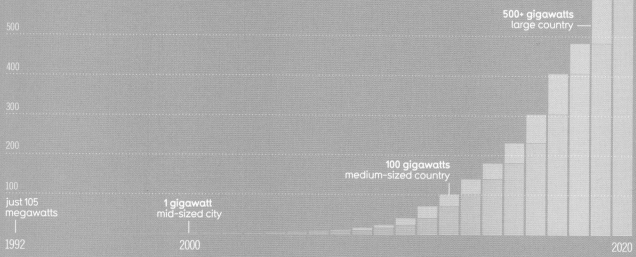

500

400

300

200

100

just 105 megawatts

1 gigawatt
mid-sized city

100 gigawatts
medium-sized country

500+ gigawatts
large country —

1992

2000

2020

A gigawatt of solar supports about 2 million average African people, or 225,000 Europeans
source: International Energy Agency

Efficiency of Solar Panels Is Increasing
Major leaps

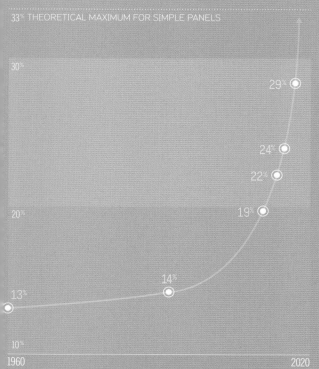

33% THEORETICAL MAXIMUM FOR SIMPLE PANELS

30%

29%

24%

22%

19%

20%

14%

13%

10%

1960

2020

source: EnergySage

The Price Has Decreased
It's never been more competitive

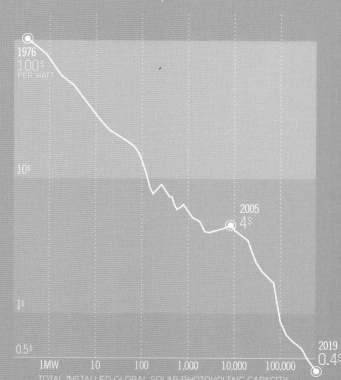

1976
100$
PER WATT

10$

2005
4$

1$

0.5$

1MW 10 100 1,000 10,000 100,000

2019
0.4$

TOTAL INSTALLED GLOBAL SOLAR PHOTOVOLTAIC CAPACITY

source: Our World in Data

Ukraine's first solar power plant has opened at the site of the Chernobyl nuclear disaster

source: *Independent*

Oil Fields Make Great Solar Farms
Just sayin'

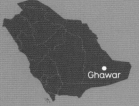

the world's largest oil field is in Saudi Arabia

Ghawar

8,400 square kilometers

it's the size of Tokyo, the world's largest city

CURRENTLY GENERATES **0.9**

petawatt hours of energy per year (1.4% of global use)

WOULD GENERATE **1.6**

petawatt hours as a solar farm (2.4% of global use)

source: Carbon Brief

Types of Solar Power

photovoltaic
solar panels convert energy from the sun into electricity

passive
floors, walls & windows of buildings designed to maximize & store solar energy

thermal
Arrays of many mirrors concentrate the sunlight onto a heatable fluid

concentrated
thousands of mirrors or lenses focus light onto a receiver which drives a turbine

India's PV Capacity Has Quadrupled
Gigawatts

+44%

36
2019
enough for 87 million Indian people

+39%

25
2018

+100%

18
2017

9 GW
2016

+400%

sources: IEA, Quartz

Spain Leads the World in CSP
Megawatts per km²

Spain
456

United Arab Emirates
121

Morocco
119

South Africa
33

Israel
29

USA
18

India
7

others
7

source: Statista.com

It's Legal to Be Gay in the
Majority of the World's Countries

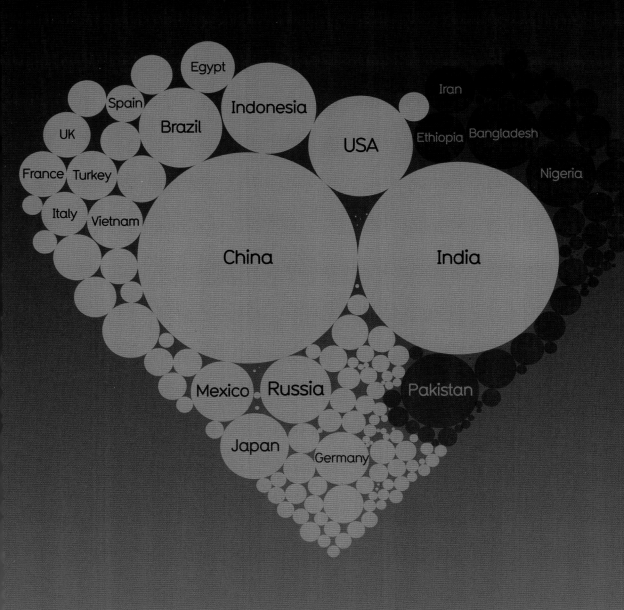

population

source: International Lesbian, Gay, Bisexual, Trans and Intersex Association

300+ US Hospitals Created Their Own Nonprofit Drug Company

Providing generic drugs to hospitals at affordable prices to counter big pharma price hikes

Major price hikes in common drugs
since 2012

Nitropress
Blood pressure

310%

Clomipramine
Obsessive-compulsive disorder

Isuprel
Heart

585%

Doxycycline
Antibiotic

1,300%

20,875%
increase

922%

Niacin ER
Cholesterol

1,790%

Daraprim
Anti-parasitic

3,850%

5,456%

Captopril
ACE inhibitor

Tetracycline
Antibiotic

186 countries agreed on a law to reduce plastic waste

Consent will be required before sending contaminated & unrecyclable plastics to other countries

86 nations agreed to curb aviation emissions

29 US States, Australia, the UK, Japan, South Korea & the EU have all adopted a **renewable portfolio standard**
It requires electrical utilities to get a certain % of their electricity from renewables in a flexible, market-driven way

Amazing Agreements

A New Global Plan Aims to Cut Emissions from International Shipping

Ships are a major contributor to global greenhouse gas emissions

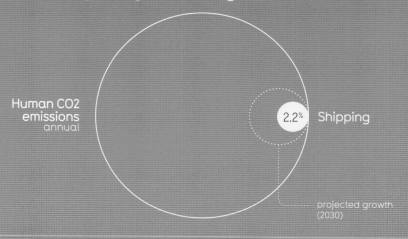

Human CO2 emissions
annual

2.2% Shipping

projected growth (2030)

The United Nations International Maritime Organization adopted a new plan to help solve the problem

CO2 emissions

-40%

-70%

2008 2030 2050

GHG emissions

-50%

2008 2050

energy efficiency
compulsory standards
for all international ships

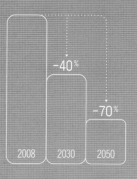

sharing tech
to assist low-income
nations to transition

data collection
on fuel consumption
will be mandatory

source: United Nations International Maritime Organization

World's Biggest Tree Planting Campaigns

India	Brazil	UK			Nepal	Iceland
116 million trees	**73**	**50**	27 Russia		20 Kenya	
			30 Australia (Yarra Yarra)		20 Australia (Landcare)	

Australia
1 BILLION
Forestry plan to meet the goal of the
Paris Climate Change Agreement by 2030

Pakistan
1 BILLION
Billion Tree Tsunami project spearheaded by
cricket-star-turned-politician Imran Khan

China

9.9 BILLION

largest in the world

Northeast Hebei & Qinghai provinces; Hunshandake Desert

total trees that could realistically
be planted on Earth

1.2 TRILLION
1,200,000,000,000

Why Deforestation Is a Bad Idea
Because it...

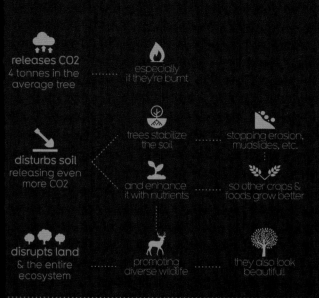

releases CO2
4 tonnes in the average tree
····· especially if they're burnt

trees stabilize the soil ····· stopping erosion, mudslides, etc.

disturbs soil
releasing even more CO2
and enhance it with nutrients ····· so other crops & foods grow better

disrupts land
& the entire ecosystem
promoting diverse wildlife ····· they also look beautiful!

Why Deforestation Happens
Different places, different reasons

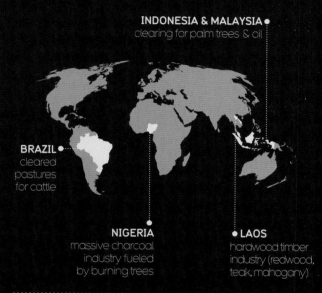

INDONESIA & MALAYSIA
clearing for palm trees & oil

BRAZIL
cleared pastures for cattle

NIGERIA
massive charcoal industry fueled by burning trees

LAOS
hardwood timber industry (redwood, teak, mahogany)

The World Is Ripe for Reforestation
Ideal regions for replanting

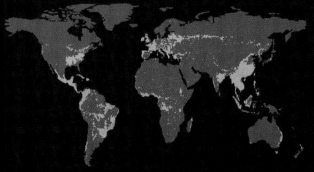

RULES FOR REFORESTATION
protect existing forests

plant on degraded land

engage local people first

'People cut down trees not because they are evil: they do it when the incentives to cut down trees are stronger than the incentives to leave them alone.'

BILL GATES

sources: World Economic Forum, EcoWatch, *New York Times*, BBC, Wikipedia, Bill Gates 'How to Avoid a Climate Disaster', Carbon Dioxide Removal Primer

More Places Are Protecting Animals

More Laws Are Coming into Effect

✳ basic law against cruelty ✴ civil code recognizing sentient nature ✳ constitutional duty to protect animal dignity

Argentina	Australia	Austria	Azerbaijan	Bangladesh	Belgium	Brazil	Bulgaria
Canada	Chile	China	Colombia	Czech Rep.	Denmark	Dom. Republic	Egypt
Finland	France	Germany	Greece	Guatemala	Hong Kong	Hungary	India
Indonesia	Israel	Italy	Japan	Kazakhstan	Kenya	Lebanon	Malawi
Malaysia	Mexico	Myanmar	Nepal	Netherlands	New Zealand	Nicaragua	Nigeria
Norway	Pakistan	P. New Guinea	Paraguay	Peru	Philippines	Poland	Portugal
Romania	Russia	Serbia	Slovakia	Slovenia	S. Africa	S. Korea	Spain
Sri Lanka	Sweden	Switzerland	Taiwan	Tanzania	Thailand	Turkey	Uganda
Ukraine	UAE	UK	USA	Venezuela	Zambia	Zimbabwe	

sources: National Geographic, Global Animal Laws, *Washington Post*

aws to Protect Animals & Pets Are Becoming More Widespread

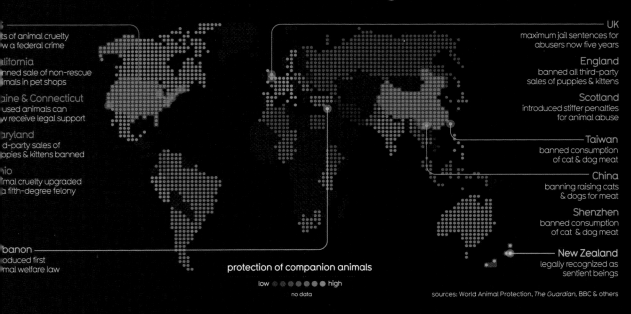

**ts of animal cruelty
w a federal crime**

alifornia
nned sale of non-rescue
imals in pet shops

aine & Connecticut
used animals can
w receive legal support

aryland
d-party sales of
opies & kittens banned

hio
mal cruelty upgraded
a fifth-degree felony

banon
oduced first
mal welfare law

UK
maximum jail sentences for
abusers now five years

England
banned all third-party
sales of puppies & kittens

Scotland
introduced stiffer penalties
for animal abuse

Taiwan
banned consumption
of cat & dog meat

China
banning raising cats
& dogs for meat

Shenzhen
banned consumption
of cat & dog meat

New Zealand
legally recognized as
sentient beings

protection of companion animals

low ● ● ● ● ● ● ● high

no data

sources: World Animal Protection, *The Guardian*, BBC & others

Bans

Wild Animals in Circuses
Whale & Dolphin Captivity
Animal Testing for Cosmetics

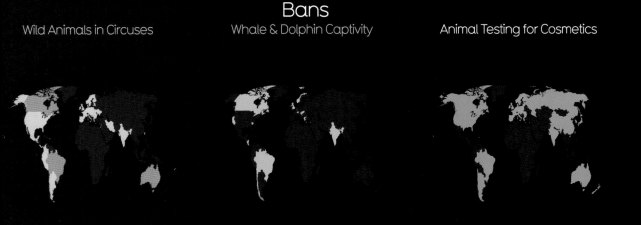

● all animals ● some

● total ban ● ban on fish testing

apturing Baby African lephants for Zoos & ircuses Is Globally

BANNED

Elephants are intelligent
& social, and suffer when
removed from their herds

They can now only be
moved to African countries
with native elephants

Export overseas is
banned - except for
genuine conservation

And Some Animals Are Bouncing Back

Mountain Gorilla Numbers Rising
One of the most endangered species in the world

254
1981

380
2003

486
2010

1,063
2018

sources: Oryx, WWF, *African Journal of Ecology*

Giant Pandas Rebounding
Numbers in the wild **and** captivity

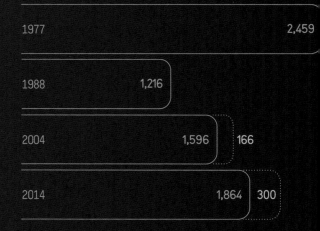

Year	Wild	Captivity
1977	2,459	
1988	1,216	
2004	1,596	166
2014	1,864	300

sources: World Wildlife Fund, IUCN Red Li

Wild Tigers Increasing
Target: nearly doubling the population by 2022

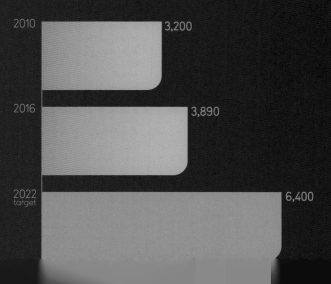

2010 — 3,200
2016 — 3,890
2022 target — 6,400

Rhino Populations Growing
Thanks to law enforcement & population relocati

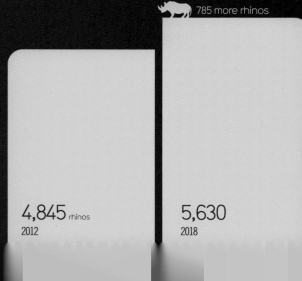

785 more rhinos

4,845 rhinos
2012

5,630
2018

Transport

Supercapacitor Buses Are a Thing Now
Shanghai has a network of efficient rechargeable buses

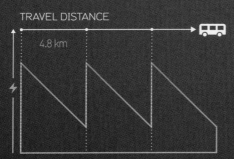

TRAVEL DISTANCE

4.8 km

At each stop, the bus charges its capacitors enough to drive to the next one

Plastic Roads
Made from recycled waste

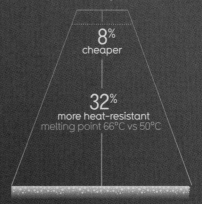

8% cheaper

32% more heat-resistant
melting point 66°C vs 50°C

Made of gravel, tar & a polymer glue extracted from plastic waste

1 km uses the equivalent of
1,000,000
plastic bags

3x longer lasting

70% faster to build

4x lighter

fully recyclable at end of lifespan

Currently made from polypropylene plastic found in

plastic furniture

plastic straws

cosmetic packaging

various car parts

bottle caps

plastic beer cups

The Inflatable Electric Scooter
The 'poimo' fits inside a backpack

quickly inflates
just a few minutes, using a small pump

customizable
could potentially be any shape

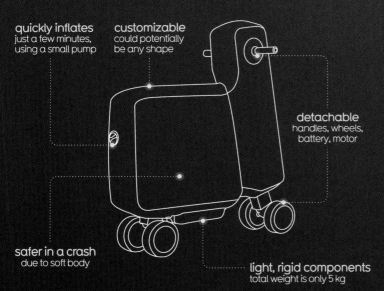

detachable
handles, wheels, battery, motor

safer in a crash
due to soft body

light, rigid components
total weight is only 5 kg

Japanese Wooden Cars

A plant-based nanofiber makes them stronger than steel, but five times lighter, removing as much as two tonnes of carbon from the car's life cycle.

Hydrogen Shipping

shipping emissions
are high, around 2% of all greenhouse gases

green hydrogen
converted to ammonia fuel = zero emissions

▸000

sources: Shine.cn, PlasticRoad BV, Dezeen, Japanese Ministry of the Environment

Microscopic ph algae in the up absorb four tim more CO2 than the Amazon

as much as 40% of our emissions

the equivalent of 1.7 TRILLION trees

ytoplankton
oper ocean
es

source: Buesseler et al (2020), *BBC Science Focus* magazine

The Kigali Amendment is maybe one of the best global agreements you've never heard of

It seeks to eliminate the use of hydrofluorocarbons

HFCs are human-made gases

We use them to replace ozone-destroying CFCs

air-conditioning ·········· used in ·········· refrigeration

HFCs up to 12,500x more

Unfortunately, they are also extremely potent greenhouse gases

warming potential of CO2

They're emitted in very small quantities...

contribution to warming 2%

...but these quantities are rising

megatonnes emitted

2000 2010

Enter the Kigali Amendment

It aims to cut HFC use by 80–85% by the late 2040s starting...

2019

rich and developed economies
e.g. Canada & EU

2024

large & emerging economies
China & Brazil

2028

hot climate, lower-income nations
India, Pakistan, Saudi Arabia

118 countries have signed up so far

If successful, the Kigali Amendment will cut warming by 0.5°C by the end of the century

The Circular Economy Makes Sense

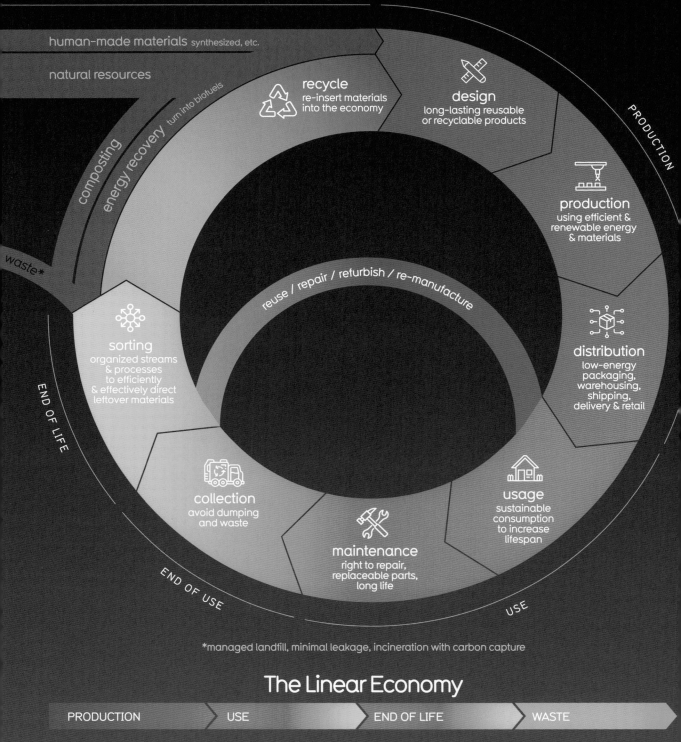

INPUT/SOURCE

human-made materials synthesized, etc.

natural resources

PRODUCTION

recycle
re-insert materials
into the economy

design
long-lasting reusable
or recyclable products

turn into biofuels

composting

energy recovery

production
using efficient &
renewable energy
& materials

waste*

reuse / repair / refurbish / re-manufacture

distribution
low-energy
packaging,
warehousing,
shipping,
delivery & retail

sorting
organized streams
& processes
to efficiently
& effectively direct
leftover materials

END OF LIFE

usage
sustainable
consumption
to increase
lifespan

collection
avoid dumping
and waste

maintenance
right to repair,
replaceable parts,
long life

END OF USE

USE

*managed landfill, minimal leakage, incineration with carbon capture

The Linear Economy

| PRODUCTION | USE | END OF LIFE | WASTE |

source: Ellen McArthur Foundation

Electric Cars Are a No-Brainer

They Are Inevitable
Million electric cars on the world's roads

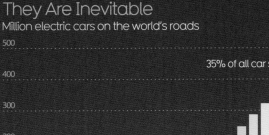

35% of all car sales

500
400
300
200
100

2015 2020 2030 2040

source: Bloomberg NEF

They Are Way More Efficient
% of energy delivered to wheels

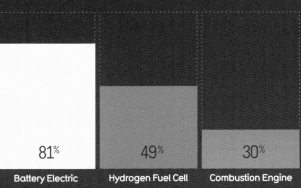

Battery Electric — 81%
Hydrogen Fuel Cell — 49%
Combustion Engine — 30%

source: Princeton University

We Are So Close to the 'Tipping Point'
When different car types are most feasible....

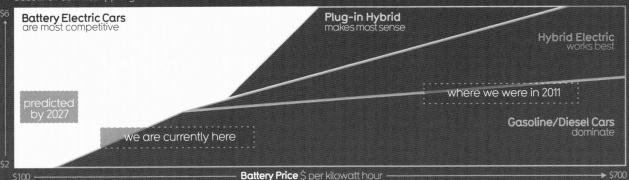

Gasoline Fuel Price $ per gallon

$6

Battery Electric Cars are most competitive

Plug-in Hybrid makes most sense

Hybrid Electric works best

predicted by 2027

where we were in 2011

we are currently here

Gasoline/Diesel Cars dominate

$2

$100 — **Battery Price** $ per kilowatt hour — $700

source: McKinsey

Norway Is Leading the Charge
Over half of new car sales are electric

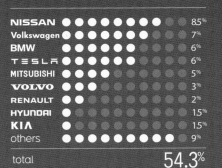

NISSAN	8.5%
Volkswagen	7%
BMW	6%
TESLA	6%
MITSUBISHI	5%
VOLVO	3%
RENAULT	2%
HYUNDAI	1.5%
KIA	1.5%
others	9%

total **54.3%**

- extensive charging network 13,000+ points
- government subsidies on new cars
- reduced parking fees & road tolls

source: US Department of Energy

Along with California
electric vehicles sold

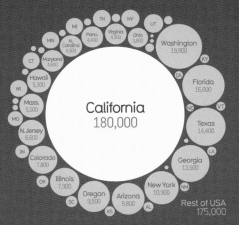

California 180,000

Washington 19,900
Florida 16,800
Texas 14,400
Georgia 13,500
New York 10,900
Arizona 9,800
Oregon 9,500
Illinois 7,900
Colorado 7,800
N. Jersey 6,600
Mass. 5,500
Hawaii 5,300
Maryland 4,800
N. Carolina 4,500
Penn. 4,400
Virginia 4,300
Ohio 3,800

TN NV UT MI MN CT WI MO IN OK SC KS AL NM LA VT NE IA KY

Rest of USA 175,000

source: US Department of Energy

...Europe and China
million sales 2018 2019 **2020**

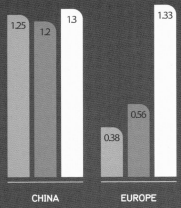

CHINA — 1.25 / 1.2 / 1.3
EUROPE — 0.38 / 0.56 / 1.33

source: BusinessWire

Electric Cars
Have The Lowest Costs & Emissions Over Time

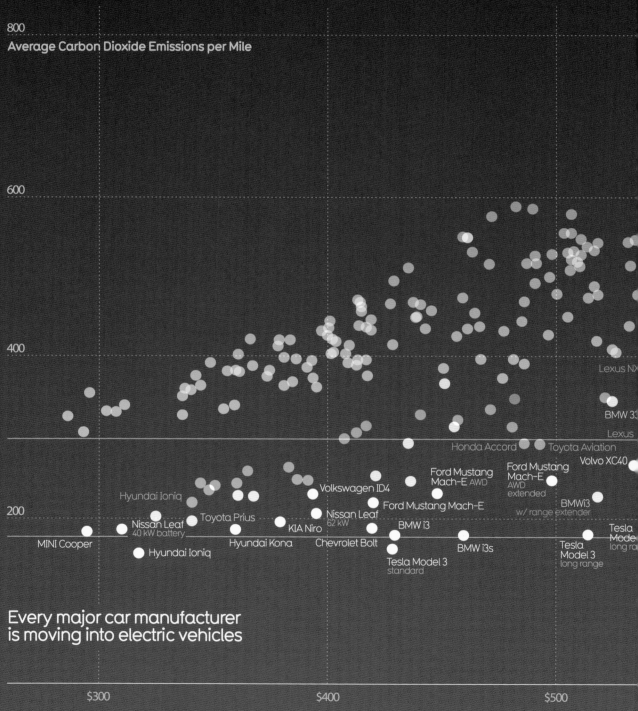

800

Average Carbon Dioxide Emissions per Mile

600

400

Lexus NX

BMW 33

Lexus

Honda Accord Toyota Aviation

Volvo XC40

Ford Mustang
Mach-E AWD

Ford Mustang
Mach-E
AWD
extended

Hyundai Ioniq

Volkswagen ID4

BMWi3
w/ range extender

Ford Mustang Mach-E

200

Toyota Prius

Nissan Leaf
62 kW

Nissan Leaf
40 kW battery

KIA Niro

BMW i3

Tesla
Mode
long ra

MINI Cooper

Hyundai Kona Chevrolet Bolt

BMW i3s

Tesla
Model 3
long range

Hyundai Ioniq

Tesla Model 3
standard

Every major car manufacturer
is moving into electric vehicles

$300 $400 $500

Average Cost per Month
(purchase price, maintenance, fuel)

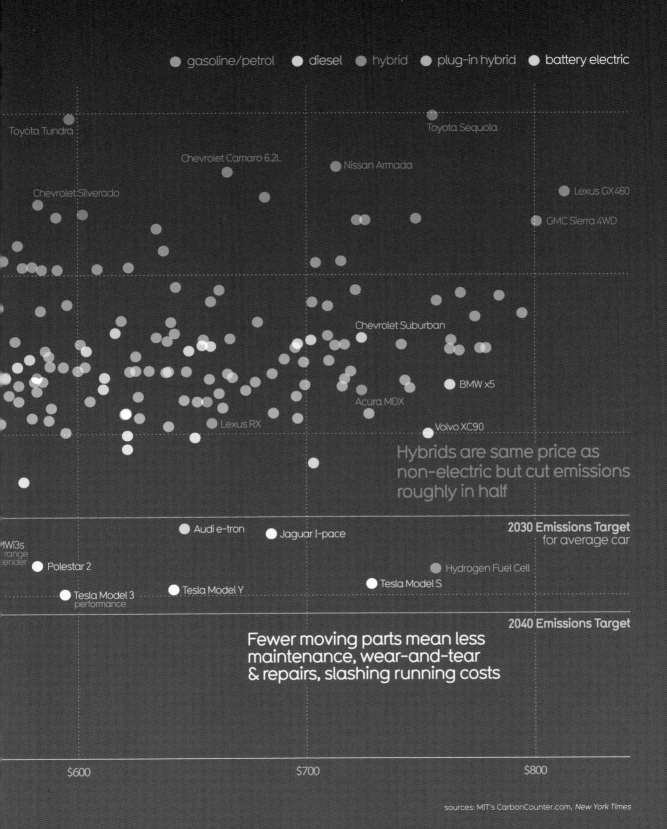

gasoline/petrol ● diesel ● hybrid ● plug-in hybrid ● battery electric

Toyota Tundra

Toyota Sequoia

Chevrolet Camaro 6.2L

Nissan Armada

Chevrolet Silverado

Lexus GX460

GMC Sierra 4WD

Chevrolet Suburban

BMW x5

Acura MDX

Lexus RX

Volvo XC90

Hybrids are same price as
non-electric but cut emissions
roughly in half

2030 Emissions Target
for average car

Audi e-tron

Jaguar I-pace

MWi3s
range
ender

Polestar 2

Hydrogen Fuel Cell

Tesla Model Y

Tesla Model S

Tesla Model 3
performance

2040 Emissions Target

Fewer moving parts mean less
maintenance, wear-and-tear
& repairs, slashing running costs

$600

$700

$800

sources: MIT's CarbonCounter.com, *New York Times*

Batteries Are Getting Better & Better

2-3x increase likely

600

Rechargable Lithium–based Batteries Are the World Leader

very versatile
due to high weight-
to-power ratios

ideal for

phones

laptops

tools

electric cars

great cycle life
can be charged &
discharged many times

abundant material
enough world lithium for
one billion electric cars

They Are Getting Cheaper & More Powerful

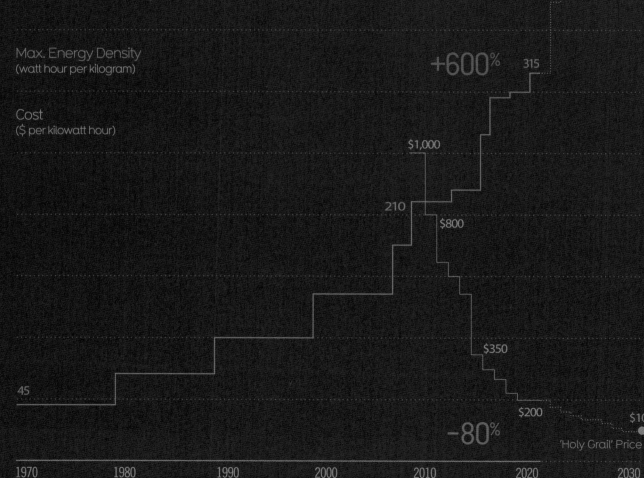

Max. Energy Density
(watt hour per kilogram)

Cost
($ per kilowatt hour)

+600% 315

$1,000

210

$800

45

$350

$200

−80%

$10

'Holy Grail' Price

1970 1980 1990 2000 2010 2020 2030

sources: Bloomberg NEF, Chen-Xi Zu et al (2011), * = theoretical limit for Liithium batteries is 1,000 Wh/Kg

Old-School, Current & Future Battery Technology

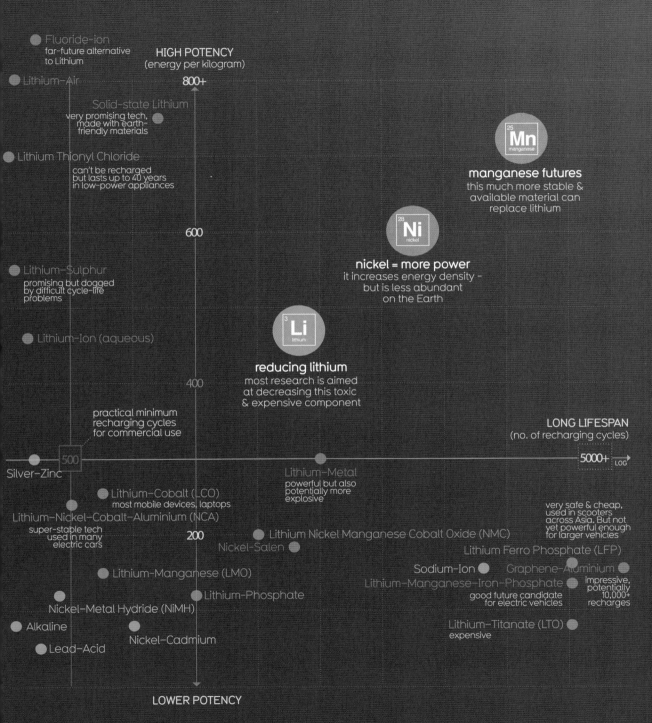

HIGH POTENCY
(energy per kilogram)

Fluoride-ion
far-future alternative
to Lithium

800+

Lithium-Air

Solid-state Lithium
very promising tech,
made with earth-
friendly materials

Lithium Thionyl Chloride
can't be recharged
but lasts up to 40 years
in low-power appliances

manganese futures
this much more stable &
available material can
replace lithium

Mn
25
manganese

600

Ni
28
nickel

nickel = more power
it increases energy density -
but is less abundant
on the Earth

Lithium-Sulphur
promising but dogged
by difficult cycle-life
problems

Li
3
lithium

Lithium-Ion (aqueous)

reducing lithium
most research is aimed
at decreasing this toxic
& expensive component

400

practical minimum
recharging cycles
for commercial use

LONG LIFESPAN
(no. of recharging cycles)

500

5000+ LOG

Silver-Zinc

Lithium-Metal
powerful but also
potentially more
explosive

Lithium-Cobalt (LCO)
most mobile devices, laptops

very safe & cheap,
used in scooters
across Asia. But not
yet powerful enough
for larger vehicles

Lithium-Nickel-Cobalt-Aluminium (NCA)
super-stable tech
used in many
electric cars

200

Lithium Nickel Manganese Cobalt Oxide (NMC)

Nickel-Salen

Lithium Ferro Phosphate (LFP)

Lithium-Manganese (LMO)

Sodium-Ion

Graphene-Aluminium

Lithium-Manganese-Iron-Phosphate
good future candidate
for electric vehicles

impressive,
potentially
10,000+
recharges

Lithium-Phosphate

Nickel-Metal Hydride (NiMH)

Alkaline

Lithium-Titanate (LTO)
expensive

Lead-Acid

Nickel-Cadmium

LOWER POTENCY

sources: *Forbes*, Associated Press, Battery University, Yang et al (2019), Broux (2018), Wikipedia

Fewer People Are Suffering from Neglected Tropical Diseases

29% of world population affected

21%

2010 2017

Major NTDs

 = impact on lives (DALYS

ansen's Disease
Curable bacterial
infection causes
skin & nerve
damage

Echinococcosis
A hookworm
disease, often
spread by dogs,
causing cysts

Trematodiasis
Liver and lung
disease carried
in fish and
vegetables

River blindness
Parasitic infection
with severe
itching & eventual
blindness

Leishmaniasis
Spread by sand
flies, triggering
skin sores and
organ damage

Yaws
Chronic infection
affecting the skin,
bone, and
cartilage

Rabies
Fatal infection of
brain and nerves,
spread by dogs &
bats

Cysticercosis
Tapeworm
infection causes
cysts in eyes,
brain & spine

Lymphatic filariasis
Chronic disease
from microscopic
worms, spread by
mosquito bites

Dengue fever
Mosquito-borne
infection with
flu-like
symptoms

Schistosomiasis
Flatworm infection
causing organ
damage and
stunted growth

Helminthiasis
Parasitic worm
disease causing
gastrointestinal
symptoms

A Wall of Fertile Land Will Cross Africa
The Great Green Wall is a mosaic of trees, cropland & ecosystems

improve food
& water supply

restore 1 million km2
of degraded land

create 10 million
rural jobs

250m
tonnes
sequester
carbon dioxide

prevent
migration out

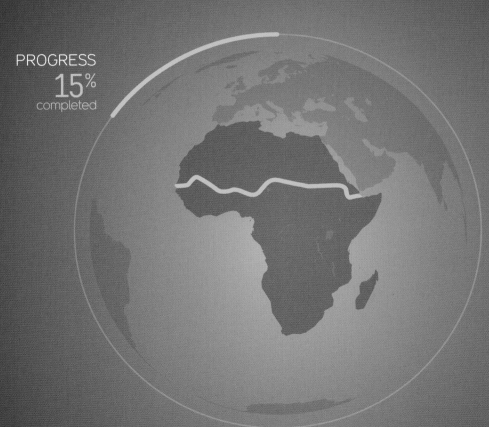

PROGRESS
15%
completed

FINAL LENGTH
8,000km

source: GreatGreenWall.org

carbon taxes/pricing

fees that must be paid when greenhouse gases are released into the atmosphere

Current emitters don't pay for the climate damage caused by emissions

That's why fossil fuels stay artificially cheap to produce and use. Their true cost is hidden.

(usually hundreds of billion dollars a year – hurricanes, wildfires, floods, heatwaves, forest fires)

Carbon pricing reinjects these costs back into the economy to create a true price for emissions.

This coaxes businesses to pay for environmental pollution so returning any revenue back to taxpayers & society

If done well, carbon pricing can...

use market forces effectively to encourage change

act as a disincentive to emit greenhouse gases

spur creation of carbon-free alternatives

reduce consumption of carbon fuels

motivate improvement of energy efficiency

peed up the transition to zero-carbon fuels

reduce or even eliminate the use of fossil fuels

raise money to combat climate fallout & rising energy costs

It's challenging to make work, but currently the best option for a fair, global framework that will actually drive down emissions

the Paris Agreement has many provisions for carbon pricing

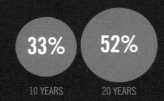

33%
10 YEARS

52%
20 YEARS

models show carbon taxes & pricing substantially reducing emissions

many systems are already in place or planned....

sources: Carbon Tax Center, National Geographic, Carbon Brief, Clean Technica, World Bank, *New York Times*

Carbon Pricing Is Catching On Around the World

57 schemes implemented or scheduled worldwide

46 national, 28 subnational regions and cities

$230 billion carbon trading global market already established

growing fast year on year ≈ 30% in 2019

 on track to become one of the biggest commodity markets

 11 gigatonnes or 20% of human emissions covered

Global Carbon Schemes IN OPERATION SCHEDULED UNDER CONSIDERATION

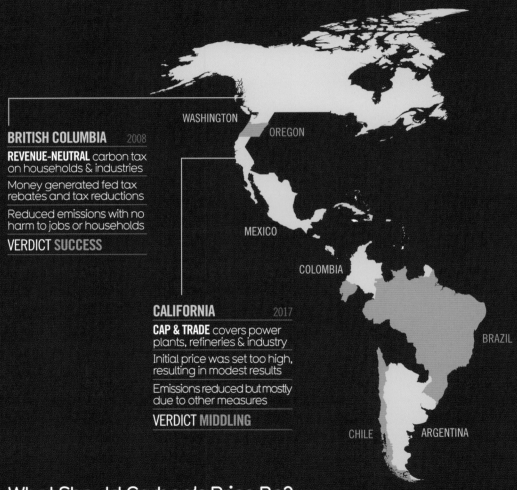

WASHINGTON

OREGON

MEXICO

COLOMBIA

BRAZIL

CHILE

ARGENTINA

BRITISH COLUMBIA 2008

REVENUE-NEUTRAL carbon tax on households & industries

Money generated fed tax rebates and tax reductions

Reduced emissions with no harm to jobs or households

VERDICT SUCCESS

CALIFORNIA 2017

CAP & TRADE covers power plants, refineries & industry

Initial price was set too high, resulting in modest results

Emissions reduced but mostly due to other measures

VERDICT MIDDLING

What Should Carbon's Price Be?

Calculating the correct price for carbon pollution is difficult as the social cost varies between countries

CARBON PRICE $ PER TONNE OF CO2e

$40 - $80 MINIMUM PRICE TO MEET PARIS CLIMATE CHANGE AGREEMENT

| CALIFORNIA $16 | UK $25 | IRELAND $38 | SPAIN & FRANCE ~$49 | NORWAY $59 | CANADA $63 |

types

- **WELL HEAD** the company which extracts the carbon is taxed
- **REVENUE-NEUTRAL** softens impact of pricing by reducing taxes elsewhere in society
- **CAP & TRADE** companies buy, sell & trade a fixed number of permits to emit carbon
- **HYBRID** a mix, perhaps involving subsidies, feed-in tariffs, direct carbon taxes, etc.

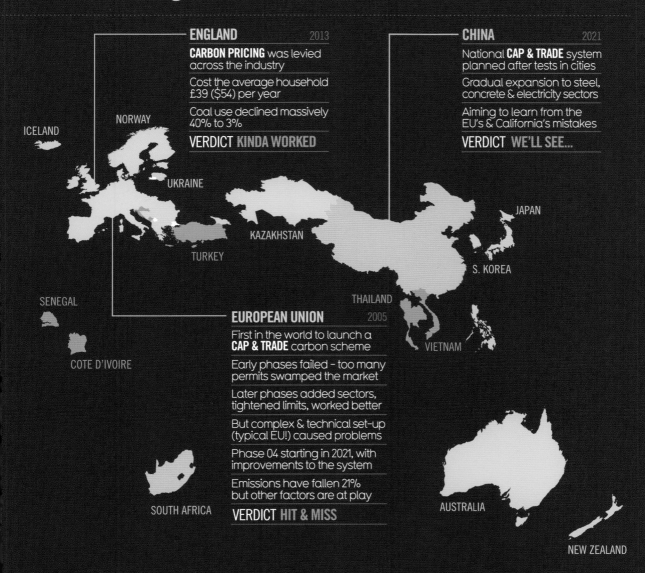

ENGLAND · 2013

CARBON PRICING was levied across the industry

Cost the average household £39 ($54) per year

Coal use declined massively 40% to 3%

VERDICT KINDA WORKED

CHINA · 2021

National **CAP & TRADE** system planned after tests in cities

Gradual expansion to steel, concrete & electricity sectors

Aiming to learn from the EU's & California's mistakes

VERDICT WE'LL SEE...

EUROPEAN UNION · 2005

First in the world to launch a **CAP & TRADE** carbon scheme

Early phases failed – too many permits swamped the market

Later phases added sectors, tightened limits, worked better

But complex & technical set-up (typical EU!) caused problems

Phase 04 starting in 2021, with improvements to the system

Emissions have fallen 21% but other factors are at play

VERDICT HIT & MISS

ICELAND · NORWAY · UKRAINE · KAZAKHSTAN · TURKEY · JAPAN · S. KOREA · THAILAND · VIETNAM · SENEGAL · COTE D'IVOIRE · SOUTH AFRICA · AUSTRALIA · NEW ZEALAND

| ARGENTINA $72 | COLOMBIA $84 | CHILE $89 | SWITZERLAND $96 | SINGAPORE $101 | JAPAN $106 | MEXICO $109 | SWEDEN $127 | POLAND $129 |

sources: World Bank, New York Times

US Smoking Rates Are the Lowest Ever

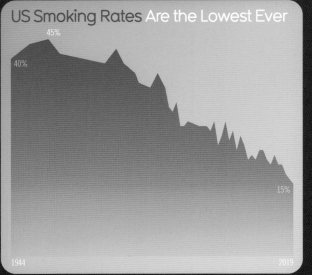

45%
40%
15%
1944
2019

source: Gallup

Suicide Attempts Among LGBT Teens Fell After Same-Sex Marriage Was Legalized

% US LGBT students attempting to take their own life

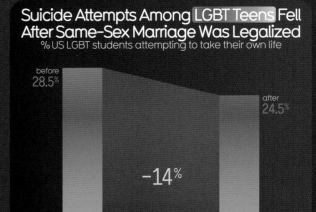

before
28.5%

after
24.5%

−14%

source: JAMA Pediatrics, 2017 data

Oil Spills Have Decreased
thousand tonnes spilt

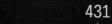

636 Main spill:
Independenta (95)
Romanian carrier collided
with a Greek freighter at the
southern entrance of
Bosphorus, Turkey

383

384

431

ABT Summer (260)
Liberian flag, Iranian oil.
Sank due to unexplained
explosion 700 miles off the
coast of Angola

190

Sanchi (113) **116**
Iranian-owned tanker hit a
Hong Kong-flagged cargo ship
300 km off Shanghai, China

1970

2019

sources: International Tankers Owners Pollution Federation Limited

Norway Recycles Almost All of Their Plastic Bottles

Norway
97%
recycling rate

United States
30%

These Cities Are Ruling Bike-Sharing
rental bikes per 100,000 people

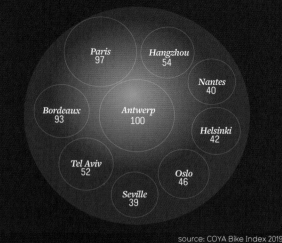

Paris 97
Hangzhou 54
Nantes 40
Bordeaux 93
Antwerp 100
Helsinki 42
Tel Aviv 52
Oslo 46
Seville 39

Most Women Have Some Legal Access to Abortion

Reasons permitted:

any	social/economic	life at risk only	health	none
36%	23%	22%	14%	5%

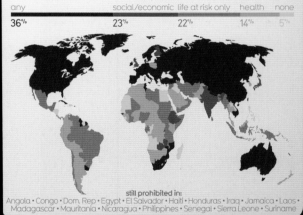

still prohibited in:
Angola • Congo • Dom. Rep • Egypt • El Salvador • Haiti • Honduras • Iraq • Jamaica • Laos • Madagascar • Mauritania • Nicaragua • Philippines • Senegal • Sierra Leone • Suriname

Soy & Oat Milk Are the Most Sustainable

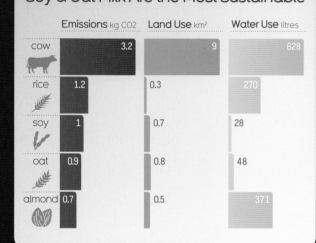

	Emissions kg CO2	Land Use km²	Water Use litres
cow	3.2	9	628
rice	1.2	0.3	270
soy	1	0.7	28
oat	0.9	0.8	48
almond	0.7	0.5	371

Global Literacy Is Increasing

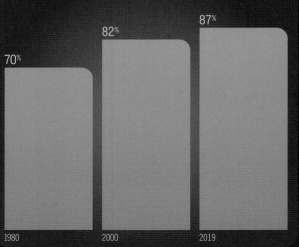

1980	2000	2019
70%	82%	87%

Ecosia is a search engine that plants trees every time you search.

82,500,000 so far
One every 1.3 seconds

A 100% Biodegradable, Comfortable Sanitary Pad Has Finally Been Developed

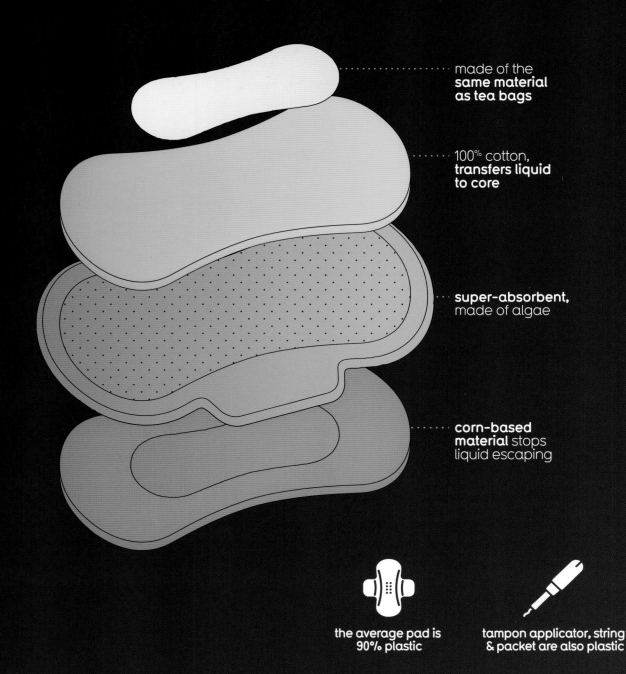

made of the **same material as tea bags**

100% cotton, transfers liquid to core

super-absorbent, made of algae

corn-based material stops liquid escaping

the average pad is **90% plastic**

tampon applicator, string & packet are also plastic

BIO PAD
1.5 to 6 months to degrade

Nearly a Quarter of the World Now Supports
Sales-Tax-Free or Reduced-Cost Menstrual Products

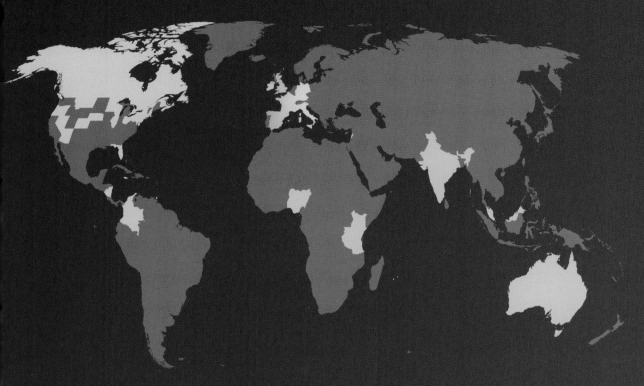

Australia, Canada, Colombia, India, Ireland, Jamaica, Kenya, Lebanon, Malaysia, Mauritius, Nicaragua, Nigeria, Tanzania, Trinidad & Tobago

Alaska, Arizona, Colorado, Connecticut, D.C., Delaware, Florida, Illinois, Maryland, Massachusetts, Minnesota, Montana, Nebraska, Nevada, New Hampshire, New Jersey, New York, Ohio, Oregon, Pennsylvania, Wisconsin

17 billion tampons are sold yearly

and at least 40% more sanitary pads

98% are discarded, ending up in landfills

and take hundreds of years to degrade

NORMAL PAD
centuries to degrade

sources: University of Utah, Civio, BBC, Tax Foundation

Yay Germany!

Germany's Renewable Energies Are Pushing Back on Fossil Fuels

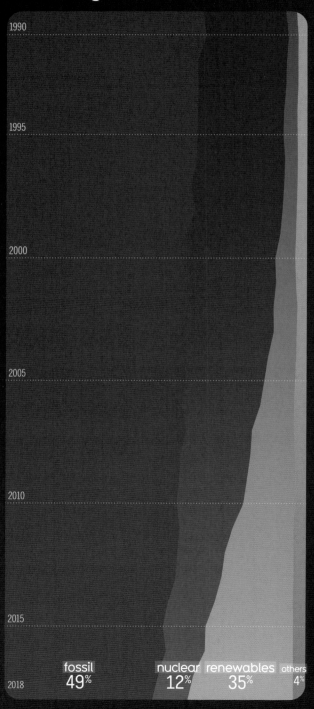

| 1990 |
| 1995 |
| 2000 |
| 2005 |
| 2010 |
| 2015 |
| 2018 |

fossil **49**% **nuclear** **12**% **renewables** **35**% others **4**%

source: Energie AG

Over Two-Thirds of Refugees in Germany Are Employed after Five Years

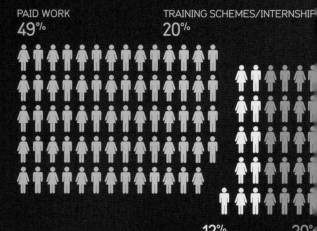

PAID WORK
49%

TRAINING SCHEMES/INTERNSHIP
20%

12%
'MINI JOBS'
earning less than
€450 per month

20%
UNEMPLOYED

source: Deutsche Welle, Data 2013-201

The first country in the world to ban chick-shredding

the chicken & egg industry's dirty secret

all newborn
male chicks
are killed
at birth

often by just
being thrown
into mechanical
shredders

because they
can't lay eggs
so are not
profitable

45 MILLION CHICKS KILLED A YEAR IN GERMANY ALONE
123,000 per day **5,100** per hour **85** per minute

⊗ verboten from January 1, 2022 ⊗

farmers will use tech to determine
a chick's sex before birth

source: DW.com

More and More People Are Gaining
Access to Electricity

89.6%

71.5%
plugged in

340,000
people per day

1990

2018

source: World Bank

New Ways to Create & Store Energy

In-Stream Hydro Generates Zero-Carbon Power Without Environmental Damage

Small hydropower units can be placed in rivers or even inside city water pipes

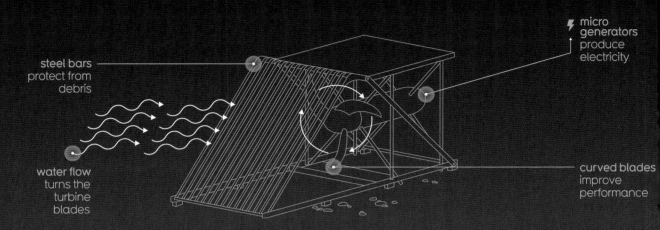

steel bars protect from debris

water flow turns the turbine blades

micro generators produce electricity

curved blades improve performance

From Alaska to Nepal, schemes are being proposed in remote communities to replace old, dirty, and expensive diesel generators

PROS

 predictable power output

 easy to install and maintain

 very little space required

 low costs (no dams)

 low ecological impact

minimal noise disturbance

CONS

 low power in summer months

 care to avoid hurting fish

source: Smart Hydro Power

Rivers Could Generate Thousands of Power Plants' Worth of Energy

Salt is made of positive and negative charged particles

When salt water meets fresh water, the particles detach

Newly invented blue membrane separates them

Separate areas are then connected by wire to generate electricity

source: *Science* magazine

Coating Solar Panels with Carbon Nanotubes* Can Triple Efficiency

TRADITIONAL PANEL

WITH NANOTUBES

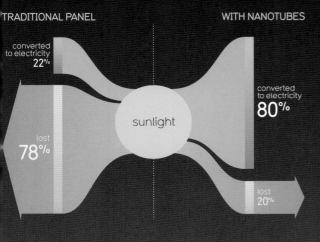

converted to electricity **22%**

sunlight

lost **78%**

converted to electricity **80%**

lost **20%**

* tubes one millionth of a millimeter wide with extraordinary electrical & thermal properties

source: Rice University

Combining Solar Panel Technologies Could Boost Energy Production by a Third

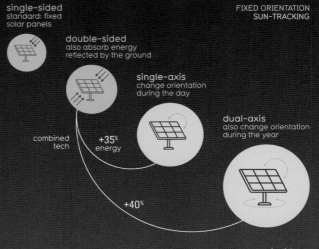

single-sided
standard: fixed solar panels

double-sided
also absorb energy reflected by the ground

single-axis
change orientation during the day

dual-axis
also change orientation during the year

FIXED ORIENTATION
SUN-TRACKING

combined tech

+35% energy

+40%

source: newscientist.com

A New Device Can Harness Electricity from Raindrops

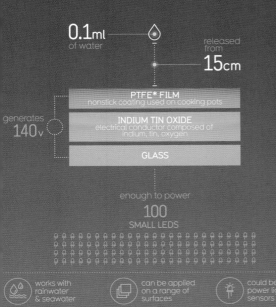

0.1ml of water

released from **15cm**

PTFE* FILM
nonstick coating used on cooking pots

INDIUM TIN OXIDE
electrical conductor composed of indium, tin, oxygen

GLASS

generates **140v**

enough to power **100** SMALL LEDS

works with rainwater & seawater

can be applied on a range of surfaces

could be used to power lights or sensors

* polytetrafluoroethylene

source: Wanghuai Xu et al (2020)

Ingenious Concrete-Filled Trains Act as Giant Batteries

Excess power slowly pulls trains up a slope

Regenerative braking produces electricity on the way back down

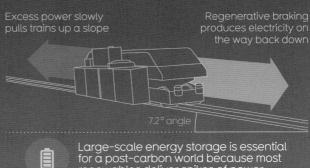

7.2° angle

Large-scale energy storage is essential for a post-carbon world because most renewables deliver spikes of power

% of energy retrievable:

TRAINS	80%
FLYWHEELS	80–90%
BATTERIES	75–90%
HYDRO	65–80%
ELECTROTHERMAL	65–75%
COMPRESSED AIR	65–75%

*e.g. water wheels, steam engines, etc

sources: OVO Energy, Energymag

Yay USA!

American People Are Very Generous...
Average $ donated per person per year

$1,370

$1,000

$500

1976

2019

...Donating Billions per Year

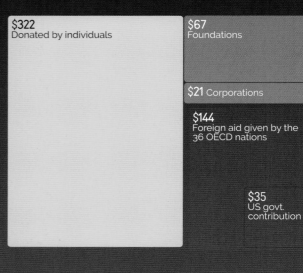

$322
Donated by individuals

$67
Foundations

$21 Corporations

$144
Foreign aid given by the
36 OECD nations

$35
US govt.
contribution

US Prisoner Numbers Are Finally Declining
Yearly increase/decrease

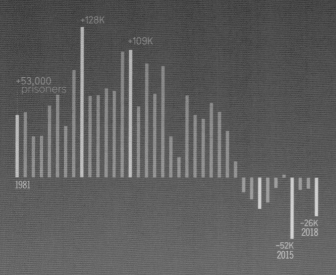

+128K

+109K

+53,000
prisoners

1981

−52K
2015

−26K
2018

Along with Black Incarceration Rates
Variation in % of total prisoners

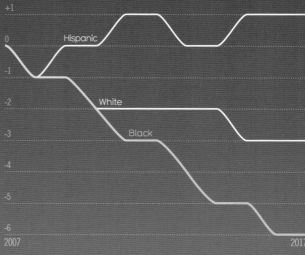

+1

0

−1

Hispanic

−2

White

−3

Black

−4

−5

−6

2007

2017

The Average US Citizen Now Lives Much Longer After Retirement

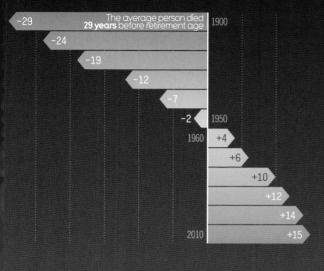

−29	The average person died **29 years** before retirement age
−24	1900
−19	
−12	
−7	
−2	1950
+4	1960
+6	
+10	
+12	
+14	
+15	2010

source: Statista

US Recycling Is Finally Picking Up

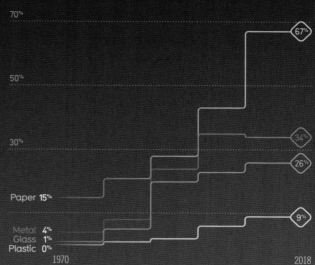

70%
50%
30%

Paper 15%

Metal 4%
Glass 1%
Plastic 0%

1970

67%
34%
26%
9%

2018

source: US Environmental Protection Agency

US Teen Pregnancies Have Halved

Births per 1,000 females aged 15–19

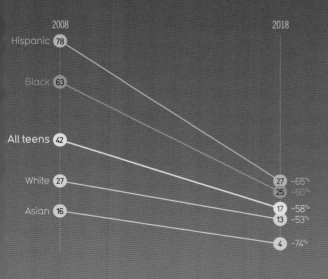

2008 2018

Hispanic (78) 27 −65%
 25 −60%
Black (63)

All teens (42) 17 −58%
 13 −53%
White (27)

Asian (16) 4 −74%

sources: Centers for Disease Control, Pew Research Center

US Child Poverty Has Reached an All-Time Low

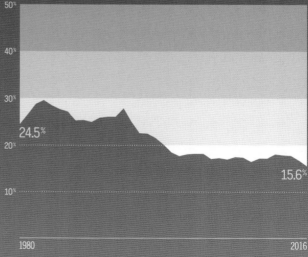

50%
40%
30%
24.5%
20%
15.6%
10%

1980 2016

source: US Department of Agriculture

The US Aims to Halve Food Waste by 2030

A joint effort by institutions, restaurants & grocery stores

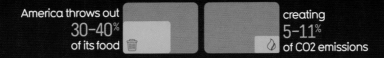

America throws out **30–40%** of its food

creating **5–11%** of CO_2 emissions

over $162bn worth

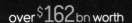

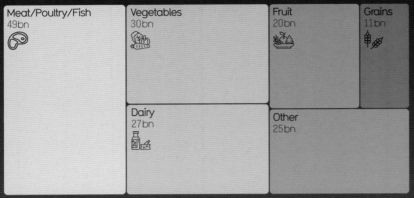

Meat/Poultry/Fish
49bn

Vegetables
30bn

Fruit
20bn

Grains
11bn

Dairy
27bn

Other
25bn

Breakdown by source

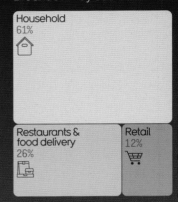

Household
61%

Restaurants & food delivery
26%

Retail
12%

that's **58** billion meals

Why is this Happening?

spoilage
insects, rodents, molds & bacteria

poor management
bad conservation, over-ordering

customers
buy or cook more than needed

attitude
42% don't have time to consider waste

How will it be fixed?

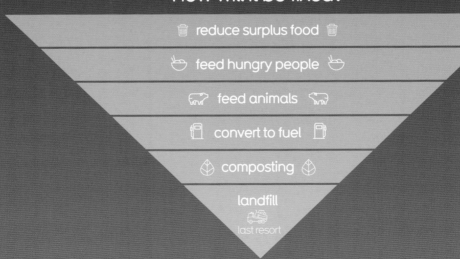

- reduce surplus food
- feed hungry people
- feed animals
- convert to fuel
- composting
- landfill
 last resort

sources: USDA, Rescuing Leftover Cuisine, UNEP, Qi (2016)

HIV / AIDS

The World's No. 5 Killer Infection
Infectious disease deaths per day

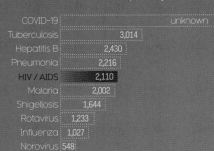

COVID-19	unknown
Tuberculosis	3,014
Hepatitis B	2,430
Pneumonia	2,216
HIV / AIDS	2,110
Malaria	2,002
Shigellosis	1,644
Rotavirus	1,233
Influenza	1,027
Norovirus	548

source: XXXXX

Claims Nearly 1m Lives Per Year
Million global deaths per year

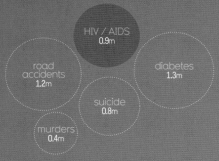

- HIV / AIDS 0.9m
- road accidents 1.2m
- diabetes 1.3m
- suicide 0.8m
- murders 0.4m

source: XXXXX

Mostly in Southern Africa
Highest deaths

Highest deaths
0% 1% 2.5% 5% 10% 20% 25% 50%

source: Our World in Data

But HIV/AIDS Is in Remission Globally
Thanks mainly to widespread anti-viral-drug treatment

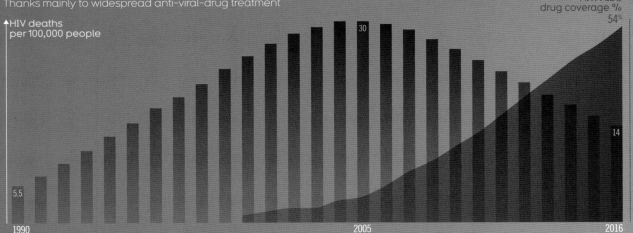

HIV deaths per 100,000 people

HIV/AIDS drug coverage % — 54%

5.5 · 30 · 14

1990 · 2005 · 2016

source: Global Health Data Exchange

Prevention of Mother-to-Child HIV Transmission Is Saving Kids

pregnant women with HIV receiving anti-retroviral meds

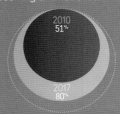

2010 51%
2017 80%

averted child HIV infections (2010–2018)

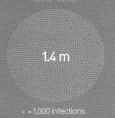

1.4 m

• = 1,000 infections

risk of HIV transmission from mother to infant

no treatment
15% · 45%

with treatment
<5%

source: Avert.org

Even More Sufferers Are Being Treated
% treated (past & projected)

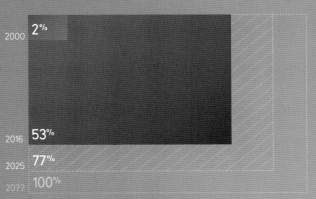

2000 2%
2016 53%
2025 77%
20?? 100%

sources: *The Lancet, The Guardian*

The Potential of Wind Power Is Amazing

480,000,000
daily megawatt hours
global wind-energy potential

63,300,000
humanity's entire
electricity use

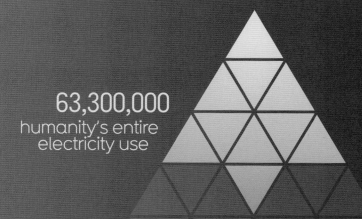

0.8%

amount we're currently using

source: Global Wind Energy Council

It Now Supplies 5% of the World's Energy
and it's growing

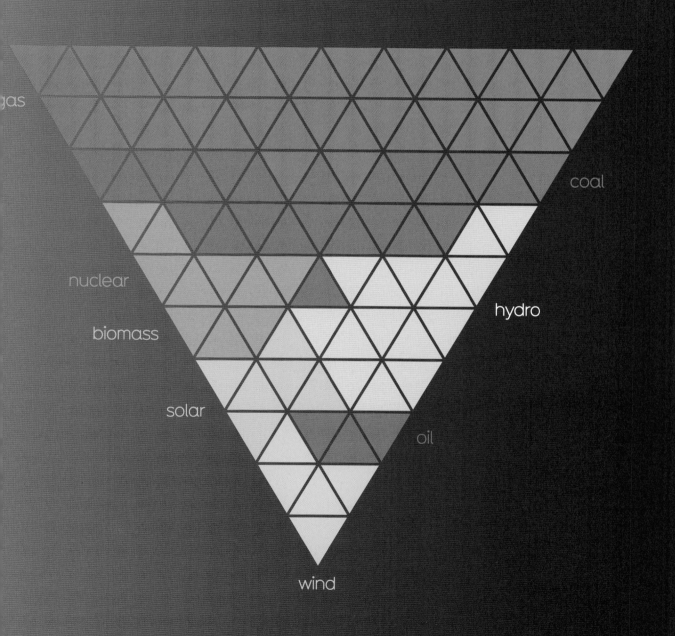

gas

coal

nuclear

hydro

biomass

solar

oil

wind

source: International Energy Agency

Suicide

Global number per 100,000 people

−39%

15

10

5

1994

2019

Declines in some of the worst-suffering countries

Japanese Rate Is the Lowest for 46 Years
Suicides per 100,000 people

Russia Is Also at a 50-Year Low

price of vodka drops sharply
(overproduction & uncollected tax)

Gorbachev begins
anti-alcohol campaign

overwork (karōshi)
cited as main reason

Asian financial crisis

alcohol sales
reform

peak economic
post-war prosperity

government
invests $150m
into suicide
prevention

fall of
USSR

50

40

30

20

10

1972 1991 1998 2007 2009 2018

1965 1984 1989 1994 2006 2014

sources: Japanese government statistics, *New York Times*

sources: Human Cause of Death Database, RossSTAT, *Mosc*

What reduces suicides?

dedicated suicide care on offer

mental health awareness policies & programs

easier access to mental health support

reducing the stigma of seeking help

crisis helplines

responsible media reporting

strengthening economic security

identification & support of people at risk

community follow-up & group support

restriction in access to means of suicide

reduction in harmful use of alcohol

interventions for vulnerable groups & people

source: Global Health Data Exchange, *New York Times*

Heartening Declines in Sri Lanka
Had the world's highest suicide rate in 1990

Hungary Is also Showing a Steady Decline

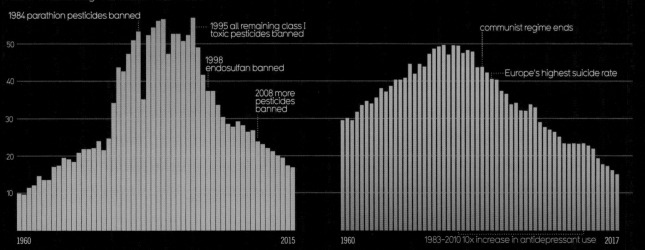

1984 parathion pesticides banned

1995 all remaining class I toxic pesticides banned

1998 endosulfan banned

2008 more pesticides banned

communist regime ends

Europe's highest suicide rate

50

40

30

20

10

1960 2015

1960 1983–2010 10x increase in antidepressant use 2017

sources: Worldbank, *The Lancet*

source: OECD

Yay Australia!

Australia's Homicide Rate Has Never Been Lower
% variation 1990-2016

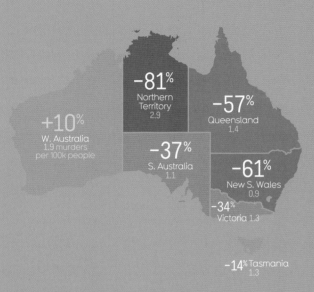

+10%
W. Australia
1.9 murders
per 100k people

−81%
Northern
Territory
2.9

−57%
Queensland
1.4

−37%
S. Australia
1.1

−61%
New S. Wales
0.9

−34%
Victoria 1.3

−14% Tasmania
1.3

source: World Bank

On Track to Eradicate Transmission of HIV among Gay Men by End of Decade
Free condoms, clean needles & antiviral therapy

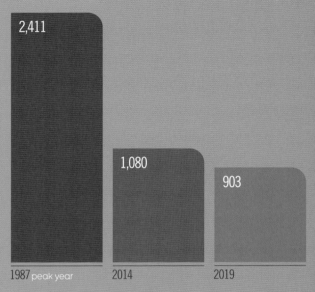

2,411

1,080

903

1987 peak year

2014

2019

sources: Kirby Institute, *The Guardian*

One in Four Australian Homes Now Has Solar Panels

sources: Energy Matters, Australian PV Institute

Government buildings & infrastructure in three major Australian cities are now powered by 100% renewable energy

 SYDNEY MELBOURNE ADELAIDE

street lights, government buildings, swimming pools, sports fields

75% wind, 25% solar

source: PV Magazine

Aboriginal Australians Are Now Empowered to Reduce Wildfires
using ancient indigenous techniques

Defensive burning is a fire-prevention strategy

Strategic small fires reduce undergrowth that can fuel bigger blazes

$80 million

Given to organizations that practice defensive burning

−40% greenhouse gases

Fewer fires, fewer emissions thanks to these techniques

source: *New York Times*

Australia Has a Mobile Shower and Laundry Service for the Homeless
It focuses on empathetic, positive connections

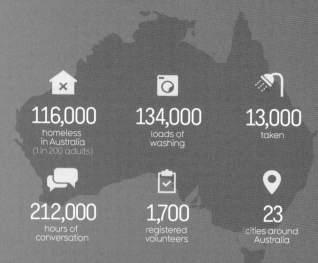

116,000
homeless in Australia
(1 in 200 adults)

134,000
loads of washing

13,000
taken

212,000
hours of conversation

1,700
registered volunteers

23
cities around Australia

source: OrangeSky.org.au, per year

Building the most ambitious renewable energy project ever
The Australian–Singapore power link

WORLD'S LARGEST SOLAR FARM	WORLD'S LARGEST BATTERY	transporting energy to Singapore	...WORLD'S LONGEST UNDERSEA CABLE	TOTAL INVESTMENT

9 million solar panels

30 GWh

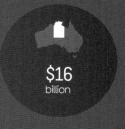

Australia to Singapore
3,700 km
— — — — —
730 km
Norway to UK cable

$16 billion

10 GW

enough for a small country or 10 mid-sized cities

Buzen Substation Battery (Japan)
300MWh

Hornsdale (Australia)
193MWh

2.2 GW

20% of Singapore's electricity use per year

1.4 GW

1,500 jobs

$750 million export revenue per year

sources: SunCable.sg, US Dollars

Magic Materials

 PLANT **ANIMAL** **MINERAL**

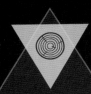

Gulam

Short for 'glued laminated timber'.
One of the highest available
strength-to-weight ratios.

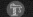 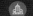

CONSTRUCTION BUILDINGS

Totally renewable & recyclable
Strength can vary, also expensive

Shrilk

Leftover shrimp shells & silk proteins.
As strong as aluminum, but
half the weight.

 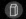

MEDICAL PACKAGING

Totally biodegradable
Limited supply of raw materials

Hemp

Ancient, very fast-growing woven
fiber material derived from cannabis.
Huge variety of uses.

TEXTILES PAPER CLOTHING

Lightweight & breathable
Illegal in some nations due to cannabis laws

Nanocellulose

Tiny non-toxic fibers from
ground-up wood pulp are 10 times
stronger than steel.

PACKAGING FURNITURE CLOTHING

extremely versatile, totally biodegradable
requires a lot of energy to produce

Mycelium

Webbed branching filaments
from fungi. Growable almost
anywhere, in any kind of shape.

PACKAGING FURNITURE CLOTHING

Extremely versatile, already in production
None!

Aerogels

Lightest known material. A rigid, ultralight foam with excellent heat and sound insulation.

INSULATION BUILDING

Extremely versatile
Very brittle – shatters under high pressure

Carbon Nanotubes

Layers of carbon atoms rolled into cylinders with extraordinary thermal & electrical properties.

SENSORS TRANSISTORS BATTERIES

100x stronger than steel, 6x lighter
Tricky to create large amounts

Bioconcrete

Mixing sand, water, microbes, and calcium creates a stone-like substance with low eco-impact.

CONSTRUCTION

Concrete is a major source of emissions
Process needs scaling up

Hyaline

AI-developed flexible, transparent, cellophane-like bio-electronic film, made via bacterial fermentation.

FOLDABLE PHONES WEARABLES

Amazingly flexible & recyclable
Already patented & commercialized

Graphene

A single-atom-thick sheet of carbon with incredible flexibility & strength.

ELECTRONICS

Transparent & electrically conductive
Proving difficult to scale up

Stone Wool

Igneous rock and slag from steelmaking, when melted together, can be spun into versatile fibers.

INSULATION

Great for eco-conscious building
Protective gear required

sources: BBC, *Huffington Post*, *Nature* (journal), NASA Jet Propulsion Lab, ACS, *Forbes*

The world has

fourth type of

beyond

DARK
WHITE
MILK

there's now **RUBY**

gained a chocolate...

Ruby chocolate, invented in 2017 by Belgian-Swiss confectioner Barry Callebaut, is made from unfermented cocoa beans. The exact process is a trade secret, but the result is a "sweet yet sour" taste: milkier than dark, fruitier than milk, and even sweeter than white chocolate.

Renewable Energy

Costs Are Falling Fast
Decrease in price 2017 to 2018

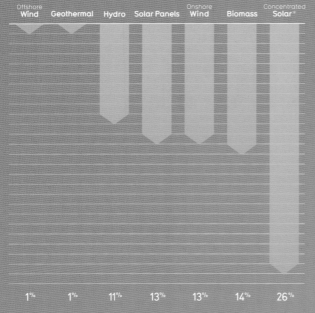

Offshore **Wind**	**Geothermal**	**Hydro**	**Solar Panels**	Onshore **Wind**	**Biomass**	Concentrated **Solar***
1%	1%	11%	13%	13%	14%	26%

* uses mirrors to focus sunlight to power a generator source: IRENA.org

Renewables Are Rapidly Outpacing Coal
Global energy production
(gigawatts)

2,200

2008 2017

sources: International Renewable Energy Agency, Carbon Brief

Global Investment Is Rising...

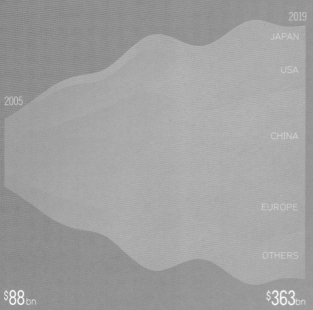

2019
JAPAN
USA

2005

CHINA

EUROPE

OTHERS

$88bn $363bn

source: World Bank

...To Twice as Much as Fossil Fuels
$billion power sector investment

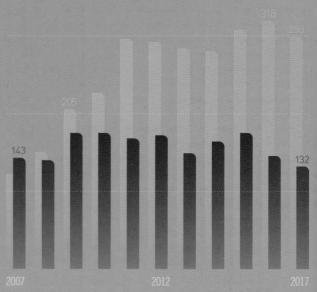

318
298
205
143 132

2007 2012 2017

source: International Energy Agency

Renewable Energy Superstars
% of electricity from renewables

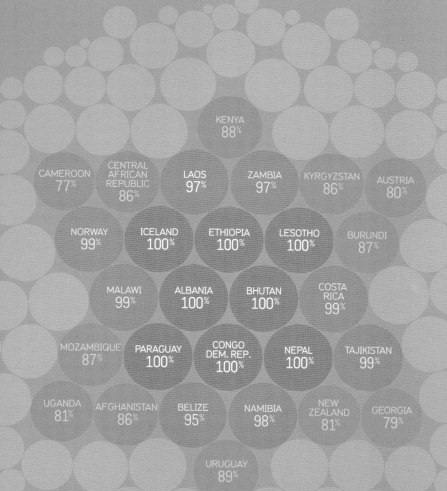

KENYA 88%

CAMEROON 77%
CENTRAL AFRICAN REPUBLIC 86%
LAOS 97%
ZAMBIA 97%
KYRGYZSTAN 86%
AUSTRIA 80%

NORWAY 99%
ICELAND 100%
ETHIOPIA 100%
LESOTHO 100%
BURUNDI 87%

MALAWI 99%
ALBANIA 100%
BHUTAN 100%
COSTA RICA 99%

MOZAMBIQUE 87%
PARAGUAY 100%
CONGO DEM. REP. 100%
NEPAL 100%
TAJIKISTAN 99%

UGANDA 81%
AFGHANISTAN 86%
BELIZE 95%
NAMIBIA 98%
NEW ZEALAND 81%
GEORGIA 79%

URUGUAY 89%

source: International Energy Agency

Fairphone 3 Is a Sustainable Alternative to Polluting Smartphones

Reducing electronic waste & improving workers' conditions

Smartphones Are a Major Contributor to Electronic Waste

rare materials
extraction process is
energy-intensive;
recycling is hard

obsolescence
impossible to
replace components,
only entire phone

strong glue
makes it difficult
to disassemble,
fix, or recycle

E-Waste Produced per Person per year

80%
dumped, traded,
unofficially recycled

2016
6.1
kg/person

2021
6.8 kg
11% increase

20%
collected
& officially recycled

the fate of most
e-waste is unknown

Fairphone 3

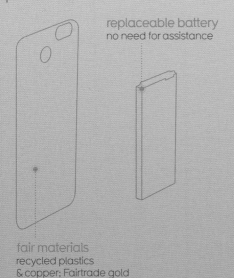

replaceable battery
no need for assistance

modular design
fixing & upgrading
is simpler & cheaper

fair materials
recycled plastics
& copper; Fairtrade gold

screws, not glue
for quick replacement
of components

ethical production
manufacturer guarantees
workers' rights

sources: Dezeen.com, United Nations University

We Are Winning the Fight Against Tuberculosis (TB)

TB Deaths Are Falling Worldwide

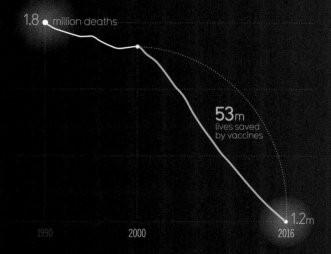

1.8 million deaths

53m lives saved by vaccines

1.2m

1990 2000 2016

It's One of the World's Biggest Killer Diseases
Average global disease deaths per day

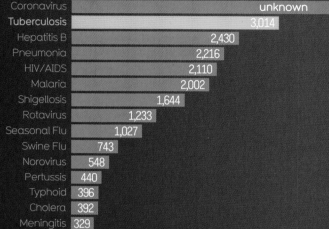

Disease	Deaths per day
Coronavirus	unknown
Tuberculosis	3,014
Hepatitis B	2,430
Pneumonia	2,216
HIV/AIDS	2,110
Malaria	2,002
Shigellosis	1,644
Rotavirus	1,233
Seasonal Flu	1,027
Swine Flu	743
Norovirus	548
Pertussis	440
Typhoid	396
Cholera	392
Meningitis	329

90%+ of Children Are Now Vaccinated
In over 100 vulnerable countries

The Deadliest Form of TB Is Now Curable
Cure rate of extensively drug-resistant strain (XDR)

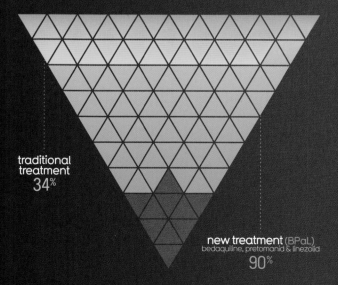

traditional treatment
34%

new treatment (BPaL)
bedaquiline, pretomanid & linezolid
90%

sources: *New York Times*, Centers for Disease Control, Global Burden of Disease Collaborative Network, World Health Organisation

the problem

S. Koreans generate
a huge volume
of food waste

It's even bigger
than **Europe** and
North America

130
kg/year
per person

average
105
kg/year

the solution

ban on dumping food in landfill	compulsory food recycling	using special biodegradable bags	average monthly bag cost per family	bags fund most of the scheme

$6 60%

the results

Food Waste Recycled

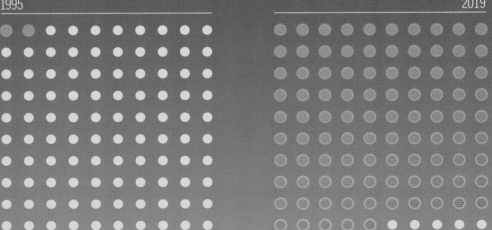

1995

2%

2019

95%

source: World Economic Forum

Numbers of Infections

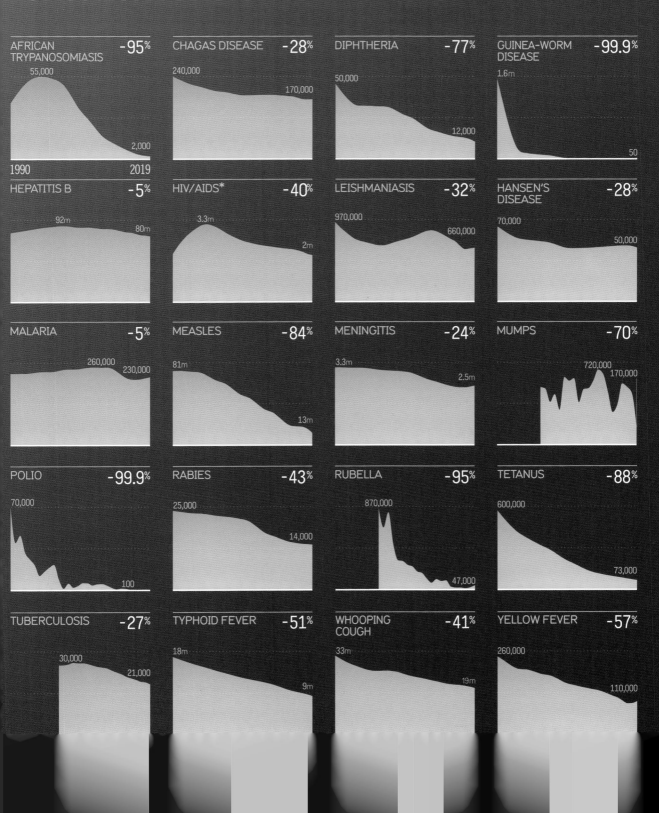

AFRICAN TRYPANOSOMIASIS −95%
55,000
2,000
1990 — 2019

CHAGAS DISEASE −28%
240,000
170,000

DIPHTHERIA −77%
50,000
12,000

GUINEA-WORM DISEASE −99.9%
1.6m
50

HEPATITIS B −5%
92m
80m

HIV/AIDS* −40%
3.3m
2m

LEISHMANIASIS −32%
970,000
660,000

HANSEN'S DISEASE −28%
70,000
50,000

MALARIA −5%
260,000
230,000

MEASLES −84%
81m
13m

MENINGITIS −24%
3.3m
2.5m

MUMPS −70%
720,000
170,000

POLIO −99.9%
70,000
100

RABIES −43%
25,000
14,000

RUBELLA −95%
870,000
47,000

TETANUS −88%
600,000
73,000

TUBERCULOSIS −27%
30,000
21,000

TYPHOID FEVER −51%
18m
9m

WHOOPING COUGH −41%
33m
19m

YELLOW FEVER −57%
260,000
110,000

Global Tree Cover Is Expanding

Gain and loss of tree canopy cover 1982–2016

	AFRICA	ASIA	EUROPE	N. AMERICA	S. AMERICA	OCEANIA	WORLD
NET RESULT	−0.1%	+11.7%	+27.3%	+6.5%	−4.9%	+2.4%	+5.4%

Life Expectancy in Africa Is Soaring

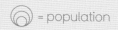 = population

	1960	1990	2018

2018:
Morocco
Tunisia · Algeria
Mauritius
Libya · Egypt · Cabo Verde
Kenya
Ethiopia
South Africa
Angola
Côte D'Ivoire · Nigeria · Chad
Central African Rep. · Sierra Leone

1990:
Mauritius
Tunisia · Libya
Algeria
Cabo Verde
Egypt
Morocco
South Africa
Mali · Nigeria · Ethiopia
Angola
Sierra Leone
Rwanda

1960:
70 years
Mauritius
South Africa
Zimbabwe
Botswana
Cabo Verde
Egypt · Morocco
60
50
Ethiopia
Nigeria
40
30
Sierra Leone
Mali

source: World Bank

China is...

Eradicating Extreme Poverty
People living on less than $1.90 per day

7m
2016

1990
756m

source: World Bank

Pioneering the Electric Bus

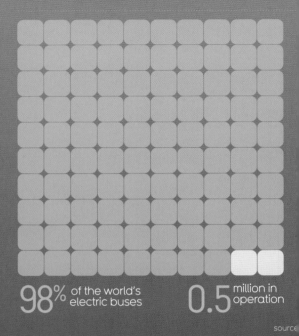

98% of the world's electric buses

0.5 million in operation

source

Crushing Demand for Ivory

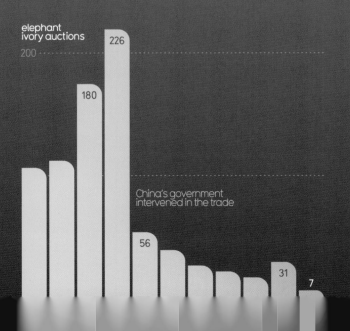

elephant ivory auctions

200

226

180

China's government intervened in the trade

56

31

7

A World Leader in Electric Cars

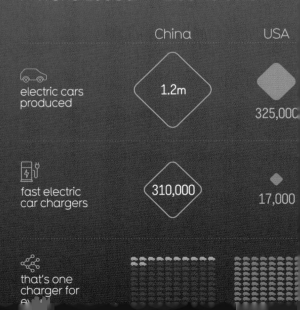

	China	USA
electric cars produced	1.2m	325,000
fast electric car chargers	310,000	17,000
that's one charger for		

Especially in places like Shenzhen
China's 6th biggest city (population 12 million)

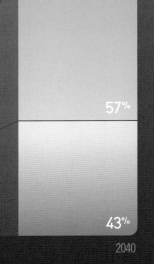

100% first all-electric bus fleet

16,000 e-buses

1,700 chargers

across 104 locations

48% less CO2 emissions

26 million tonnes of CO2 saved

sources: Bloomberg NEF, International Energy Agency

Aiming to Generate Half Its Energy from Renewables by 2040

3,188 GW

1,625 gigawatts

renewables **35%**

fossil fuel & nuclear **65%**

57%

43%

2016

2040

Winning Its War on Air Pollution
Fine particulate matter (PM 2.5) reduction (selected regions)

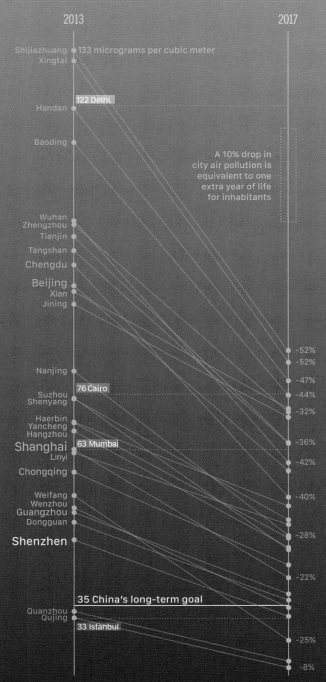

2013

2017

Shijiazhuang — 133 micrograms per cubic meter
Xingtai

122 Delhi

Handan

Baoding

A 10% drop in city air pollution is equivalent to one extra year of life for inhabitants

Wuhan
Zhengzhou
Tianjin
Tangshan
Chengdu
Beijing
Xian
Jining

-52%
-52%

Nanjing

-47%

Suzhou 76 Cairo
Shenyang

-44%

Haerbin
Yancheng
Hangzhou

-32%

Shanghai 63 Mumbai

-36%

Linyi

-42%

Chongqing

Weifang
Wenzhou
Guangzhou
Dongguan

-40%

Shenzhen

-28%

-22%

35 China's long-term goal

Quanzhou
Qujing

33 Istanbul

-25%

-8%

We're Eliminating Malaria Worldwide
Countries certified malaria-free

 = population

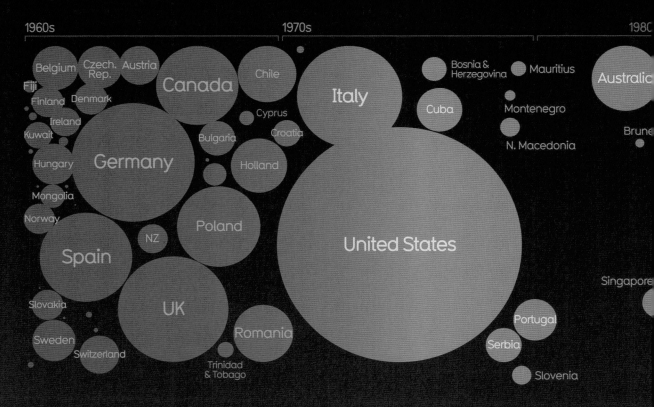

1960s 1970s 1980

Belgium • Czech. Rep. • Austria • Chile • Bosnia & Herzegovina • Mauritius • Australia
Fiji • Finland • Denmark • Canada • Italy • Cuba • Montenegro • Brunei
Ireland • Cyprus • N. Macedonia
Kuwait • Croatia
Hungary • Germany • Bulgaria • Holland
Mongolia
Norway • Poland • United States • Singapore
NZ
Spain • UK • Romania • Portugal • Serbia
Slovakia • Slovenia
Sweden • Switzerland • Trinidad & Tobago

Fewer Children Are Dying
Thousands of deaths per year

627 — 2004
545 — 2007
431 — 2010
323 — 2013
288 — 2016

Simple bed nets have prevented half a billion malaria infections

source: United Nations Children's Fund (UNICEF)

source: Our World in Data

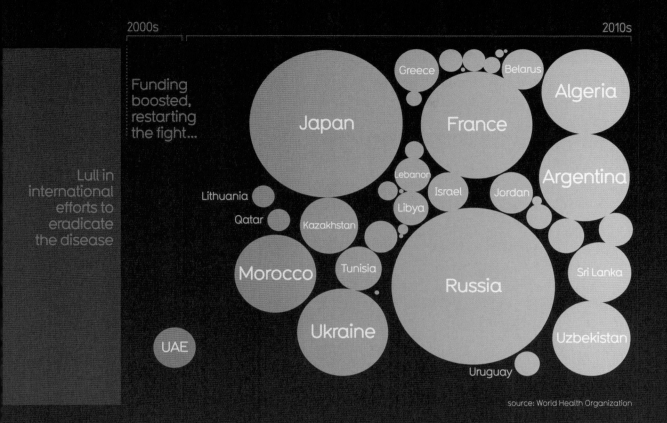

2000s

Funding
boosted,
restarting
the fight...

Lull in
international
efforts to
eradicate
the disease

2010s

Greece

Belarus

Algeria

Japan

France

Argentina

Lebanon

Lithuania

Israel

Jordan

Libya

Qatar

Kazakhstan

Sri Lanka

Morocco

Tunisia

Russia

Ukraine

Uzbekistan

UAE

Uruguay

source: World Health Organization

Global Deaths Are Falling

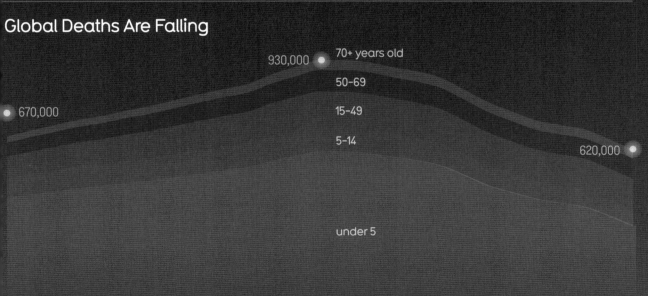

930,000 • 70+ years old

50-69

15-49

670,000

5-14

620,000 •

under 5

1990

2003

2016

source: Our World in Data

How do we solve our PLASTICS problem?

 pollution
 microplastics
 carbon emissions
 poor biodegradability

the problem

TOTAL PLASTIC EVER PRODUCED
8.3 BILLION TONNES

Half of all plastics have been made in the last fifteen years

One million single-use plastic drink bottles are purchased every minute

USED ONCE
70%
5.8 BILLION TONNES

STILL IN USE
30%
2.5 BILLION TONNES

DISCARDED AFTER SINGLE USE
55%
4.6 BILLION TONNES

RECYCLED
6%
500 MILLION TONNES

BACK IN USE
1%
500 MILLION TONNES

TOTAL DISCARDED
59%

INCINERATED
10%

STILL IN USE
31%

Main Types of Plastic

PLASTIC	PET	HDPE	PVC	LDPE	PP	PS	other
	♳ 1	♴ 2	♵ 3	♶ 4	♷ 5	♸ 6	♹ 7
NAME	Polyethylene Terephthalate	High-Density Polyethylene	Polyvinyl Chloride	Low-Density Polyethylene	Polypropylene	Polystyrene	many different plastics
AKA	polyester, PETE	polythene	vinyl			Styrofoam	
USES	water & fizzy drink bottles, combs, shampoo, food and medicine containers	milk & juice bottles, some shopping bags, shampoo & detergent & bleach bottles, some toys	plumbing pipes, some grocery bags, plastic wrap, shoes	plastic bags, disposable gloves, clingfilm, squeezable bottles (like mustard)	nappies/diapers, straws, yogurt pots, prescription bottles, pegs, ice cream tubs, plant pots	disposable coffee cups, plastic cutlery, some toys, coat hangers	baby bottles, eye glasses, plastic furniture
PROPERTIES	clear, very tough	crinkles to touch, floats	transparent, strong	soft, flexible but tough	heat-resistant	brittle, glassy, insulating	multiple
% OF PRODUCTION	9%	14%	10%	17%	18%	6%	26%
AMOUNT IN ENVIRONMENT	11.2%	14%	5.3%	20%	19.3%	6%	24.2%
RECYCLABILITY	HIGH	HIGH	NO	HIGH	MEDIUM	LOW	MIXED

BIODEGRADABLE?	NO	NO	NO	NO	NO	NO	some
HEALTH & SAFETY	mixed — odors & flavors leak in, do not reuse	safe	no — no contact with food or drink, leaks chemicals	safe	safe	no — affected by fats, never use as food storage, extremely toxic	no — usually not healthy, do not use to store food
COMMON WASTE see page ▶ 000	most single-use plastic waste			food wrappers, grocery bags	bottle tops, straws	majority of ocean waste	
PYROLYSIS see page ▶ 000	NO	YES	NO	YES	YES	MAYBE	MAYBE

	NAME	AKA	USES
PUR	Polyurethane	spandex, lycra	clothing
PC	Polycarbonate		compact discs, eyeglass lenses, riot shields
PMMA	Polymethylmethacrylate	perspex, acrylic	contact lenses, glazing, paints
PA	Polyamides	nylon	clothing, tires, ropes, toothbrush bristles
PTFE	Polytetrafluoroethylene	teflon	non-stick frying pans, plumber's tape
PCL	Polycaprolactone ♻ = biodegradable	bio-polyester	clothing, glues
ABS	Acrylonitrile butadiene styrene		Lego, computer keyboards, printers
PVDC	Polyvinylidene chloride	plastic wrap	packaging
XPS	Extruded polystyrene		insulation
PF	Phenol formaldehyde	bakelite	foam, moldings, billiard balls
POM	Polyoxymethylene	acetal	gears, industrial uses
MF	Melamine formaldehyde		children's cups & plates
SAN	Styrene acrylonitrile		food containers, kitchenware, packaging
APET	Amorphous PET		water bottles
PBA	Polybutyrate ♻		paper cups
PBS	Polybutylene succinate ♻		agriculture
CPET	Crystalline PET		microwave containers

POPULARITY ◀

The properties
that make plastics
so versatile & useful
also make them
difficult or impossible
for nature to fully
assimilate

sources: The Guardian, Our World in Data

'Biodegradable' Plastics

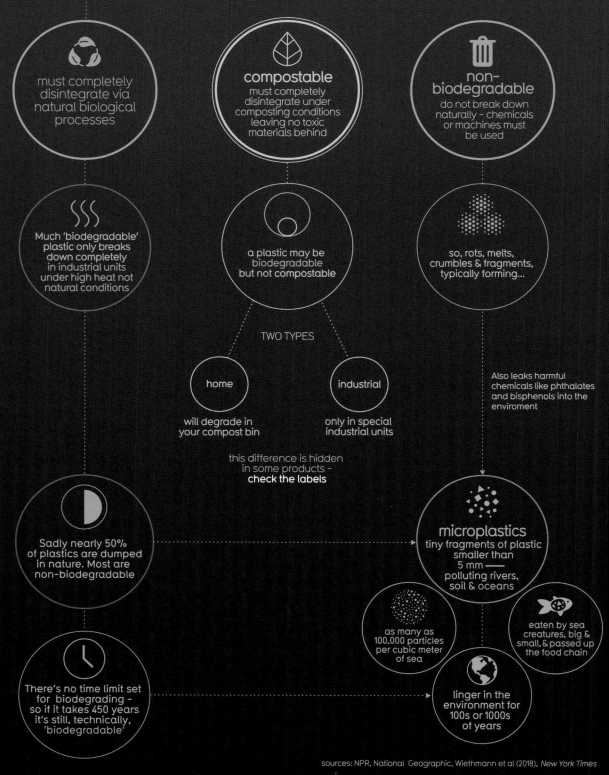

must completely disintegrate via natural biological processes

compostable
must completely disintegrate under composting conditions leaving no toxic materials behind

non-biodegradable
do not break down naturally – chemicals or machines must be used

Much 'biodegradable' plastic only breaks down completely in industrial units under high heat not natural conditions

a plastic may be biodegradable but not compostable

so, rots, melts, crumbles & fragments, typically forming...

TWO TYPES

home
will degrade in your compost bin

industrial
only in special industrial units

this difference is hidden in some products –
check the labels

Also leaks harmful chemicals like phthalates and bisphenols into the enviroment

Sadly nearly 50% of plastics are dumped in nature. Most are non-biodegradable

microplastics
tiny fragments of plastic smaller than 5 mm —— polluting rivers, soil & oceans

as many as 100,000 particles per cubic meter of sea

eaten by sea creatures, big & small, & passed up the food chain

There's no time limit set for biodegrading – so if it takes 450 years it's still, technically, 'biodegradable'

linger in the environment for 100s or 1000s of years

sources: NPR, National Geographic, Wiethmann et al (2018), *New York Times*

Can't we just use bioplastics instead?

plastics not made from fossil fuels like oil
instead come from 'bio', potentially renewable sources like:

 starch

 wood pulp

 proteins

 sugars

crop residues

Watch out for marketing terms like
'plant-based', 'bio-based' or
'compostable'

Any plastic derived from these
sources can be called a
'bioplastic'

But those sources aren't necessarily
biodegradable, compostable, or even
ecofriendly

⊕ PROS

usually more sustainable
80% less energy usage
80% less emissions
fewer toxins released in production
several are biodegradable
a few are compostable

⊖ CONS

extra land, water to grow materials
more fertilizer used
not as strong or versatile as normal plastics
chemical additives still used (dyes, fillers, coatings)
broadly no more biodegradable than normal plastics
not always recyclable in usual recycling streams

What *are* they good for?

food service	foil packaging	diapers/ nappies	fruit & veg packaging	tires	mulch foils	bags
25%	22%	17%	11%	11%	7%	6%

Current usage

1% of all plastics

Popular & emerging bio-plastics

POPULARITY		PRIMARY SOURCE	USES	♳	🌐	🏭	🏠	🔥	NOTE
	TPS	maize starch	films, bags, cutlery, packaging	*	●	●	●	●	starch is abundant & renewable
	PLA	corn starch	3D printing, cups, nappies, teabags	●	●	●	●	●	can replace PS(6), PP(5), ABS
	PHB	glucose	transparent films	●	●	●	●	?	may replace PVC(3) & LDPE (4)
	PHA	sugars	packaging, films, straws, bottles	?	●	●	●	●	very promising, replaces PP, tricky to scale
	bioPE	ethanol	water bottles	*	●	●	●	●	identical to PE just not fossil-fuel
	PEF	sugars	bottles, films, food trays	*	●	●	●	?	shows promise
	plantic	corn starch	food packaging	*	●	●	●	?	great food packaging, home compostable

good ♳ recyclable ● separate stream req. 🌐 biodegradable 🏭 industrially compost 🏠 home compost 🔥 heat resistant (good for packaging)

sources: Wikipedia, Forbes, US Environmental Protection Agency, Broeren (2017), Yale School of the Environment

Most Plastic Waste

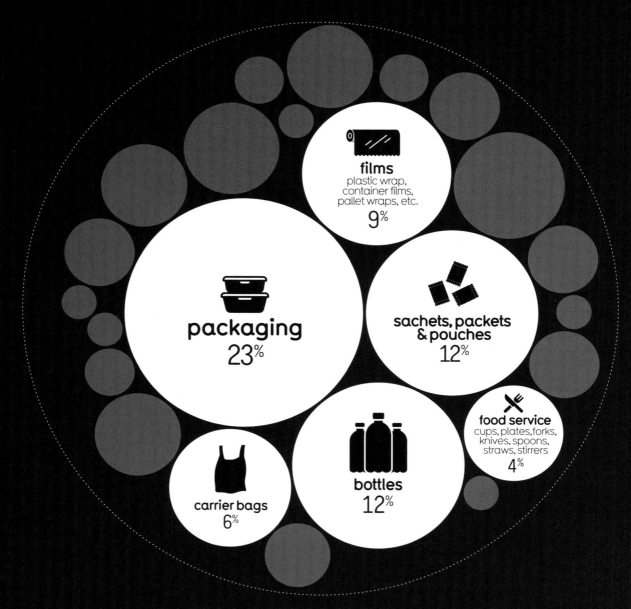

films
plastic wrap,
container films,
pallet wraps, etc.
9%

packaging
23%

**sachets, packets
& pouches**
12%

food service
cups, plates, forks,
knives, spoons,
straws, stirrers
4%

carrier bags
6%

bottles
12%

Most Dumped on Beaches

8%	9%	13%	22%	10%	4%	4%
cutlery	food containers	bags	cigarette butts	caps, lids	bottles	ropes, string

Marine Debris Decomposition Time

plastic other material

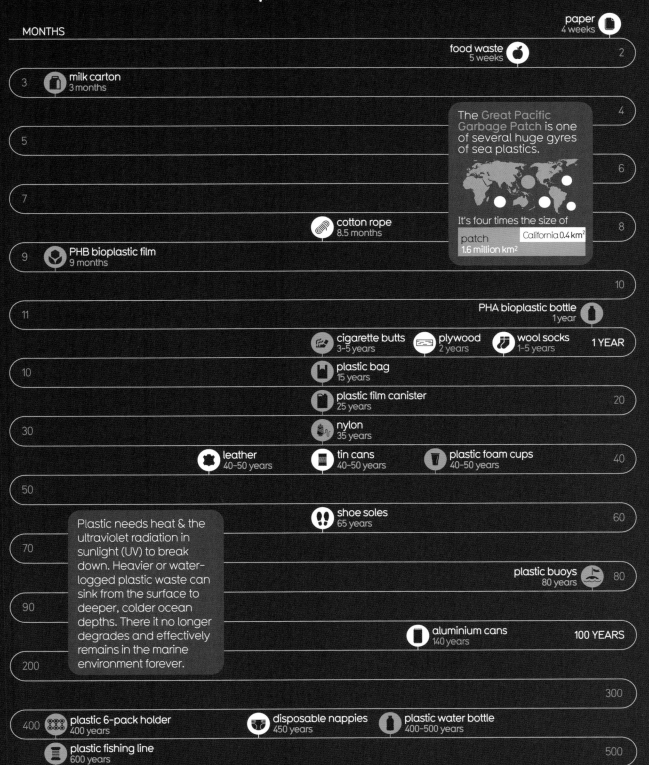

MONTHS

paper
4 weeks

food waste
5 weeks

2

3 milk carton
3 months

4

5

6

7

8

cotton rope
8.5 months

9 PHB bioplastic film
9 months

The Great Pacific Garbage Patch is one of several huge gyres of sea plastics.

It's four times the size of

patch
1.6 million km²

California 0.4 km²

10

11

PHA bioplastic bottle
1 year

cigarette butts
3–5 years

plywood
2 years

wool socks
1–5 years

1 YEAR

10 plastic bag
15 years

plastic film canister
25 years

20

30 nylon
35 years

leather
40–50 years

tin cans
40–50 years

plastic foam cups
40–50 years

40

50

shoe soles
65 years

60

Plastic needs heat & the ultraviolet radiation in sunlight (UV) to break down. Heavier or water-logged plastic waste can sink from the surface to deeper, colder ocean depths. There it no longer degrades and effectively remains in the marine environment forever.

70

plastic buoys
80 years

80

90

aluminium cans
140 years

100 YEARS

200

300

400 plastic 6-pack holder
400 years

disposable nappies
450 years

plastic water bottle
400–500 years

plastic fishing line
600 years

500

sources: Our World in Data, Ocean Conservancy.org

Our Routes for Solving Plastics

THICKNESS = IMPACT

develop packaging-free products

decrease production of bags & films

REDUCE PLASTIC PRODUCTION

target worst plastics

PHA packaging & films ◀-------- films plastic wrap

bottles water, shampoo, etc.

PEF bottles ◀--------

INCREASE USE OF ALTERNATIVES

compostables
9% of plastics could be switched to other fully degradable materials

good bioplastics
some sustainable compostable ones exist

paper
8% of plastic products could be paper instead

producer responsibility
companies, not governments, responsible for recycling

product take-back
takeout & other services retrieve their packaging

EVEN MORE CLEAN-UPS & TAKEBACKS

deposit schemes
small deposits on returnable plastic bottles have showed impressive results

community action
#trashtag

EXTEND BANS & REGULATION

laws to reduce plastic waste

plastic bag bans

single-use plastic ban

microbead bans

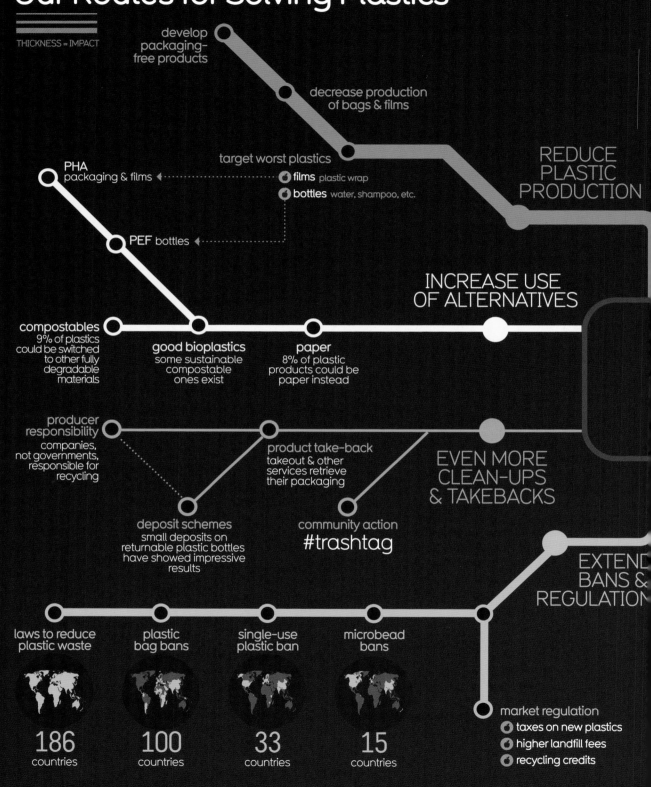

186 countries

100 countries

33 countries

15 countries

market regulation
● taxes on new plastics
● higher landfill fees
● recycling credits

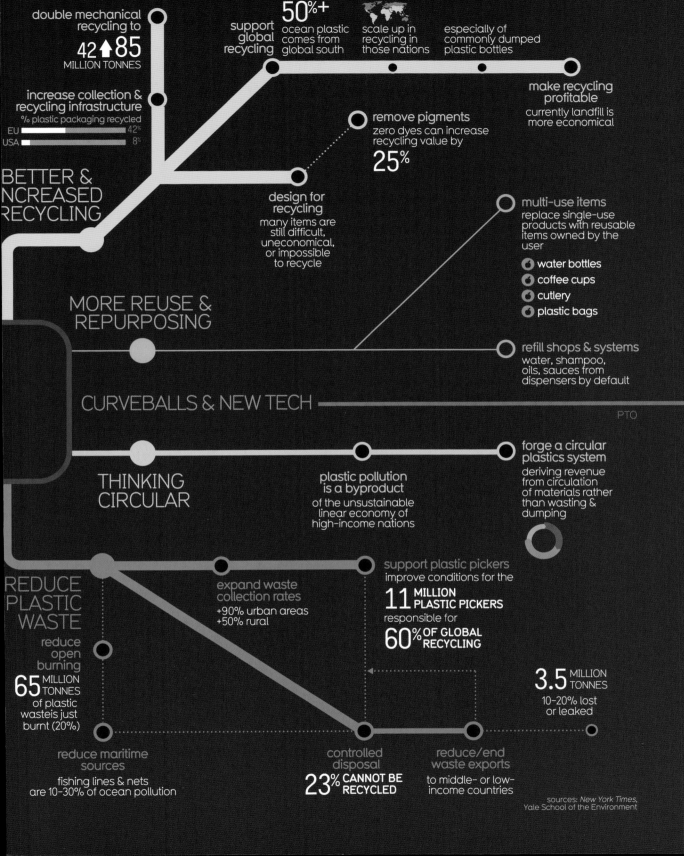

double mechanical recycling to

42 ↑ 85 MILLION TONNES

increase collection & recycling infrastructure
% plastic packaging recycled

EU ▬▬▬▬▬▬ 42%

USA ▬▬ 8%

support global recycling

50%+ ocean plastic comes from global south

scale up in recycling in those nations

especially of commonly dumped plastic bottles

make recycling profitable
currently landfill is more economical

remove pigments
zero dyes can increase recycling value by **25%**

BETTER & INCREASED RECYCLING

design for recycling
many items are still difficult, uneconomical, or impossible to recycle

multi-use items
replace single-use products with reusable items owned by the user

- water bottles
- coffee cups
- cutlery
- plastic bags

MORE REUSE & REPURPOSING

refill shops & systems
water, shampoo, oils, sauces from dispensers by default

CURVEBALLS & NEW TECH

PTO

forge a circular plastics system
deriving revenue from circulation of materials rather than wasting & dumping

THINKING CIRCULAR

plastic pollution is a byproduct
of the unsustainable linear economy of high-income nations

support plastic pickers
improve conditions for the **11 MILLION PLASTIC PICKERS** responsible for **60% OF GLOBAL RECYCLING**

expand waste collection rates
+90% urban areas
+50% rural

REDUCE PLASTIC WASTE

reduce open burning
65 MILLION TONNES of plastic waste is just burnt (20%)

3.5 MILLION TONNES
10-20% lost or leaked

reduce maritime sources
fishing lines & nets are 10-30% of ocean pollution

controlled disposal
23% CANNOT BE RECYCLED

reduce/end waste exports
to middle- or low-income countries

sources: *New York Times*, Yale School of the Environment

Creative Solutions

Pyrolysis converts used, unrecyclable waste back into plastic & energy

what is it?
a chemical process that breaks plastic back down into its molecular building blocks

major impact
chemical conversion could recycle 26 million tonnes per year (up from 1.4m today)

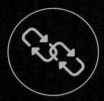

double recycling
plastics that are too contaminated or can't be mechanically recycled can undergo pyrolysis

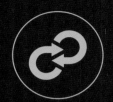

infinite recycling
potentially a plastic can go through pyrolysis over and over again, ad infinitum

Pyrolysis is an early-stage technology, so accurate data on its impact & contributions is still emerging

source: PEW

Bespoke Enzymes Can Turn Major Plastics into Biodegradables

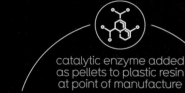

catalytic enzyme added as pellets to plastic resin at point of manufacture

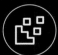

dissolves both to water, CO2, and organic material in less than a year

after a dormancy period, enzymes kick in and digest the plastic into wax

the wax attracts and is edible by microbes, fungi & bacteria which consume it

works on world's leading non-biodegradable plastics **polyethylene** (PET) and **polypropylene** (PP)

PET **PP**

Doesn't work on landfill. Only works on dumped plastic. On land & not in the ocean.

source: Polymateria.com

Six Organic, Biodegradable Alternatives to Single-Use Plastics

seaweed extract
a jelly (agar) made from the
fast-growing sea plant
(replaces **bags**)

fish scales
waste from food factories
bound with algae
(packaging)

cellulose nanofibers
tiny, crystalline molecules
extracted from wood pulp
(styrofoam)

hemp
tough, super-versatile
material from cannabis plants
(bottles)

elephant grass
a low-cost, hardy, fibrous
African plant
(packaging)

mycelium
thread-like roots of mushrooms
bound into plant material
(styrofoam)

sources: *Wired*, CNN, Washington State University

We're Developing & Harnessing Natural Organisms & Substances That Can Eat & Digest Plastic Waste

bacteria
breaks the plastic down & uses it
as fuel for further digestion

fungi
promising & already in use but much
harder to harness on an industrial scale

enzymes
mutant bacterial enzyme (PET hydrolase)
can easily metabolize plastic in hours

mealworms
microorganisms in the guts of the darkling
beetle larvae break down plastic

PUR
Polyurethane
e.g. sneakers,
diapers, sponges

PET
Polyethylene
bottles, food
containers

PS
Polystyrene
disposable cups &
glasses, packaging

sources: European Commission, *Nature* (journal), Stanford University

What can you do?
Simple actions to take in your everyday life

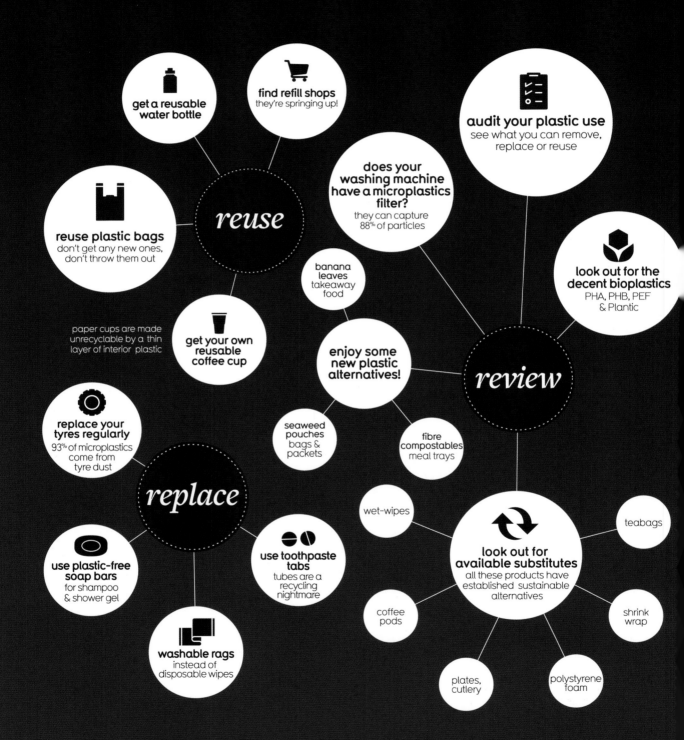

get a reusable water bottle

find refill shops
they're springing up!

audit your plastic use
see what you can remove, replace or reuse

does your washing machine have a microplastics filter?
they can capture 88% of particles

reuse

reuse plastic bags
don't get any new ones, don't throw them out

look out for the decent bioplastics
PHA, PHB, PEF & Plantic

banana leaves takeaway food

paper cups are made unrecyclable by a thin layer of interior plastic

get your own reusable coffee cup

enjoy some new plastic alternatives!

review

replace your tyres regularly
93% of microplastics come from tyre dust

seaweed pouches bags & packets

fibre compostables meal trays

replace

wet-wipes

teabags

use plastic-free soap bars
for shampoo & shower gel

use toothpaste tabs
tubes are a recycling nightmare

look out for available substitutes
all these products have established sustainable alternatives

shrink wrap

washable rags
instead of disposable wipes

coffee pods

plates, cutlery

polystyrene foam

size =
impact

**join or start a
plastic-picking
club**
#trashtag

think circular
gonna keep saying
it over & over
▸140

bin your cigarettes
cigarette butts & filters are
one of the highest plastic
waste products

rethink

**watch where that
cap or lid is going**
10% of all plastic waste

recycle

**don't be duped
by 'bio-bottles'**

**don't be
seduced by
'biodegradable'**

**double-check
'compostable'**

labels can lie:
industrially compostable
means it must be picked up
& treated by your local
authority

**beauty
& cosmetic
packaging**
only 50% is
recycled

**rinse out & wash
your plastics
before recycling**

contaminated waste
usually ends up in landfill

**plastic
straws**
metal, paper
– anything
is better

**plastic
bin-liners**
wash out &
line with
newspaper

carry your own cutlery
don't use those at
cafes & takeouts, etc.
They're just dumped
afterwards

refuse

sachets are the devil!
48% end up dumped.
Try to avoid them

plastic wrap
PVC is the worst!
Persists for
centuries

**avoid food delivery
using plastic containers**
or petition for returnables
if you really like
their food!

**buy food that isn't
over-packaged**

sources: *New York Times, The Guardian,* Our World in Data

Blood donors Canada, and receive a text when their is used

in Sweden, the UK

blood

The blood you donated has now helped a patient! Thanks!

sources: Global News Canada, Independent, NHS

The Death Penalty is Disappearing

Nations who have banned

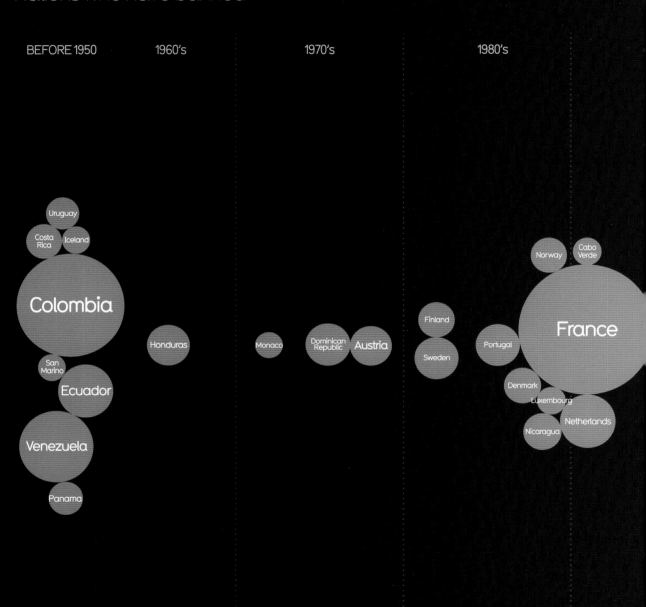

BEFORE 1950 1960's 1970's 1980's

Uruguay

Costa Rica Iceland

Colombia

Honduras

Monaco Dominican Republic Austria

Finland

Norway Cabo Verde

France

San Marino

Ecuador

Sweden

Portugal

Denmark

Luxembourg

Venezuela

Nicaragua Netherlands

Panama

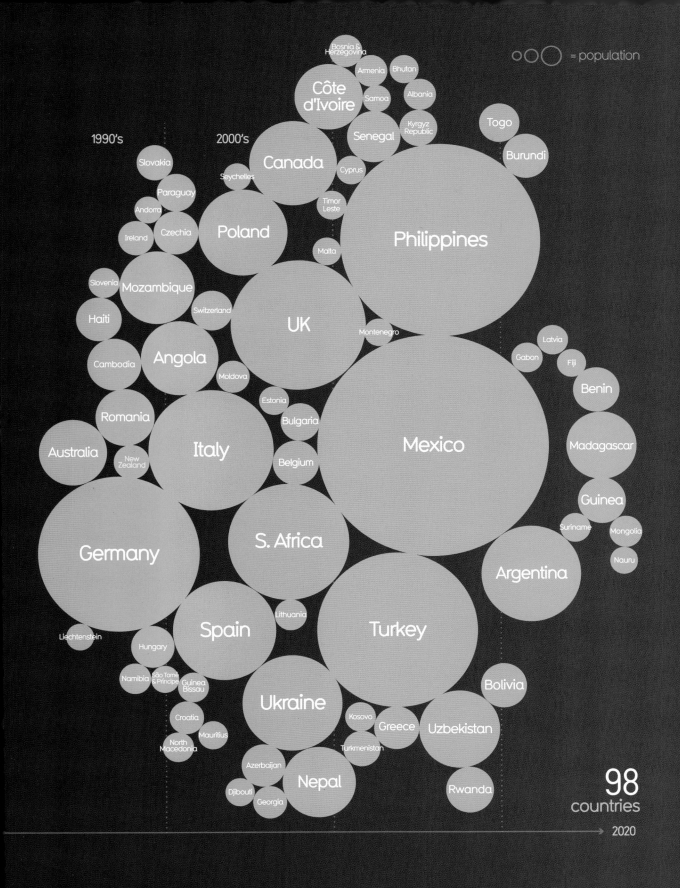

Unexpectedly Positive Things to Arise out of the Tragedy of the Coronavirus Pandemic

Millions Volunteered...
to help fight the coronavirus on all fronts

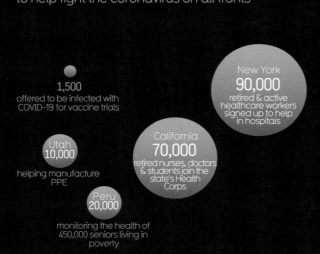

1,500
offered to be infected with COVID-19 for vaccine trials

Utah 10,000
helping manufacture PPE

Peru 20,000
monitoring the health of 450,000 seniors living in poverty

California 70,000
retired nurses, doctors & students join the state's Health Corps

New York 90,000
retired & active healthcare workers signed up to help in hospitals

UK 1,000,000+
volunteer to help in the free National Health Service (NHS)

sources: *The Guardian, Scientific American, New York Times,* NBC

Cases of Flu Crashed
Number of positive influenza tests per week, N. America

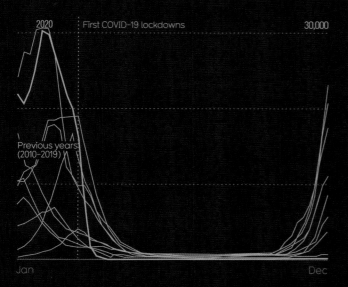

2020

First COVID-19 lockdowns

30,000

Previous years (2010–2019)

Jan

Dec

source: *Scientific American*

Emissions from Aviation Dropped
Megatonnes of C02 in 2020 vs 2019

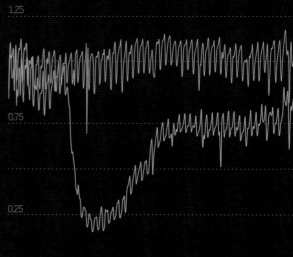

1.25

0.75

0.25

source: US Bureau of Justice Statistics

Lockdown Measures Saved Millions
Minimum lives saved....

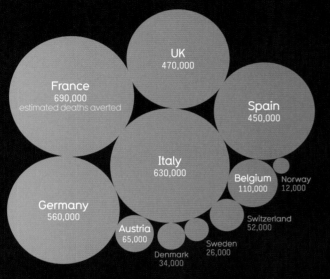

France
690,000
estimated deaths averted

UK
470,000

Spain
450,000

Italy
630,000

Belgium
110,000

Norway
12,000

Germany
560,000

Switzerland
52,000

Austria
65,000

Sweden
26,000

Denmark
34,000

source: *Nature* (journal)

We've Never Developed Such Powerful & Effective Vaccines So Quickly...

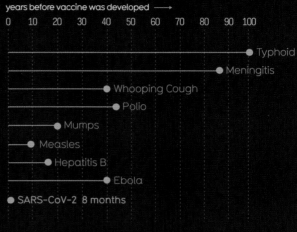

years before vaccine was developed ⟶

0 10 20 30 40 50 60 70 80 90 100

Typhoid
Meningitis
Whooping Cough
Polio
Mumps
Measles
Hepatitis B
Ebola
SARS-CoV-2 8 months

Thanks to unprecedented international funding, resources, collaboration and sharing of research

source: *Nature* (journal)

Traffic Congestion Plummeted
Hours stuck in traffic per average driver per year

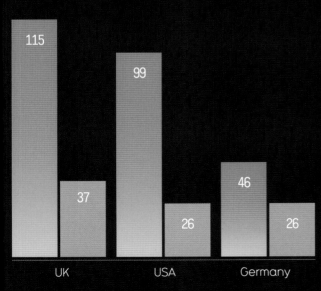

115
99
37
26
46
26

UK USA Germany

sources: Centers for Disease Control, Pew Research Center

We can recycle our plastic disposable face masks into roads to reduce waste

1 km of road would use up **3 million masks**, preventing **93 tonnes of waste** going to landfill.

6.8 billion masks are used worldwide daily. That's **2,268 km** of potential road surface.

sources: Centers for Disease Control, Pew Research Center

Corporate Power Pledges

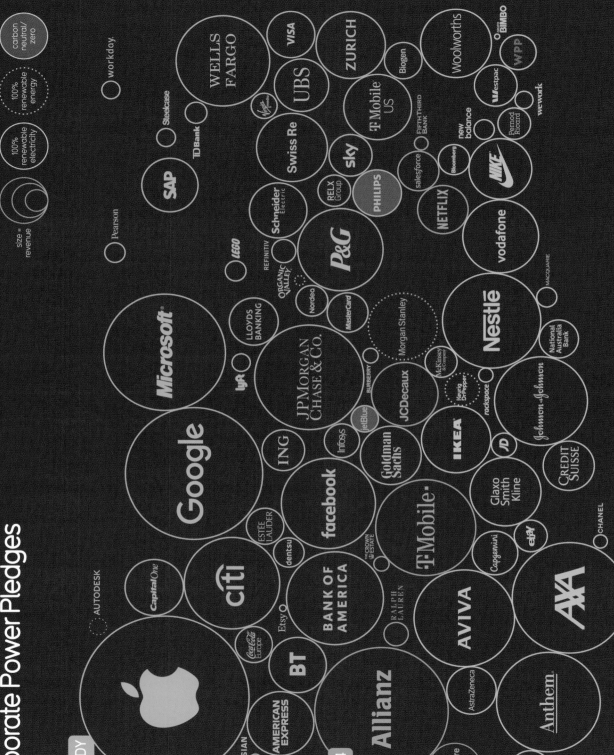

size = revenue

100% renewable electricity

100% renewable energy

carbon neutral/ zero

workday.

ALREADY

2021-24

2025

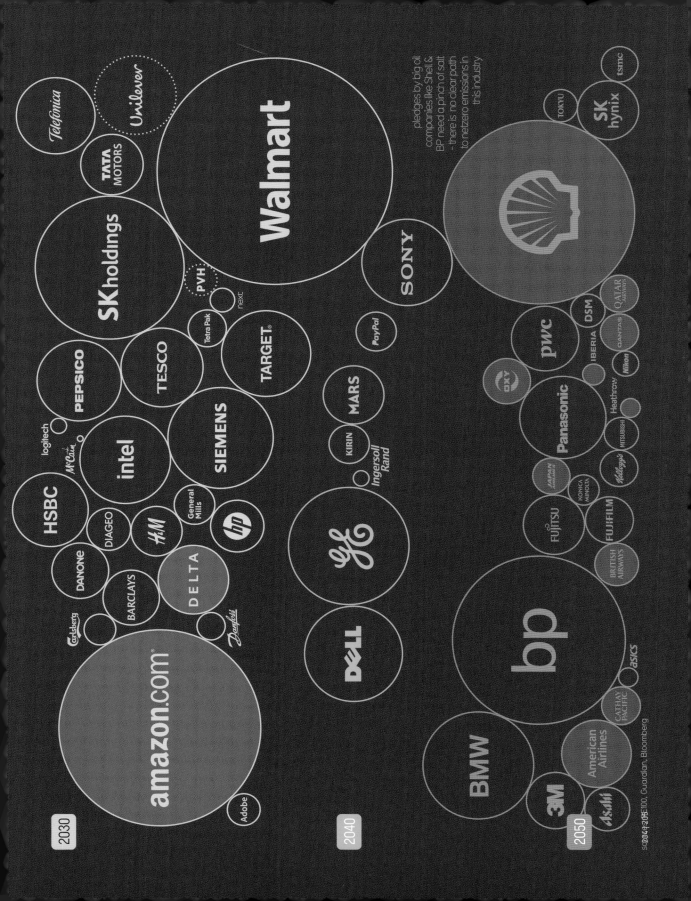

pledges by big oil companies like Shell & BP need a pinch of salt – there is no clear path to net-zero emissions in this industry

2030

Telefónica · Unilever · TATA MOTORS · Walmart · SK holdings · PVH · next · PEPSICO · TESCO · TARGET · Tetra Pak · logitech · McCain · intel · SIEMENS · HSBC · DIAGEO · H&M · General Mills · hp · DANONE · BARCLAYS · DELTA · Carlsberg · Danfoss · amazon.com · Adobe · SONY

2040

PayPal · MARS · KIRIN · Ingersoll Rand · GE · DELL

2050

SK hynix · tsmc · TOKYU · Shell · pwc · DSM · OXY · IBERIA · QATAR AIRWAYS · QANTAS · Panasonic · Heathrow · Nikon · MITSUBISHI · Kellogg's · KONICA MINOLTA · JAPAN AIRLINES · FUJITSU · FUJIFILM · BRITISH AIRWAYS · bp · asics · BMW · 3M · CATHAY PACIFIC · American Airlines · Asahi

Source: F100, Guardian, Bloomberg

City & Country Climate Pledges

REGION
STATE
City

TRANSITION ········· ▲ 100% IMPACT ||| (population) ········· IMPLIED (not pledged)

% RENEWABLE ELECTRICITY % RENEWABLE ENERGY REDUCTION % DECREASE EMISSIONS / GHGs ELIMINATION NETZERO / CARBON NEUTRAL

now Helsinki
 KENYA
 Melbourne

2025 Adelaide
 BRAZIL
 Copenhagen
 NEW ZEALAND
 PUERTO RICO
 San Francisco

2030 Amsterdam
 AUSTRALIA
 Boulder
 BRAZIL
 CHINA
 DENMARK
EUROPEAN UNION
 Glasgow
 Hamburg
LATIN AMERICA
 Nevada
 New York City
 NORWAY
 Oslo
 San Francisco
 Sydney
 UK
 Washington, DC
 Helsinki
 NEW ZEALAND

2040 New York
 PUERTO RICO
 Stockholm

2045
CALIFORNIA
Glasgow
HAWAII
Los Angeles
NEW MEXICO
SWEDEN
WASHINGTON

2050
Amsterdam
Boulder
Chicago
DENMARK
EUROPEAN UNION
FINLAND
FRANCE
Hamburg
JAPAN
London
Los Angeles
Minneapolis
Nevada
New York City
NEW ZEALAND
Portland
Puerto Rico
Rio de Janeiro
San Francisco
Seattle
SOUTH KOREA
SWEDEN
Sydney
Toronto
USA
Vancouver
Washington, DC
Yokohoma

2060
BRAZIL
CHINA

phase out fossil fuels

fossil-fuel free

sources: Carbon Neutral Cities Alliances, Reuters, New York Times, WWF, Guardian, Climate Action Tracker

Things Going Down! Down! Down!
in a good way

Discriminatory Policies
against ethnic minorities

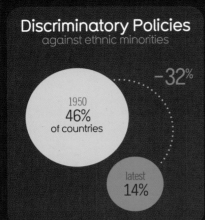

1950
46%
of countries

latest
14%

−32%

Global Death Penalty
executions per year

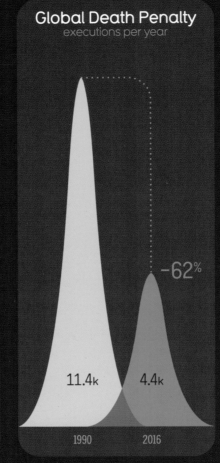

−62%

11.4k 4.4k

1990 2016

Hours of Housework
average weekly hours

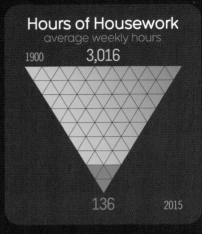

1900 **3,016**

136 2015

Lab-Grown Meat
cost per pound

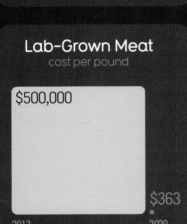

$500,000

$363

2013 2020

Child Labor
% of children 5-17 in work

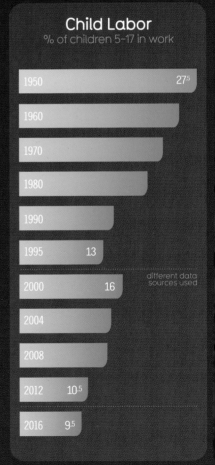

Year	%
1950	27.5
1960	
1970	
1980	
1990	
1995	13
2000	16
2004	
2008	
2012	10.5
2016	9.5

different data sources used

Stunted Growth
kids under 5

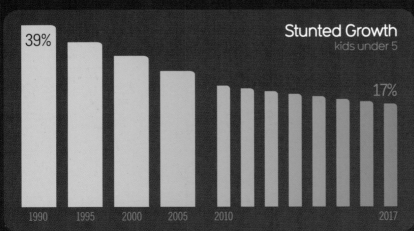

39%

17%

1990 1995 2000 2005 2010 2017

sources: World Bank, *The Economist*, Cato Institute, University of Maryland, Our World in Data

Land Preservation **Is Happening**

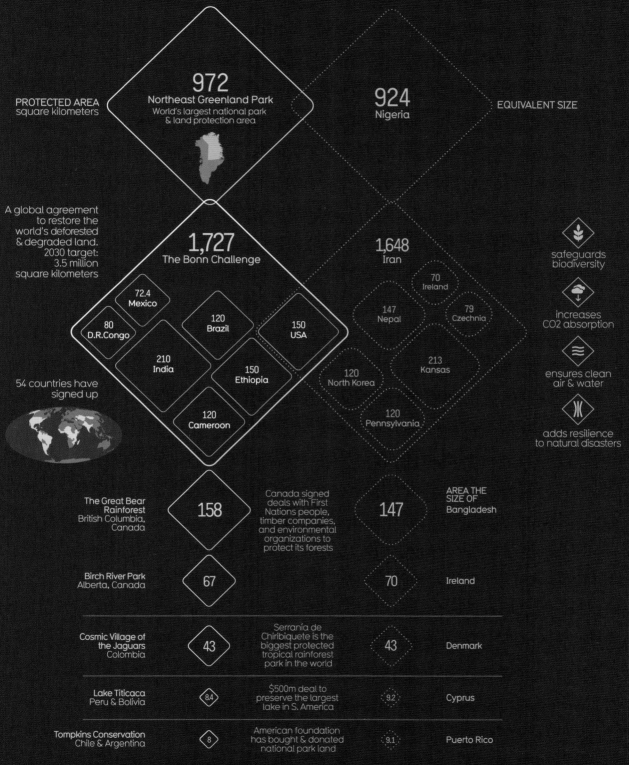

PROTECTED AREA
square kilometers

972
Northeast Greenland Park
World's largest national park
& land protection area

924
Nigeria

EQUIVALENT SIZE

A global agreement
to restore the
world's deforested
& degraded land.
2030 target:
3.5 million
square kilometers

1,727
The Bonn Challenge

1,648
Iran

72.4
Mexico

80
D.R.Congo

120
Brazil

150
USA

210
India

150
Ethiopia

120
Cameroon

70
Ireland

147
Nepal

79
Czechnia

120
North Korea

213
Kansas

120
Pennsylvania

safeguards
biodiversity

increases
CO2 absorption

ensures clean
air & water

adds resilience
to natural disasters

54 countries have
signed up

The Great Bear
Rainforest
British Columbia,
Canada

158

Canada signed
deals with First
Nations people,
timber companies,
and environmental
organizations to
protect its forests

147

AREA THE
SIZE OF
Bangladesh

Birch River Park
Alberta, Canada

67

70

Ireland

Cosmic Village of
the Jaguars
Colombia

43

Serranía de
Chiribiquete is the
biggest protected
tropical rainforest
park in the world

43

Denmark

Lake Titicaca
Peru & Bolivia

8.4

$500m deal to
preserve the largest
lake in S. America

9.2

Cyprus

Tompkins Conservation
Chile & Argentina

8

American foundation
has bought & donated
national park land

9.1

Puerto Rico

sources: BBC, Bonn Challenge, National Geographic

Protecting the Surface of the Earth

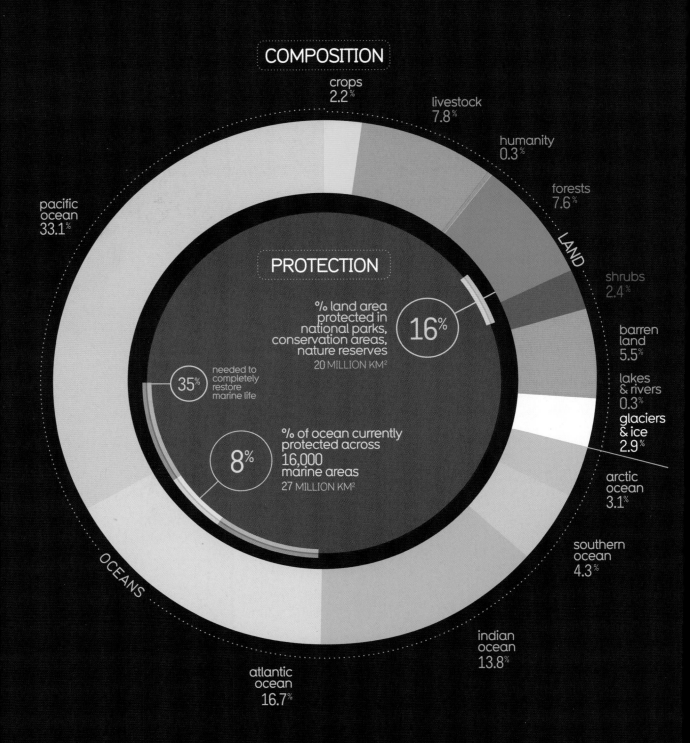

COMPOSITION

crops
2.2%

livestock
7.8%

humanity
0.3%

forests
7.6%

LAND

shrubs
2.4%

barren
land
5.5%

lakes
& rivers
0.3%

glaciers
& ice
2.9%

arctic
ocean
3.1%

southern
ocean
4.3%

indian
ocean
13.8%

atlantic
ocean
16.7%

OCEANS

pacific
ocean
33.1%

PROTECTION

% land area
protected in
national parks,
conservation areas,
nature reserves
20 MILLION KM²

16%

35% needed to
completely
restore
marine life

8% % of ocean currently
protected across
16,000
marine areas
27 MILLION KM²

sources: Our World in Data, Wikipedia

LED Bulbs

Use Far Less Energy to Generate the Same Amount of Light...

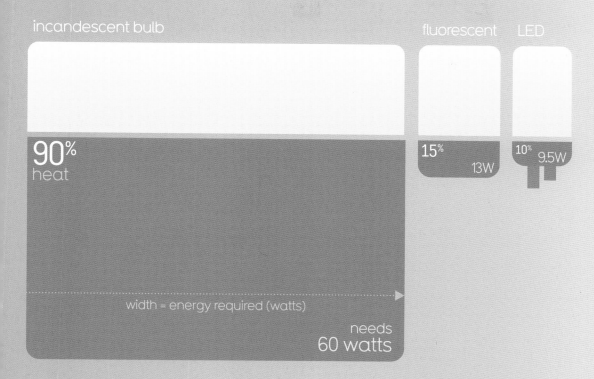

incandescent bulb

fluorescent

LED

90% heat

15% 13W

10% 9.5W

width = energy required (watts)

needs **60 watts**

...Saving Energy & Money

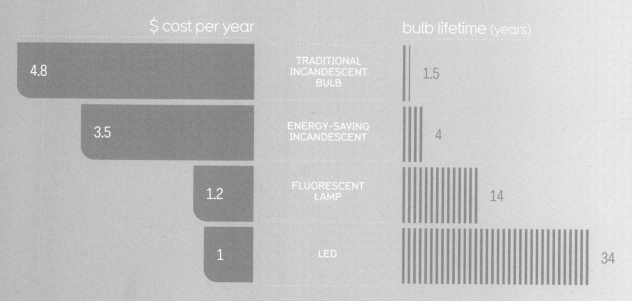

$ cost per year

bulb lifetime (years)

	$ cost per year	bulb lifetime (years)
TRADITIONAL INCANDESCENT BULB	4.8	1.5
ENERGY-SAVING INCANDESCENT	3.5	4
FLUORESCENT LAMP	1.2	14
LED	1	34

sources: International Energy Agency, energy.gov

CO2 Removal Is Part of Getting to Netzero

We probably can't limit global heating without sucking carbon from the air

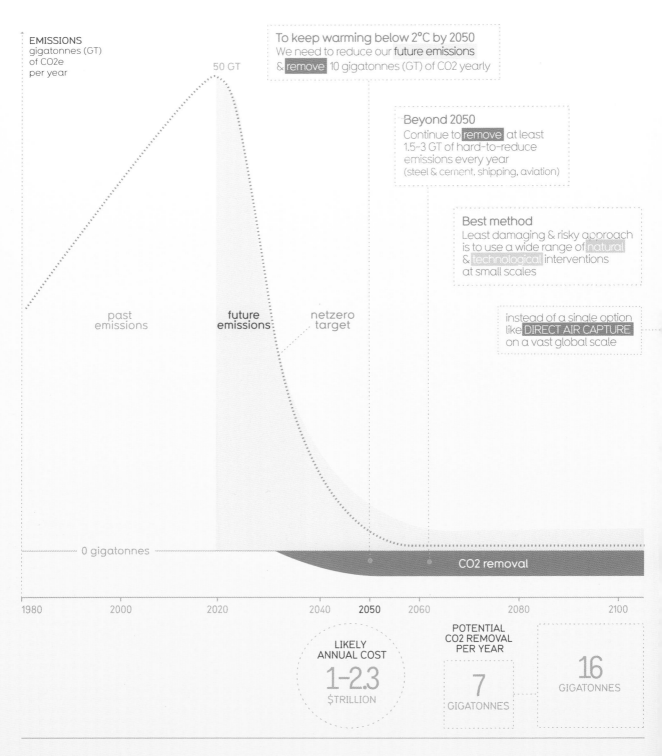

EMISSIONS
gigatonnes (GT)
of CO2e
per year

50 GT

To keep warming below 2°C by 2050
We need to reduce our future emissions
& remove 10 gigatonnes (GT) of CO2 yearly

Beyond 2050
Continue to remove at least
1.5–3 GT of hard-to-reduce
emissions every year
(steel & cement, shipping, aviation)

Best method
Least damaging & risky approach
is to use a wide range of natural
& technological interventions
at small scales

instead of a single option
like DIRECT AIR CAPTURE
on a vast global scale

past emissions

future emissions

netzero target

0 gigatonnes

CO2 removal

1980 2000 2020 2040 **2050** 2060 2080 2100

LIKELY
ANNUAL COST
1–2.3
$TRILLION

POTENTIAL
CO2 REMOVAL
PER YEAR
7
GIGATONNES

16
GIGATONNES

Our Portfolio of CO2 Capture Techniques

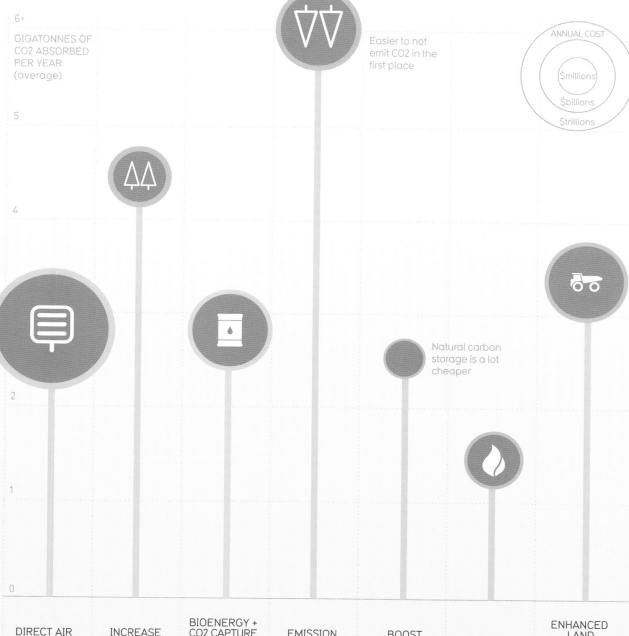

6+

GIGATONNES OF
CO2 ABSORBED
PER YEAR
(average)

5

4

2

1

0

Easier to not
emit CO2 in the
first place

ANNUAL COST

$millions

$billions

$trillions

Natural carbon
storage is a lot
cheaper

**DIRECT AIR
CAPTURE**

Suck CO2 from
ambient air &
store it deep
underground or
turn into minerals.

**INCREASE
FORESTATION**

Plant trees to
absorb more CO2.
Restore degraded
forests. Stop
deforestation.

**BIOENERGY +
CO2 CAPTURE
& STORAGE**

Burn biomass in
power stations for
fuel. But capture
the resulting CO2
and bury it.

**EMISSION
REDUCTION**

The world limits
CO2 emissions
to below crisis
thresholds
starting NOW!

**BOOST
SOIL CARBON**

Support use of
agricultural &
land practices
that increase CO2
storage in soils.

BIOCHAR

Convert waste
vegetation –
straw, leaves, etc.
– into charcoal &
bury in the soil.

**ENHANCED
LAND
WEATHERING**

Add minerals
to soil to speed
up natural
CO2 absorption
by rocks.

LIKELY ← → UNLIKELY

Climate Hacking: For Emergencies Only

Extreme Geoengineering & Solar Management Are Fallbacks

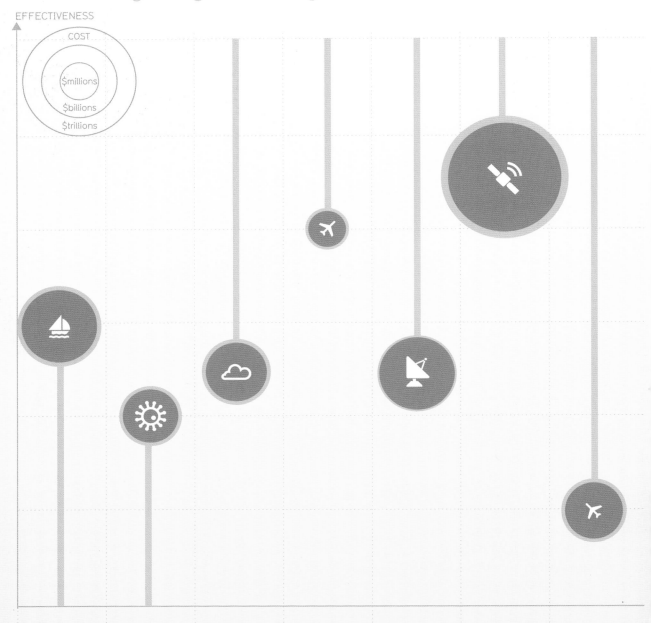

EFFECTIVENESS

COST

$millions

$billions

$trillions

OCEAN ALKALINIZATION	OCEAN FERTILIZATION	CLOUD WHITENING	STRATOSPHERIC AEROSOLS	DESERT REFLECTORS	SPACE REFLECTORS	SKY ALKALINIZATION
Stir megatonnes of limestone into oceans so more CO2 absorbed by less acidic water.	Add iron filings to surface water & boost growth of CO2-absorbing algae.	Air-spray particles of sea salt to make clouds whiter & reflect more sunlight.	Scatter sulphate particles high in the atmosphere to reflect sunlight & lower heat.	Cover vast areas of unused land with foil. No, seriously.	Launch thousands of orbital mirrors to divert sunlight away from the Earth's surface.	Seed clouds with minerals to create 'alkali rain' to wash CO2 out of the air.

CREDIBLE ← → INCREDIBLE

Carbon Capture at Source
Suck up the CO2 before it even hits the atmosphere

INDUSTRIAL SOURCES
Install special capture devices at fossil-fuel plants to absorb emissions

SUPER EFFECTIVE
Capture the highly concentrated greenhouse emissions before they're diluted in the air

BUT EXPENSIVE
Hundreds of $millions to install and operate. Plus heat energy is required to extract the CO2.

ON THE RISE
Many projects already installed, capturing 40 million tonnes per year (0.1% of emissions)

CARBON CAPTURE FACILITIES WORLDWIDE

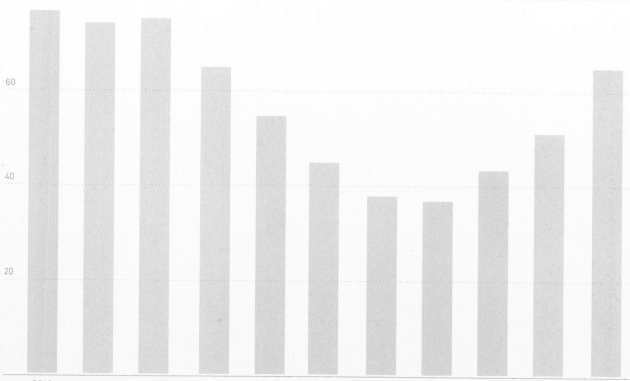

80

60

40

20

2010 2020

CAPTURE COSTS ARE DECREASING
$ per metric tonne of CO2 captured

current prices
COAL EMISSIONS NATURAL GAS

$30 $52 $60 $80 $90

ideal price for carbon capture to be viable

GOVERNMENTS ARE ALREADY INVESTING

tax credits and subsidies already deployed in US, China & Europe

$90 BILLION in investment is likely before 2030

TONNES OF INNOVATION IN THE PIPELINE...

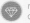 integration with carbon pricing schemes ▸148

 new extraction materials & techniques

 novel ways to store captured CO2 ▸060

sources: *New York Times*, IPCC, National Academy of Sciences, Carbon Dioxide Removal Primer, Cicero, BBC, The Royal Academy

Is it Wrong to Fly?

Air travel accounts for ~2.5% of global greenhouse gas emissions

But closer to 5–8% of climate impact due to high-altitude release of gases & vapors

CARBON DIOXIDE

NITROUS OXIDE

SOOT plays a key role in contrails, which increase warming

WATER VAPOR

relative global heating effects (radiative forcing) of major components of aviation emissions

From nearly 100,000 daily flights in a typical year

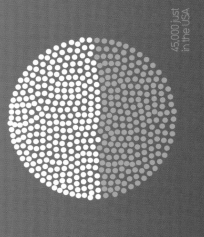

45,000 just in the USA

It's definitely one of the worst forms of transport, emissions-wise

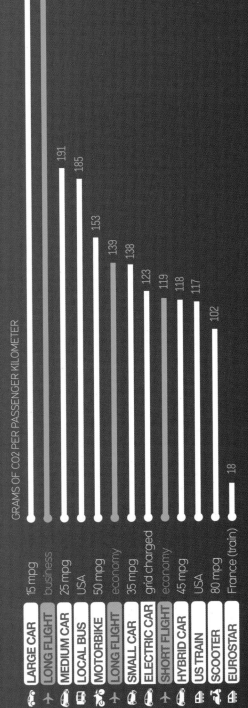

GRAMS OF CO2 PER PASSENGER KILOMETER

Transport		Value
LARGE CAR	15 mpg	312
LONG FLIGHT	business	297
MEDIUM CAR	25 mpg	191
LOCAL BUS	USA	185
MOTORBIKE	50 mpg	153
LONG FLIGHT	economy	139
SMALL CAR	35 mpg	138
ELECTRIC CAR	grid charged	123
SHORT FLIGHT	economy	119
HYBRID CAR	45 mpg	118
US TRAIN	USA	117
SCOOTER	80 mpg	102
EUROSTAR	France (train)	18

Flying has become an essential part of our society, culture & economy

MILLIONS OF FLIGHTS PER YEAR

16.6
1993

39.4
24.4
2020
PREDICTED

It's not going away

And nor are its emissions

PREDICTED INCREASE

between

240%

and

360%

71.6
2035

If aviation's eco-targets aren't met soon, air travel could consume 25% of our global carbon emissions* allowance

Paris Agreement carbon budget to stay under 1.5°C

* Paris Agreement carbon emissions*

12.5% if 50% CO2–emission–reduction targets are met

And many things are as bad or worse emitters & maybe easier to tackle...

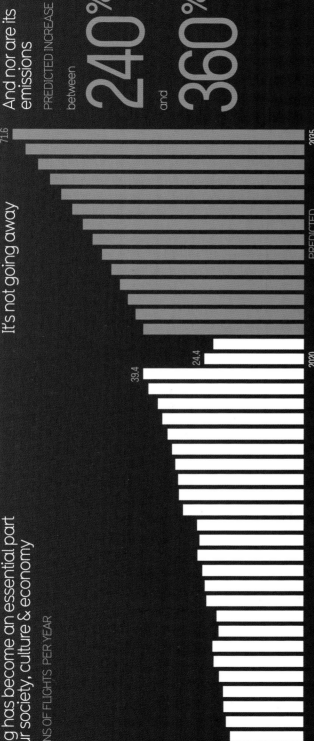

AIR TRAVEL

SHIPPING

FOOD WASTE
▶162

LANDFILLS

CARS
▶141

But if everyone just stopped flying, it would have a minor impact on emissions

sources: New York Times, Carbon Brief, IPCC, National Geographic, NRDC, IATA

Some Solutions Are Ready for Take-Off

'CORSIA' CARBON OFFSETTING & REDUCTION SCHEME FOR INTERNATIONAL TRAVEL

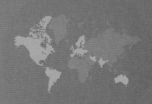

Global agreement where airlines commit to using sustainable aerofuels or offsets to cancel out emissions from international flights

192 countries onboard

non-mandatory until 2027

not domestic flights
Paris Agreement covers those

private jets exempt

Sustainable Aerofuels

 Up to 80% emissions savings across entire lifecycle

 Not here yet – still expensive & difficult to produce

 Stringent safety requirements means uptake is low

 Will work best for international flights (400 miles or more)

Boosting Aircraft Efficiency

% IMPROVEMENT SINCE 1980

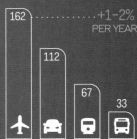

+1–2% PER YEAR

162 — Lighter materials, next-gen engines
112
67
33

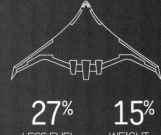

27% LESS FUEL BURNED

15% WEIGHT REDUCTION

New aerodynamic plane designs

Better Personal Choices

THE 12% OF US ADULTS WHO TAKE 6+ FLIGHTS A YEAR ARE RESPONSIBLE FOR 70% OF ALL US AVIATION EMISSIONS

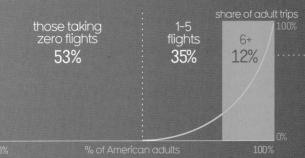

those taking zero flights
53%

1–5 flights
35%

6+
12%

share of adult trips
100%

0%

0% % of American adults 100%

 choose direct flights
they're better because 25% of emissions occur on take-off and landing

 consider cabin class
first-class passengers use 5x the emissions of economy by taking up more plane space

reduce unnecessary flights

 seek alternative transport
trains, especially electric trains in Europe, are most ideal – but US trains are fossil-fuel powered

offset your flight emissions
there are some good schemes – see our guide 220

sources: US Bureau of Transport, Nat Geo, World Bank

Electric Planes?

Top Speed km/h

Boeing 747	965
Airbus A320	904
Cessna*	800
Helicopter	300
Alice	440

$Fuel Cost per 100km

400
207
100
42
6

Passenger Capacity

Cessna	8
Alice	9
Heli	18
A320	150
747	660

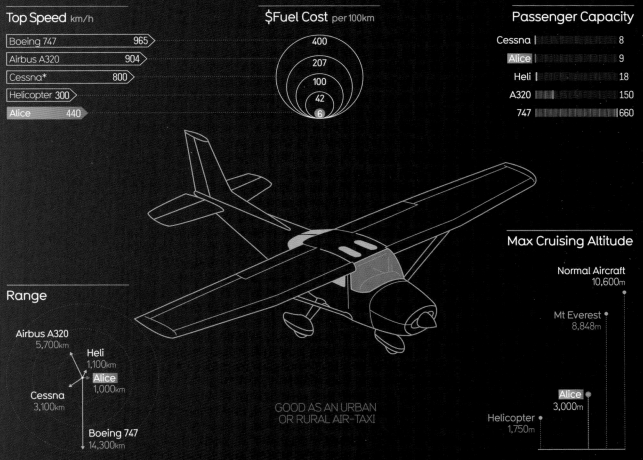

Range

Airbus A320
5,700km

Heli
1,100km

Alice
1,000km

Cessna
3,100km

Boeing 747
14,300km

GOOD AS AN URBAN
OR RURAL AIR-TAXI

Max Cruising Altitude

Normal Aircraft
10,600m

Mt Everest
8,848m

Alice
3,000m

Helicopter
1,750m

* Cessna Citation XLS, Airbus H175 Helicopter

sources: BBC, Wikipedia & others

Challenges OVER 200 ELECTRIC PLANE DESIGNS ARE IN DEVELOPMENT BUT THE TECHNOLOGICAL HURDLES ARE HIGH

The aviation industry is built on energy-dense fuels	An electric 747 would need a battery	Future battery tech might reduce this	Hydrogen or hybrid-electric planes are possible
Gasoline is incredibly energy dense	7x heavier than the plane itself	But by not nearly enough	But continued use of aerofuels more likely
			at least for international flights

sources: BBC, Wikipedia

Does Carbon Offsetting Really Work?

when you reduce emissions **in one place** to **compensate** for emissions you caused **somewhere else**

so to offset the 1.5 tonnes of CO2 on your transatlantic return flight

you might invest in programs to support

renewable energy clean-water access cleaner cookstoves tree planting

problem!

there are no global or national regulations in most countries on what a **carbon offset** is

so anyone can sell one

early programs proved useless, even fraudulent

but today, some **beautifulnews**

Gold Standard ········· solid independent certifications exist ········· **Green-e**

what makes a good one?

high quality schemes need to be

real	verified	enforceable	permanent	additional	leak-proof
the project actually exists	independent 3rd-party checks	repercussions if not completed	not easily reversible	accomplishing something new	emissions stopped not just shifted

ultimately, do offsets work?

mathematically	socially/politically	ethically
YES	KINDA	UNCLEAR
If executed well, and are high quality, they can deliver a fair offset	Does voluntary offsetting take the pressure off corporate polluters & detract from systemic issues?	Is it okay for people in rich countries to just 'buy out' their climate guilt ?

sources: IPCC, National Geographic, Natural Resources Defence Council

50 Countries Have Reduced Their Overuse of Fertilizers

Decrease in nitrogen, potash & phosphate per hectare

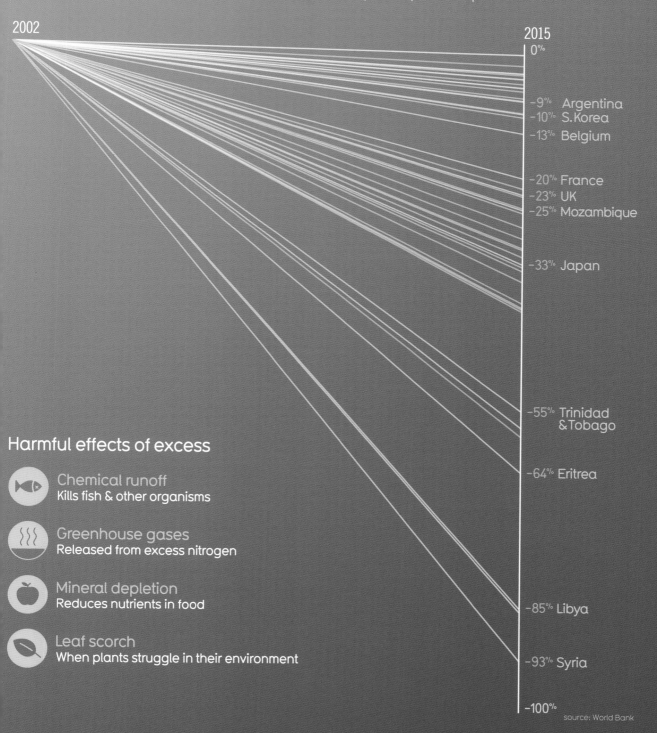

2002

2015

0%

−9% Argentina
−10% S. Korea
−13% Belgium

−20% France
−23% UK
−25% Mozambique

−33% Japan

−55% Trinidad & Tobago

−64% Eritrea

−85% Libya

−93% Syria

−100%

source: World Bank

Harmful effects of excess

Chemical runoff
Kills fish & other organisms

Greenhouse gases
Released from excess nitrogen

Mineral depletion
Reduces nutrients in food

Leaf scorch
When plants struggle in their environment

More than institutions have de-in $14 TRILLION from fossil- companies

1,200

worldwide

vested

fuel

breakdown of institutions

faith institutions 15% de-invested	philanthropy 17%
education 15%	pension funds 14%
government 15%	corporations 6%
	NGOs 4% / health care 1%

source: GoFossilFree.org

Seaweed: food, fertilizer, feed, fuel

Can it be all these things – and tackle our emissions problem?

Sea Trees

Seaweed absorbs at least as much CO2 as trees, but without taking up valuable land. A dry tonne of kelp absorbs about **a tonne of CO2** in its lifetime.

sources: Nature Geoscience, Science, FAO, ScienceNordic, Project Drawdown

Ultra Fast Growing

MAX GROWTH PER DAY (cm)

Bamboo	90
Kelp	60
Kudzu	30
Algae	4.2
Acacia	2.5

Kelp seaweed grows incredibly quickly – it's one of the fastest-growing plants in nature. So fast, it could be harvested for its various uses **every 90 days**.

sources: Drawdown, PLOS One, BBC, Monterey Bay Aquarium, EarthnWorld

Biofertilizer

Seaweed contains powerful, growth-stimulating hormones.* They stimulate seed germination and nutrient uptake while protecting plants from infections.

*auxins, cytokinins, gibberellins

source: Journal of Scientific & Industrial Research

100% Sustainable, Low-Carbon Crop

Ocean seaweed farms have none of the major downsides of land farming: **deforestation, overuse of fertilizers, fresh water,** and **fuel-burning machinery**.

Because they grow vertically, seaweed farms **use less space**, and attract aquatic life, boosting the ecosystem. They also sit 25m underwater so boats can pass above.

Harvesting is simple and often done by hand, using very little CO2 burning fuel.

The first seaweed farms are in trials off the coast of Hawaii.

sources: Project Drawdown, *Matters Journal, The Atlantic,* World Bank, National Geographic, BBC

Seafood Diet

Norwegian Kelp
(Fibre, Calcium, Copper)

Grass Kelp
(Iron, Iodine)

Irish Moss
(Magnesium)

Oarweed
(Potassium)

Widespread seaweed farms could supply very high-quality, high-nutrient food. Great source of **calcium, iron, magnesium, potassium & iodine**.
Plus it's very tasty!

sources: Nutrition Reviews, Nutrition Value

Fuel for Thought

About 50% of seaweed is oil, perfect for making biofuel.

It yields **30x more energy per acre** than other biofuel crops like soy or corn.

And there's no need to clear forests to grow it!

1,920,000km²
Area of kelp needed to switch all the world's petrol to seaweed biofuel.

695,000
Size of Texas

392,000
To switch USA's gas to biofuel

sources: Project Drawdown, World Bank, Biotechnology Reports, Oceanography, ADFC
Renewable & Sustainable Energy Review, Applied Energy

Livestock Feed

There's preliminary evidence that **cattle feed made from seaweed** reduces the methane expelled from both ends of the animal.

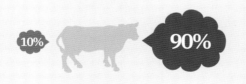

10%

90%

12% of the world's methane emissions come from the billions of cows, sheep, and goats around the world.

In ongoing studies, cows fed *limu kohu* seaweed saw their methane emissions drop between **12–58%**. In sheep, it was **80%**.

sources: Project Drawdown, NASA, Carbon Brief, Animal Microbiome, Matters Journal

Ocean Forest

Today's wild **kelp forests** cover just **77,000 km²** — approximately the size of Austria. But that's only 2% of the fertile ocean.
Imagine if that was larger...

source: Project Drawdown

Methane AKA 'natural gas' – the other major greenhouse gas

Methane (CH4) makes up **16%** of our total greenhouse gas emissions – it's used mostly to generate electricity.

A more powerful GHG gas than carbon dioxide (CO2), CH4 hits the atmosphere **faster & dissipates quicker**.

So it warms the planet **rapidly in the short term.** Whereas CO2 heats the planet over the long term.

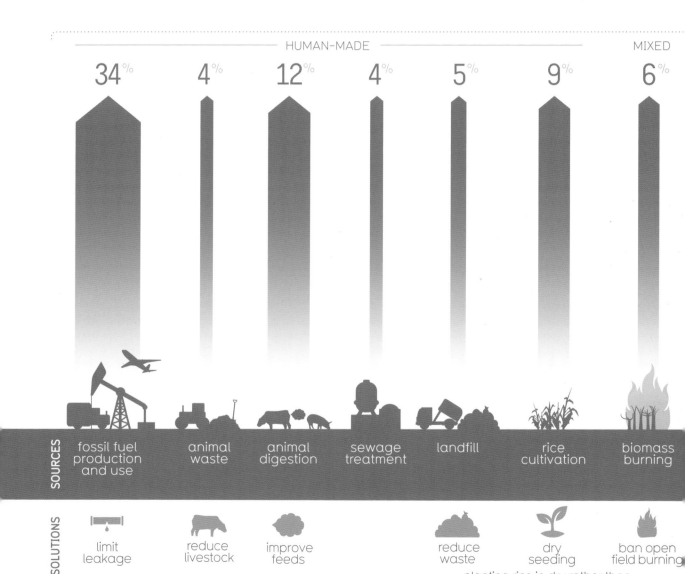

HUMAN-MADE MIXED

| 34% | 4% | 12% | 4% | 5% | 9% | 6% |

SOURCES

| fossil fuel production and use | animal waste | animal digestion | sewage treatment | landfill | rice cultivation | biomass burning |

SOLUTIONS

| limit leakage | reduce livestock | improve feeds | | reduce waste | dry seeding | ban open field burning |

◄···· capture this methane ····►

planting rice in dry rather than methane-emitting flooded fields

parts per billion
2000

atmospheric
methane increase

1500

1984 2017

558
million tonnes
emitted

548
million tonnes
absorbed

**excess
methane**

10
million tonnes
per year

NATURAL

30% 4% 3% 4% 94% 6%

wetlands termites other ocean chemical reactions soil
 natural in the atmosphere
 emissions decay methane into
 water & CO2

source: NASA, Project Drawdown, Climate & Clean Air Coalition, World Resources Instutute, Carbon Brief

The Potential of Hydrogen Power Is Amazing!

true natural resource
super-abundant, non-toxic element – will never run out

no direct emissions
burns cleanly – releasing only energy & water

highly stable
can be liquified & stored in fuel cells for weeks & years

easy to transport
via pipelines, or in trucks and ships

H is already in use around the world – and its potential looks rosy

size = potential

ALREADY	DEFINITELY	PROBABLY	PROBLEMATIC
done deal	makes sense	some obstacles	major issues
🚀 rocket fuel	✈ air-taxis	🚚 trucks/lorries	🚌 buses
oil refining	domestic heating	short-haul flights	shipping
making fertilizer	steel production	industrial transport	long-haul flights
first fuel-cell cars	industrial heating		widespread cars
	energy storage		

main problem

It's difficult to manufacture **H** without emitting carbon

TYPE OF HYDROGEN	GRAY	BLUE	BLACK/ BROWN	YELLOW	GREEN
WHAT	made from fossil fuels, mostly methane	same as gray but CO2 is captured	made with types of coal	synthesized with nuclear energy	renewable energy to extract **H** from water
% OF CURRENT GLOBAL H	76	0	23	0	2
$ PER KILO	$1-3	$1.5 *ideal price*	$2	unknown	$2.5-6
NOTE	every tonne of H generates 11 tonnes of CO2	not here yet, CO2 capture tech in its infancy ▸214	dirty tech – needs to be phased out	strong possibility for carbon-free hydrogen	

versatile
can be 'dropped in' existing
natural gas grid & boilers

a decent bet
could supply up to 20% of
global emissions – free energy

high energy density
more energy per kilogram
than most fuels, inc. gasoline

better than batteries
in terms of power-to-weight,
but not in efficiency

Global Production Is Ramping Up
With big plans for the future

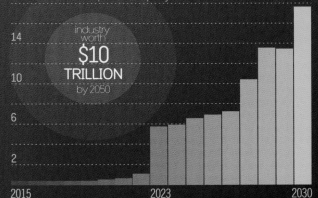

18 million tonnes H produced per year

industry worth **$10 TRILLION** by 2050

14

10

6

2

2015 2023 2030

	Hydrogen Fuel Cell	Lithium Battery	Petrol/Gasoline
energy density kilowatt hours per kilo	34	0.3	13
efficiency % energy in to energy out	38%	80%	25%
mass required kg for a 300km car journey	5	540	40

Major Players Have Entered the Race

European Union
€470bn
investment
by 2050

Russia
not going to
be left behind

UK building a
'world-leading'
blue ⒣ plant

**Germany, Portugal,
Netherlands**
leading in Europe

China
already world's
largest producer

Japan
plans to build first
'hydrogen society'

South America
Chile, Brazil &
Argentina all
potential green
⒣ exporters

Saudi Arabia
aims to transition
to ⒣ economy

Challenges Ahead Though

**leaky
hydrogen
molecules**

**flammable
& highly
explosive**

**new safety
standards &
infrastructure
required**

**manufacturing
has got to use
low-carbon electricity
– or else there's
no point**

**current green
electrolysis
is very costly**

sources: Carbon Brief, International Energy Agency, 'How to Avoid a Climate Disaster' (Gates, 2020)

What about H-Fueled Passenger Cars?

Are Fuel Cell Electric Vehicles (FCEVs) a true alternative to 'battery electric'?

fuel-celled
electricity generated from onboard supply of H tanks

fast refuelling
can fill up at a traditional gas station in 5 mins

refuelling network
infrastructure will need to be built

industrial storage
expensive level of gas compression required

Overall Efficiency Is Less Than Electric
% OF ENERGY DELIVERED TO WHEELS

16	30	33	49		77	88
gasoline		hydrogen			electric	

But Max Range Is About the Same
MILES BEFORE RECHARGE

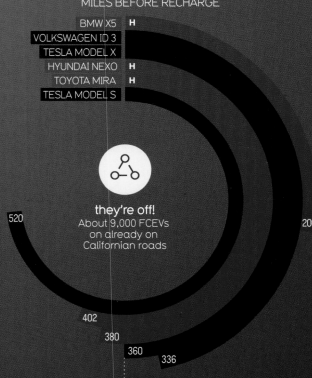

BMW X5 **H**
VOLKSWAGEN ID 3
TESLA MODEL X
HYUNDAI NEXO **H**
TOYOTA MIRA **H**
TESLA MODEL S

they're off!
About 9,000 FCEVs on already on Californian roads

520
402
380
360
336
200

Big Car Makers Are Split
MANY ARE ALREADY WEDDED TO BATTERIES

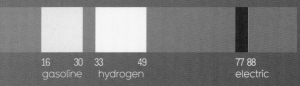

OUT	IN

Audi
FIAT DAIMLER Mercedes-Benz
Volkswagen
TESLA
General Motors

HYUNDAI
HONDA
BMW
TOYOTA

Ford ON THE FENCE **NISSAN**

H vans & lorries
most manufacturers are investing in H-powered fuel cell trucks for commercial fleets

ultimately H needs to be green & carbon-free
only H produced from renewable energy like solar & wind makes sense or else we're just adding more emissions

Hydrogen Aircraft Could Be Possible
But at least 10 years away

planes will have to be redesigned to accommodate fuel cells

liquified hydrogen needs 4x the storage of kerosene airfuels

long haul unlikely
Compounding effect of greater storage, aircraft design, etc. makes hydrogen long haul very challenging

short & medium haul is feasible
The EU is shooting for 2035-2040 for hydrogen-powered flights of less than four hours (which cause 60% of aviation's emissions)

fuel cell air-taxis
Like a big drone, basically, but powered by lighter hydrogen fuel cells for increased lift and range - 5 people up to 600 km.

hybrids possible
Using H in flight to power fuel cells, or combining with CO2 to create new synthetic liquid fuels, may mean less change to existing infrastructure

A Hydrogen PowerPaste for Scooters, Motorcycles & Drones
Amazing new solution for small vehicles

H is combined with magnesium to make powdered magnesium hydride

adding water activates a chemical reaction to produce H to drive a motor

10x energy density of electric battery

functional from -30 to 250 degrees C

stored in swappable cartridges & canisters

sources: Fraunhofer Institute, Airbus, Carbon Brief, The Week, 'How to Avoid a Climate Disaster' (Bill Gates, 2020)

Protests Engaging 3.5% of a Population Very Rarely Fail

Major movements 1960 onwards

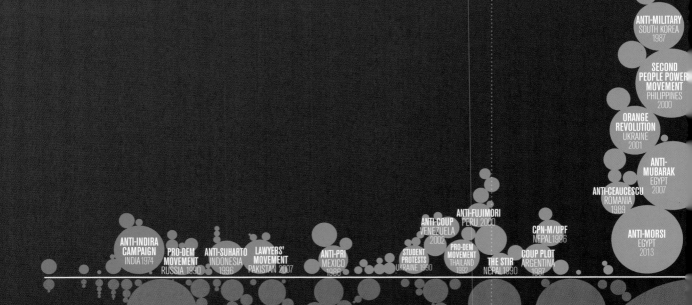

ANTI-MILITARY
SOUTH KOREA
1987

SECOND
PEOPLE POWER
MOVEMENT
PHILIPPINES
2000

ORANGE
REVOLUTION
UKRAINE
2001

ANTI-
MUBARAK
EGYPT
2007

ANTI-CEAUCESCU
ROMANIA
1989

ANTI-MORSI
EGYPT
2013

ANTI-FUJIMORI
PERU 2000

ANTI-COUP
VENEZUELA
2002

CPN-M/UPF
NEPAL 1996

ANTI-INDIRA
CAMPAIGN
INDIA 1974

PRO-DEM
MOVEMENT
RUSSIA 1990

ANTI-SUHARTO
INDONESIA
1996

LAWYERS'
MOVEMENT
PAKISTAN 2007

ANTI-PRI
MEXICO
1986

STUDENT
PROTESTS
UKRAINE 1990

PRO-DEM
MOVEMENT
THAILAND
1992

THE STIR
NEPAL 1990

COUP PLOT
ARGENTINA
1987

FAILED

0.1% OF POPULATION ENGAGED (LOG) 1%

3.5%

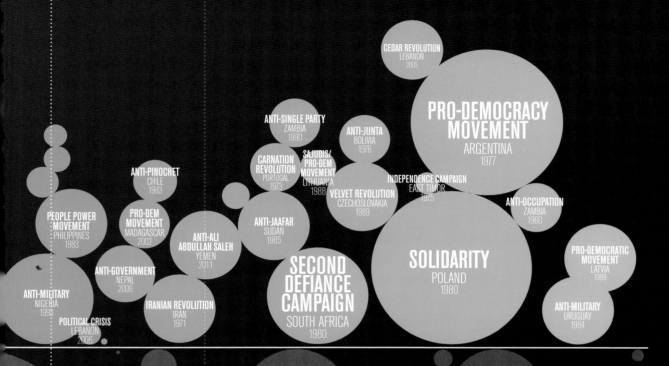

CEDAR REVOLUTION
LEBANON
2005

ANTI-SINGLE PARTY
ZAMBIA
1990

ANTI-JUNTA
BOLIVIA
1976

PRO-DEMOCRACY
MOVEMENT
ARGENTINA
1977

ANTI-PINOCHET
CHILE
1983

CARNATION
REVOLUTION
PORTUGAL
1973

SAJUDIS/
PRO-DEM
MOVEMENT
LITHUANIA
1988

INDEPENDENCE CAMPAIGN
EAST TIMOR
1975

VELVET REVOLUTION
CZECHOSLOVAKIA
1989

ANTI-OCCUPATION
ZAMBIA
1960

PEOPLE POWER
MOVEMENT
PHILIPPINES
1983

PRO-DEM
MOVEMENT
MADAGASCAR
2002

ANTI-JAAFAR
SUDAN
1985

PRO-DEMOCRATIC
MOVEMENT
LATVIA
1989

ANTI-ALI
ABDULLAH SALEH
YEMEN
2011

SECOND
DEFIANCE
CAMPAIGN
SOUTH AFRICA
1980

SOLIDARITY
POLAND
1980

ANTI-GOVERNMENT
NEPAL
2006

ANTI-MILITARY
NIGERIA
1993

IRANIAN REVOLUTION
IRAN
1971

ANTI-MILITARY
URUGUAY
1984

POLITICAL CRISIS
LEBANON
2006

 = no. of protestors

3.5% 10% 100%

source: Nonviolent & Violent Campaigns and Outcomes (NAVCO) Data Project

REF
REDUC
REUSE
REPAIR
REPURPOSE
RECYCLE (last resort)

USE
E

Armies Everywhere Are Shrinking

Soldiers as % of population

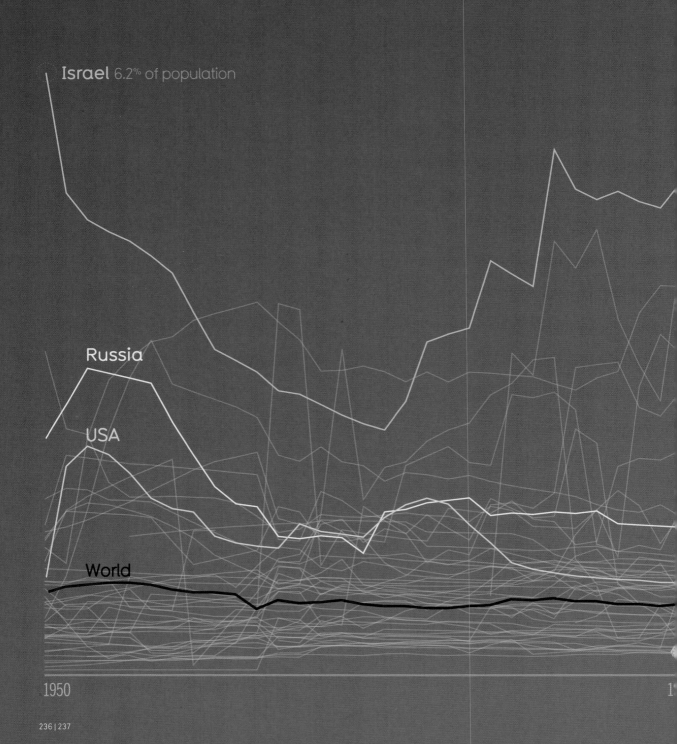

Israel 6.2% of population

Russia

USA

World

1950

1⁹

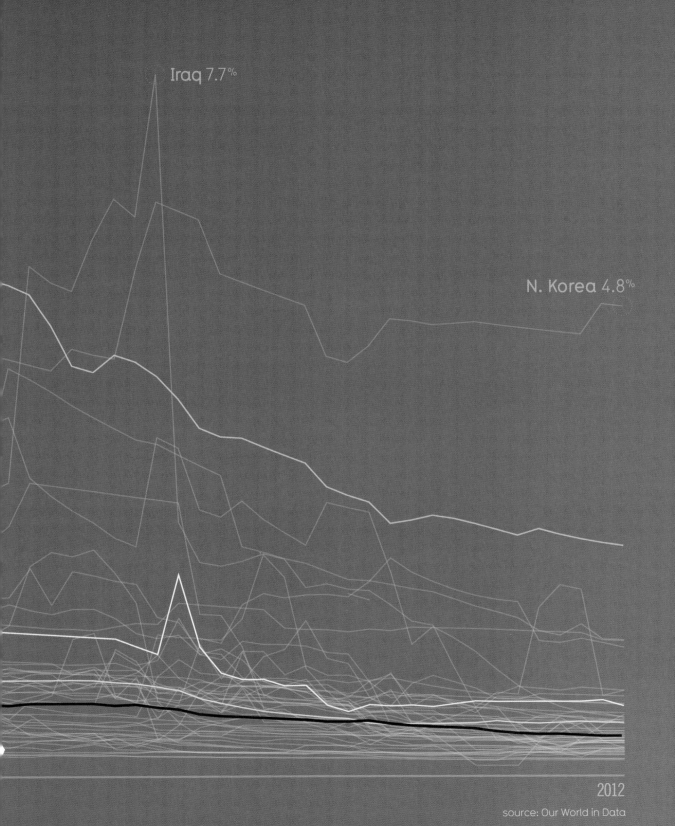

Iraq 7.7%

N. Korea 4.8%

2012

source: Our World in Data

Famine Deaths Have Plummeted Globally

1960s
5,470 DEATHS per million people

2000s
460

2010-2016
40

source: Our World in Data

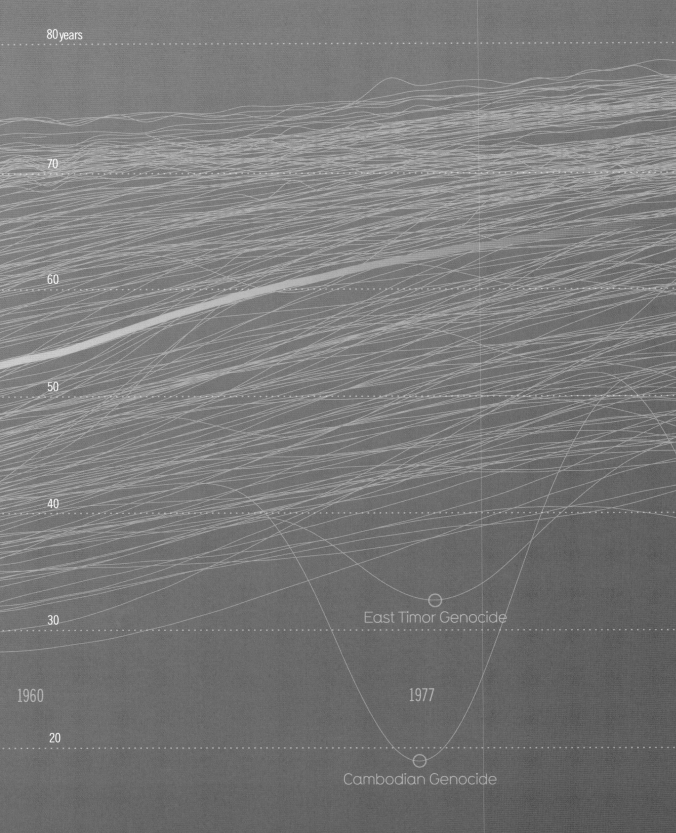

80 years

70

60

50

40

30

1960

20

○ East Timor Genocide

1977

○ Cambodian Genocide

AVERAGE: 72

AIDS epidemic in
Sub-Saharan Africa

Sierra Leone
Civil War

1993 Rwandan Genocide

2018

Everyone, Everywhere Is Living Longer
Average life expectancy in each country

sources: GapMinder, Our World in Data

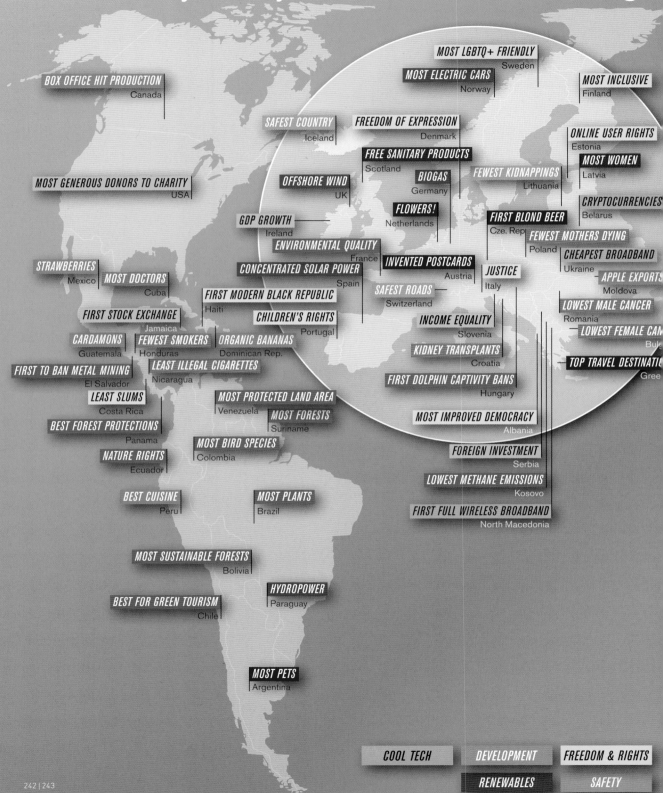

Because Every Country Is Most Beautiful at Something

MOST LGBTQ+ FRIENDLY
Sweden

MOST ELECTRIC CARS
Norway

MOST INCLUSIVE
Finland

BOX OFFICE HIT PRODUCTION
Canada

SAFEST COUNTRY
Iceland

FREEDOM OF EXPRESSION
Denmark

ONLINE USER RIGHTS
Estonia

MOST WOMEN
Latvia

FREE SANITARY PRODUCTS
Scotland

BIOGAS
Germany

FEWEST KIDNAPPINGS
Lithuania

MOST GENEROUS DONORS TO CHARITY
USA

OFFSHORE WIND
UK

FLOWERS!
Netherlands

FIRST BLOND BEER
Cze. Rep.

CRYPTOCURRENCIES
Belarus

GDP GROWTH
Ireland

FEWEST MOTHERS DYING
Poland

ENVIRONMENTAL QUALITY
France

INVENTED POSTCARDS
Austria

CHEAPEST BROADBAND
Ukraine

STRAWBERRIES
Mexico

MOST DOCTORS
Cuba

CONCENTRATED SOLAR POWER
Spain

JUSTICE
Italy

APPLE EXPORTS
Moldova

FIRST MODERN BLACK REPUBLIC
Haiti

SAFEST ROADS
Switzerland

LOWEST MALE CANCER
Romania

FIRST STOCK EXCHANGE
Jamaica

CHILDREN'S RIGHTS
Portugal

INCOME EQUALITY
Slovenia

LOWEST FEMALE CANCER
Bulgaria

CARDAMONS
Guatemala

FEWEST SMOKERS
Honduras

ORGANIC BANANAS
Dominican Rep.

KIDNEY TRANSPLANTS
Croatia

TOP TRAVEL DESTINATION
Greece

FIRST TO BAN METAL MINING
El Salvador

LEAST ILLEGAL CIGARETTES
Nicaragua

FIRST DOLPHIN CAPTIVITY BANS
Hungary

LEAST SLUMS
Costa Rica

MOST PROTECTED LAND AREA
Venezuela

BEST FOREST PROTECTIONS
Panama

MOST FORESTS
Suriname

MOST IMPROVED DEMOCRACY
Albania

NATURE RIGHTS
Ecuador

MOST BIRD SPECIES
Colombia

FOREIGN INVESTMENT
Serbia

LOWEST METHANE EMISSIONS
Kosovo

BEST CUISINE
Peru

MOST PLANTS
Brazil

FIRST FULL WIRELESS BROADBAND
North Macedonia

MOST SUSTAINABLE FORESTS
Bolivia

HYDROPOWER
Paraguay

BEST FOR GREEN TOURISM
Chile

MOST PETS
Argentina

COOL TECH — **DEVELOPMENT** — **FREEDOM & RIGHTS**
RENEWABLES — **SAFETY**

EARLIEST CHRISTIAN STATE
Azerbaijan

MOST KIDS COMPLETING SECONDARY SCHOOL
Kazakhstan

DROP IN TEEN PREGNANCIES
Afghanistan

LOWEST DISEASE DEATH RATE
Japan

LARGEST CONCENTRATED SOLAR POWER PLANT
Morocco

CHESS GRANDMASTERS
Armenia

BEST SOCIAL SAFETY NET
Mongolia

CONTACTLESS PAYMENTS
Georgia

SOLAR PANELS
China

IMPROVING COMPETITIVENESS
Cyprus

TIDAL POWER
South Korea

FIRST TO RECOGNIZE PALESTINE
Algeria

TEA CONSUMPTION
Turkey

IMPROVING UNIVERSITIES
Iran

BIGGEST RISE IN GIRLS ATTENDING SCHOOL
Nepal

MOST STARTUPS
Israel

INCREASING INTERNET USERS
Iraq

FIRST CARBON-NEGATIVE NATION
Bhutan

FEWEST CAR THEFTS
Senegal

FASTEST INTERNET
Taiwan

IMPROVING EASE OF BUSINESS
Saudi Arabia

BEST HEALTHCARE
Hong Kong

FEWEST DRINKERS
Mauritania

CAMEL RACERS
Chad

LOWEST UNEMPLOYMENT
Qatar

TACKLING MALNUTRITION
Mali

FIRST TO BAN PLASTIC BAGS
Bangladesh

BEST DIVING
Philippines

LOWEST DIABETES PREVALENCE
Benin

ENTIRE COASTLINE PROTECTED
Eritrea

BIGGEST INCREASE IN VEGETABLE INTAKE
Laos

YOUNG PEOPLE
Niger

SCRABBLE PLAYERS
Nigeria

IMPROVING HEALTHCARE ACCESS
Sudan

MOST GENEROUS
Myanmar

LOWEST UNEMPLOYMENT
Cambodia

CONTRACEPTIVE ACCESS
Liberia

CASHEWS
Vietnam

NATURAL RUBBER
Thailand

EST CHOCOLATE
Cote d'Ivoire

FASTEST-GROWING ECONOMY
Ghana

'KAIZEN'*
Ethiopia

IMPROVING SOCIOECONOMIC EQUALITY
Somalia

FIRST BIOMETRIC PASSPORT
Malaysia

BEST PEPPERCORNS
Cameroon

FITNESS
Uganda

BEST RUNNERS
Kenya

MOST GENEROUS VOLUNTEERS
Sri Lanka

IMPROVING PEDESTRIAN SAFETY
Equatorial Guinea

COBALT
Congo

IMPROVING SANITATION
South Sudan

LIFE EXPECTANCY
Singapore

LINE GOVERNMENT PARTICIPATION
Gabon

MOST WOMEN MPs
Rwanda

BIGGEST REFORESTATION PROJECT
India

100% RENEWABLE ENERGY
Congo Dem. Rep.

LOWEST CO2 EMISSIONS
Burundi

MOST MAMMALS
Indonesia

BIGGEST DROP IN HUNGER
Angola

FIRST TO VACCINATE AGAINST MALARIA
Malawi

MOST LANGUAGES
Papua New Guinea

PROTECTION OF SEXUAL ORIENTATIONS
Botswana

VANILLA
Madagascar

CONSTITUTIONAL ECO-PROTECTION
Namibia

BIGGEST IMPROVEMENT IN BASIC MEDICAL CARE
Eswatini

MOST NATURAL PARKS
Australia

EDUCATION SPENDING
Lesotho

AVERTED MOST HIV INFECTIONS
South Africa

LEAST CORRUPTION
New Zealand

| HEALTH | MONEY | NATURE | NICE! |
| SKILLZ | WOMEN & GIRLS | | |

sources: so many
* 'kaizen' = Japanese principle of continuous improvement in business

Acknowledge-Venn

research

code

Keshia Naurana-Badalge

Stephanie Starling

Duncan Geere

Tom Evans

Emily Blandford

Holly McCandless-Desmond

Paul Barton

Rhodri Marsden

Swanuja Maslekar

Omid Kashan

slack
Trello
Airtable
*VIZ**sweet***

design

Mike Deal

Fabio Bergamaschi

Hanna Piotrowska

Anca Mateescu

Emily Klein

Kathryn Ruch

logistics

GREAT OPEN DATA:
Our World in Data
THE WORLD BANK
The New York Times
World Health Organization

Ruth Jobey

BIG THANKS

Sebastian Majewski	Kelly A. Bienhoff	Gina Ivey	Giles Newton	Chris Wright
Clare Greenaway	Tom Black	Mike Jeffrey	Saara Romu	Mark Bolland
Carrie Moore	Jeff Chertack	Brycie Jones	Katie Strock	Hazel Eriksson
Iram Quraishi	Akshay Duda	Kathy Kahn	Ankur Vora	Myles Archibald
Kamila Zawadzka	Daniel Green	Mike McCray	Amber Zeddies	Max Roser

More Beautiful Stuff

InformationisBeautiful.net

- explore our collection of beautiful visualisations
- access all the data & research from this book
- get involved with commenting & crowdsourcing
- find all our latest infographics and updates

⊙ 🐦 @infobeautiful

f facebook.com/informationisbeautiful

𝓟 pinterest.com/infobeauty

VIZ*sweet* .com

- see live examples of our dataviz app
- play with interactive versions of the images in this book

beautiful news

- informationisbeautiful.net/beautifulnews
- see over 400+ graphics

Fewer Children Are Dying
010

Foreign Aid Has Exploded
012

Women Can Finally Vote Everywhere
014

World Hunger Has Reached Its Lowest Point in 20 Years 016

We've Decommissioned 85% of the World's Nukes 018

Humpback Whales Are Recovering
020

Solar Panels
022

Extreme Poverty
024

Democracy
025

Drinking Safely
026

Natural Disasters
027

Cancer
028

Compilation 1
030

Compilation 2
032

11 Diseases
034

Quick Quiz
035

Answers-Donating-Fake News-Fossil Fuel Bans 036

We're Saving Children's Lives
038

More Girls Are in School
044

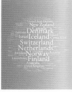

Up, up, up
046

Happiness
047

Global Flavors of Contentment
050

Transgender Rights Are Spreading
052

Vaccines!
054

Indigenous Guardians 057

Creative Ways to Deal With Our Emissions 058

Yay UK!
060

Women
062

Nuclear Power
064

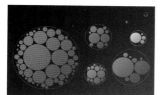

100 Cities & Towns Use
Renewable Energy 068

Every Single Country...
070

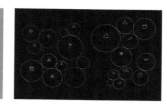

How to Get the World to Net Carbon
Zero by 2050 072

Smoking is Declining in Nearly
Every Country 090

Some of the Poorest Nations Are
Also the Most Generous 092

Food Tech
094

Canada's Protected Forests
096

The World Economy Has Ballooned
098

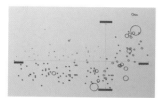

Geothermal Energy
100

Yay Africa!
102

The EU Is Leading on Recycling
& Emissions 104

Compilation 3
106

Fur
110

190 Nations Have Signed the Paris
Climate Agreement 112

Essential Health Coverage
114

Unendangered Animals
116

Solar Power is Amazing
118

Types of Solar
120

Gay
Rights 121

Amazing Agreements
122

Tree Planting
124

More Places Are Protecting Animals
128

Animals Bouncing
back 130

Transport
131

Phytoplankton
132

The Kigali Amendment
136

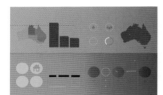
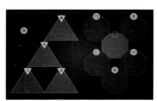

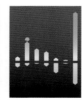

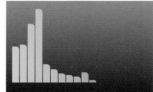

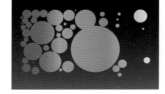

Plastic Waste & Degradation
190

Routes for Solving Plastic
192

Creative Solutions for Plastics
194

Plastics: what can you do?
196

Blood Donors
198

Death Penalty
200

Coronavirus - Unexpected Positive Things 202

Corporate Power Pledges
204

City & Country Climate Pledges
206

Down, down, down 208

Land Preservation 209

Surface of the Earth 210

LEDs
211

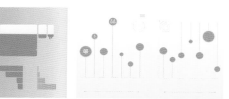

CO2 Removal
212

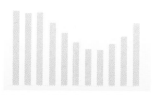

Climate Geoengineering
214

Is it Wrong to Fly?
216

Carbon Offsets
220

Fertilizers
221

De-investing from Fossil Fuels
222

Seaweed
224

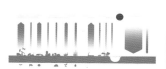

Methane
226

Hydrogen Power Is Amazing!
228

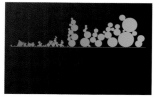

Protests with more than 3.5% of the population rarely fail 232

The Order of Things
234

Armies Around the World Are Shrinking 236

Famine Deaths Have Plummeted Globally 238

Everyone, Everywhere Is Living Longer
240

Because Every Country Is Most Beautiful at Something 242